THE COMPLETE
GUIDE TO WILDLIFE PHOTOGRAPHY

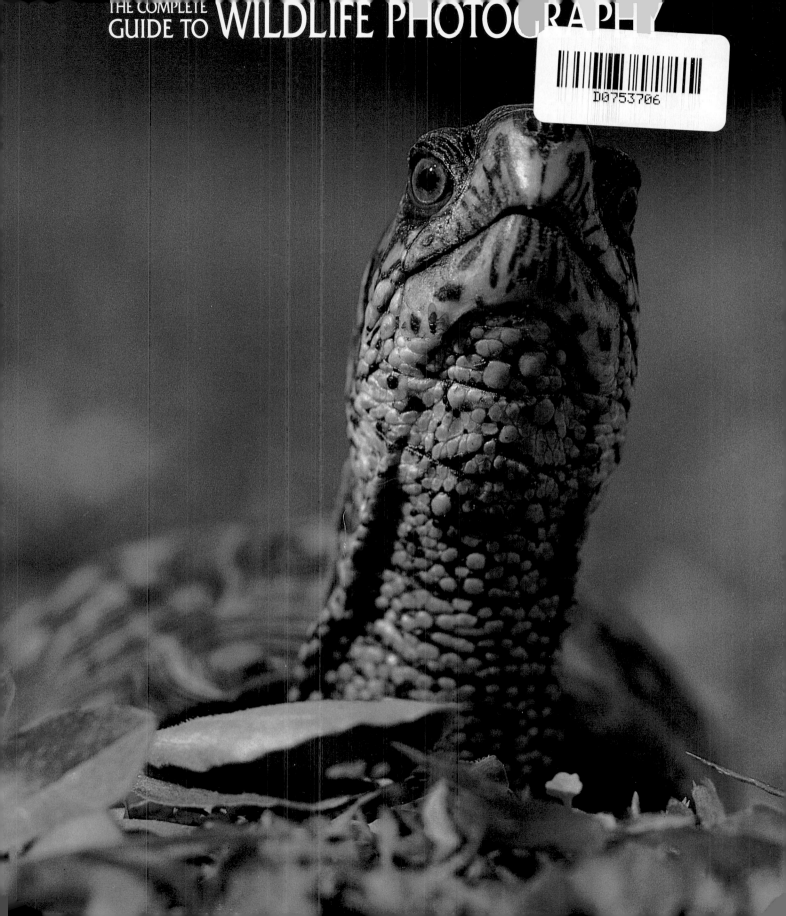

THE COMPLETE GUIDE TO WILDLIFE

Joe McDonald

PHOTOGRAPHY

AMPHOTO
An imprint of Watson-Guptill Publications
New York

PHOTO INFORMATION:

page 1
EASTERN BOX TURTLE, McClure, Pennsylvania.
100mm F4 lens, 1/60 sec. at f/13.

pages 2-3
LONG-EARED OWL IN FLIGHT, McClure,
Pennsylvania. 100mm F4 lens, 1/60 sec. at f/8
with manual flash and Dalebeam.

page 6
ATLANTIC PUFFIN, Machias Seal Island, Canada.
400mm F4.5 lens, 1/500 sec. at f/5.6.

Joe McDonald is a photographer, writer, and lecturer who leads photographic tours to exotic places around the world and conducts photography workshops throughout the United States. He advocates photographing wildlife without causing undue stress to animals. His photographs have appeared in the calendars of The Audubon Society and The Sierra Club. His images have also appeared in such national nature magazines as National Wildlife, International Wildlife, Audubon, Natural History, Ranger Rick, *and* Wildlife Conservation, *as well as in many wildlife and nature books. McDonald's work has also appeared in* Newsweek, Smithsonian, Time, *and* National Geographic. *When not traveling, he and his wife, Mary Ann, work on special photography projects near their home in Pennsylvania.*

Editorial concept by Robin Simmen
Edited by Liz Harvey and Sue Shefts
Designed by Areta Buk
Graphic production by Ellen Greene

First published in 1992 by AMPHOTO,
an imprint of Watson-Guptill Publications,
a division of BPI Communications, Inc.,
1515 Broadway, New York, NY 10036

Library of Congress Cataloging in Publication Data

McDonald, Joe.
 The complete guide to wildlife photography: how to get close and
capture animals on film.
 p. cm.
 Includes index.
 1. Wildlife photography. I. Title.
TR729.W54M33 1992 91-42527
778.9'32—dc20 CIP
 ISBN 0-8174-3717-7
 ISBN 0-8174-3718-5 (pbk.)

Manufactured in Singapore

2 3 4 5 6 7 8 9 / 00 99 98 97 96 95 94 93 92

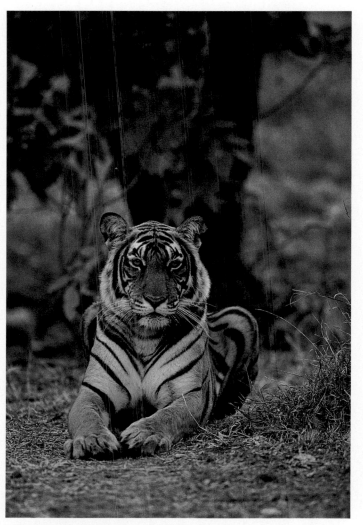

BENGAL TIGER, Ranthambore National Park, India. 300mm F2.8 lens,
1/125 sec. at ƒ/2.8, Fuji 100 pushed to ISO 200.

*Luck and field craft are both important to successful wildlife photography.
On a last game drive in India's tiger country, I was still hoping for "the
shot" that I had envisioned. With less than an hour of daylight remaining,
Mary Ann and I arrived at a spot where a tigress had just spent some
time. By guessing the direction that the cat had taken and hearing the
alarm cries of a spotted deer, we miraculously crossed paths with the
hunting cat. In the last few minutes of our safari, the tigress cooperated
by sitting for this portrait.*

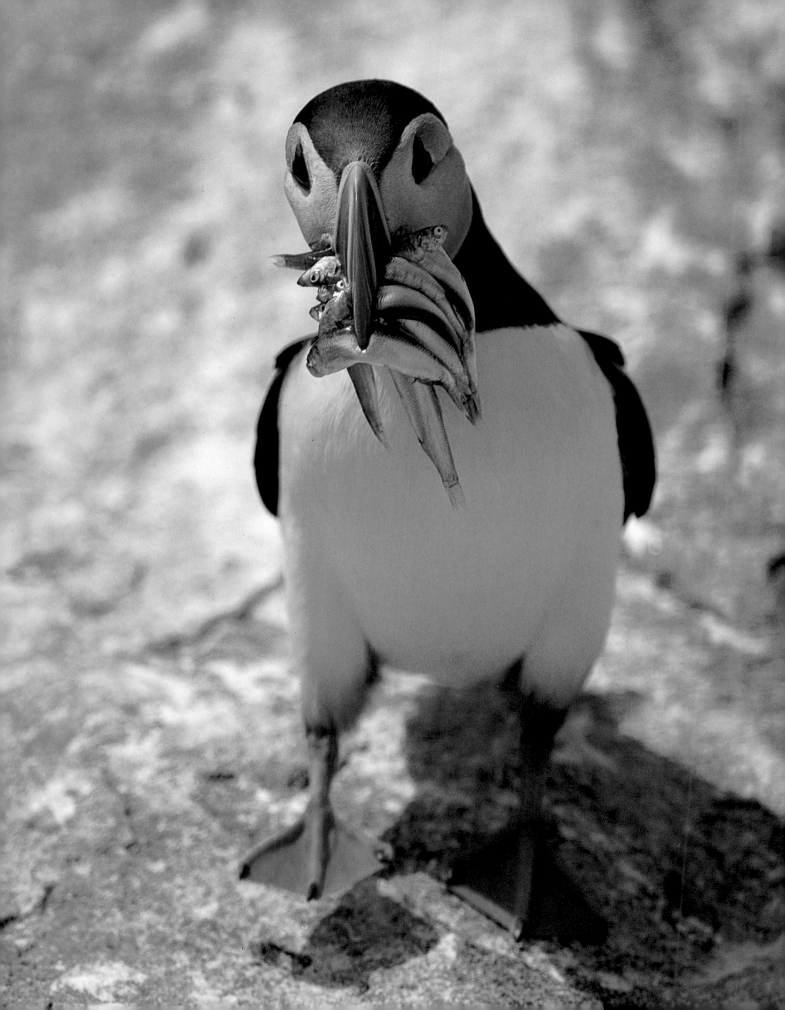

CONTENTS

INTRODUCTION

For the last eight years, I've taught a series of wildlife and nature photography workshops across the United States. During this time, equipment has grown increasingly sophisticated, with the introduction of autofocus cameras, TTL flash, and a host of other accessories. Despite this almost bewildering advancement in technology, I've found that students in these workshops ask many of the same questions every year, regardless of the gear they own.

In fact, beginners and advanced photographers frequently pose the same questions. Everyone seems troubled by exposure, composition, and getting close to their wildlife subjects. By teaching wildlife photography, I'm continually reminded of the dilemmas most photographers face when handling equipment that is unfamiliar to them or seeing a subject for the first time. I've faced many of these same questions and problems, and I continue to resolve them by seeking innovative ways to do old things or by trying to master new gear. Things never change: my students remind me that the old problems are still there, and my own work informs me that there are always new problems to solve.

In many ways, this book is a thorough extension of one of my photo workshops. In it I've attempted to present the basics of photography in a sequence and manner that make the most sense. I've assumed most people who read this book already own a camera and are anxious to take better images. For this reason, I begin with mastering exposure, the single biggest headache that plagues photographers. Most of you will add equipment as you continue in this hobby, and later chapters cover what you'll need to get the most for your time and money. Because successfully photographing a variety of wildlife and nature subjects requires practical, competent use of one's gear, I explain how to use that gear as I make reference to particular wildlife and nature applications. I've concentrated upon the basics of technique, rather than upon specific applications, because one technique can usually be applied to more than one type of subject.

Although wildlife and nature photography can be a rewarding, exquisitely enjoyable experience, it can also be frustrating, time-consuming, and physically taxing. Frequently, photography involves hard work: carrying gear, belly-crawling through sand, or baking inside a hot photo blind. Still, the rewards outweigh the disappointments, and increasing numbers of outdoor lovers are discovering the pleasures of photography.

Unfortunately, wildlife and nature photography is beginning to show signs of suffering from this popularity. Too many camera carriers are crowding into areas that, until quite recently, only the most serious photographers visited. As these areas become more crowded, in some sad cases the stressful pressure placed upon the animals affects their behavior. Because of this, parks and refuges are changing—or at least reevaluating—policies, and these changes may affect how all of us enjoy our wild areas in the future. This places a burden of responsibility upon all of us, for if we are to continue to have the freedom and ease of access we now enjoy in most places, we must do our best to work within the system. For the most part, that simply involves respecting the land and the wildlife, and interacting with both without causing harm to either.

I can't emphasize this enough. I suspect that you're photographing wildlife because you love and enjoy nature; hence it is reasonable to demand that you treat your subjects with respect. I especially caution you about this because of the nature of this book. If you're

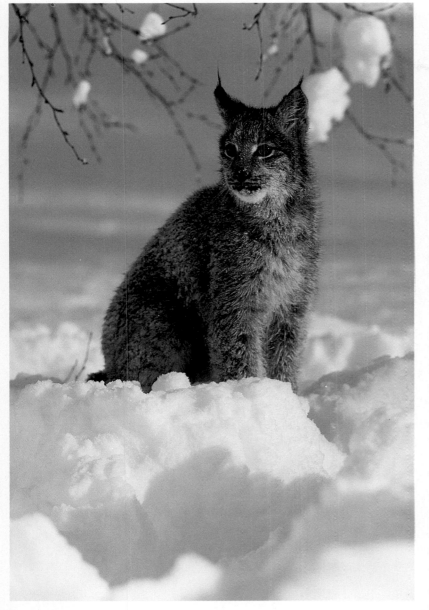

CANADA LYNX,
Wild Eyes game
ranch, Montana.
500mm F4.5 lens,
1/250 sec. at ƒ/8,
Kodachrome 64.

*A trick to successful
photography is
finding a subject. It is
extremely difficult to
photograph a North
American bobcat,
puma, or lynx in the
wild. Most shots, like
this of a young lynx,
are obtained under
controlled conditions.*

interested in all aspects of wildlife and nature, you'll be pointing your lenses at birds and bugs, mammals and reptiles. Techniques differ, and although aiming from a distance with long telephoto lenses is the best way to photograph birds, that technique would fail when attempting to photograph most salamanders or snakes. Photographing the latter may require collecting them first because many amphibians and reptiles live beneath rocks or logs. If you must collect an animal for photography, research its life requirements first. Never jeopardize the welfare of your subject for a photograph.

You might wonder if another book on wildlife or nature photography is necessary. Based on the questions and the suggestions students have given me about what they'd like to see explained in a book, I think there is room on the shelf for this one. Nonetheless, I strongly recommend that my readers buy and read *John Shaw's Closeups in Nature* (Amphoto: 1987) and *The Nature Photographers Complete Guide to Professional Field Techniques* (Amphoto: 1984), Patricia Caulfield's *Photographing Wildlife* (Amphoto: 1988), Leonard Rue's *How I Photograph Wildlife and Nature* (W.W. Norton & Co., Inc.: 1984), and my first book, *The Wildlife Photographer's Field Manual* (Amherst Media: 1991) for further information, insight, and technique.

In this text I've incorporated many of my students' suggestions, adding sections that they repeatedly requested. I've also included some intriguing exercises in the "In the Field" sections, concluding each chapter with actual problems that I've encountered. There I pose questions you should ask yourself when faced with similar situations.

You'll notice that many of the images in this book were made in only a few locations: around my home in McClure, Pennsylvania, in the Florida Everglades, in Yellowstone National Park, and in the Masai Mara Game Reserve in Kenya. There is a simple explanation for this: I visit these locations each year with small groups of students. In fact, I'm sure that many of these images are not unique but were also framed by those who have accompanied me.

I owe a great deal of thanks to my workshop and photo-tour participants. I've learned from some, and I've been inspired or humbled by others when I've looked through their viewfinders or critiqued their work. I've had a very good time doing this, traveling to some of the world's most beautiful and exciting places in the company of friends. I thank everyone involved for sharing with me this wonderful world, and I hope that this book helps you to capture on film the beauty and wonder that surrounds us outdoors.

PART 1: THE BASICS

TROPICAL TREEFROGS, Tinalandia,
Ecuador. 200mm F4 lens,
1/60 sec. at ƒ/16 with manual
flash, Kodachrome 64.

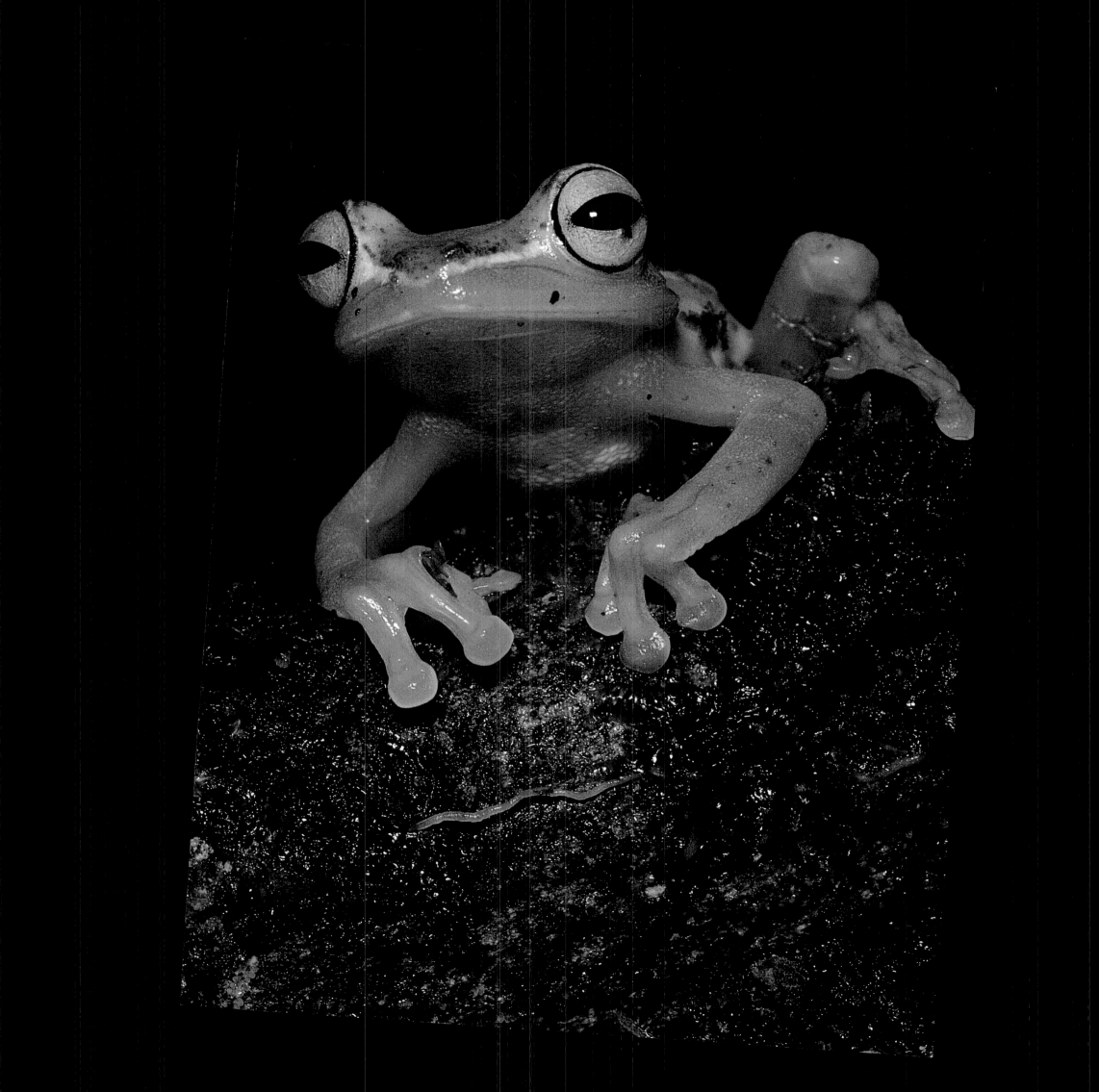

WHAT'S THERE TO SHOOT?

In a loud, Swiss-accented voice, one of the Everglades workshop participants asked, "Vat's der to shoot?" whenever our group arrived at a new shooting locale. He was joking, for he could pluck a photo gem from a visual slag heap. He had what is often called the "eye," for he had a sensitivity that allowed him to recognize a multitude of wonderful images every time he looked through his viewfinder.

One evening during the workshop, I projected one of his slides, a simple shot of a track-laced mudflat he had taken at Mrazek Pond in the southern end of Everglades National Park in Florida. He made the stunning image while most members of the group were wasting their time lamenting the absence of birds at this frequently productive area. Murmurs of admiration filled the room when, in a quiet, almost apologetic voice, he asked, "So, vat's der to shoot?"

There is plenty to shoot, if you simply open your eyes and mind to "see" what is available to you. Seeing may require a degree of sensitivity often ignored when you're too concerned with just one goal or subject. As these participants showed, the bird photographers intent on filming herons and egrets at Mrazek Pond were too preoccupied to recognize other, equally exciting possibilities.

Occasionally, of course, a subject isn't there, at least not while you are. For example, at high noon a meadow may be nothing more than harsh shadows and blowing weeds, but at daybreak, when dew lies heavily upon still grasses and chilled insects, it can be a magic location. Indeed, there is often a magic to dawn, when mist, fog, and low light combine to create photographic opportunities that no photographer could pass up. But every time of day offers something. I've often found that by simply focusing my attention on a small area and seeking vignettes of the larger, more confusing, and less inspiring scene, I can make images where nothing seemed to be at first glance. Not that this is easy. Sometimes seeing is work, requiring one to truly search out hidden subjects, textures, or patterns of light. Occasionally, I just sit for a few minutes to look at and contemplate the scene around me, and, in doing so, a photograph appears. That picture may not leap out, but may be as subtle as the interplay of a fern shadow upon a rock, or the discovery of a hidden creature nearby.

It is usually not too difficult to find a wildlife or nature subject, but the challenge truly lies in making a great photograph of what you find. Photographing animals without the thought of anything but getting the picture is little more than taking snapshots. These have their place,

YELLOW-BELLIED MARMOT, Yellowstone National Park, Wyoming. 500mm F4.5 lens, 1/125 sec. at ƒ/11 with TTL teleflash.

I made one of my favorite marmot photographs while most of our photo tour participants were busy eating lunch. Animals won't wait for you; when an opportunity arises, seize it!

GREAT HORNED OWL, Hayward, California. 100mm F4 macro lens, 1/60 sec. at ƒ/16 with manual flash, Kodachrome 64.

Other photographers and naturalists are wonderful sources of information and subject matter. Ask questions, and share information and tips with everyone you meet. At a California nature center, I became good friends with a naturalist who provided this wonderful photo opportunity.

but I think everyone hopes to make images that are beautiful or dramatic as well. This requires effort. Some try to take shortcuts by simply relying upon gear. While the right equipment is necessary for specific tasks, having it doesn't guarantee that anyone can become a good photographer. There is more to photography than that.

I run an assignment during my photo workshops that I call "the chicken salad exercise," where I take the workshop participants to an uninspiring location and ask them to make something exquisite—a "chicken salad" out of what appears to be nothing but "chicken scratch." The object of the exercise is to fine-tune your eye into seeing hidden or unnoticed images that are then shared and critiqued by the other people in the group.

The exercise can be humbling for the thin-skinned or for the person who must create a masterpiece in 20 very short minutes. Often that is the person carrying the most gear who, at the end of the period, is still wandering about, seeking images his or her closed mind will never

recognize. In contrast, there is usually someone with a rickety tripod, carrying only two lenses, who is open both to improving and to seeing. Often he or she is the one who sets up a truly outstanding image, for example, a pattern of shadows on a saw palmetto or a tree-bark detail accented by a well-camouflaged, easily overlooked spider.

By this, I'm not implying that good equipment isn't important. It is, and when used correctly it can improve your shooting dramatically. Instead, what I'm emphasizing is the importance of seeing, of previsualizing the image you wish to make, and of using your gear to make that image. A contractor doesn't randomly cut wood, haphazardly nailing pieces together, expecting to build a house. But some photographers seem to do exactly that and are surprised when they look through their cameras and see what their lenses reveal. What they've framed may in fact be striking, but it is better to know what you're getting beforehand and not to be surprised when you look through the viewfinder.

What is there for you to shoot? Plenty! Be it a drying mudflat or a grinning alligator, a roosting long-eared owl or a glowing Indian paintbrush, the natural world offers a wealth of subjects for you to render beautifully and sensitively on film. If you take the time to look, you'll discover that it was worth the effort.

WHAT YOU NEED TO SUCCEED

Even when you're armed with a vision, wildlife and nature photography is still a challenging endeavor. Consistently successful wildlife photography requires understanding both your subject and your equipment, a priceless amount of patience and luck, and a generous amount of time. Which one of these is the most important? I don't think any one can be placed above the others, for each contributes to a successful photographic image.

Knowing your subject will get you to the right place at the right time, and enable you to predict an animal's behavior before it occurs. Being at the right place is important. For example, I could work for weeks in my home state of Pennsylvania and not produce a worthwhile image of a wary, great blue heron. In contrast, at Anhinga Trail in Everglades National Park or at several other sites in Florida, I can easily photograph a great blue at any time of day in a variety of habitats. At some fishing piers, these tall herons even solicit handouts from the fishermen!

It is equally important to be at the right place at the right time. It does little good to wander the woods in June if the lady slippers you seek bloomed in early May. Unfortunately, a field guide may list both months, and you may not know that these dates apply to the flower's entire range. Sometimes, to get the facts right requires further effort. Read; talk to people, especially to other photographers; watch educational television; and, most important, go into the field and observe your subjects to acquire basic field knowledge.

You must know your equipment well in order to succeed. Most people do not. I'm amazed at how often people don't know that their camera has a PC socket, or that they can flip to a vertical image via the tripod collar on their telephoto lens, or that they can check their depth of field with a preview button. They use their gear improperly or grow frustrated with it because they don't know what the equipment can do. Here's a tip: Some of your most valuable photo resources are your equipment manuals; read them to learn all the capabilities and details of your gear.

Keep practicing if you are disappointed with your photographs. Gear can malfunction and a poor image may not be your fault, but by experiencing a failure you may be tempted to stop using some gear or technique, rather than to seek out the reason for your disappointments. Many photographers avoid flash for this reason, having tried using it once or twice without obtaining satisfactory results. Like any other skill, photography and the use of complicated

CRANE FLY (beaded with dew at dawn), McClure, Pennsylvania. 100mm F4 lens, 1/8 sec. at ƒ/8, Fujichrome 100.

Photographing this crane fly presented two challenges typical for wildlife photographers: first, finding the subject, which was difficult in a wet meadow at dawn; second, understanding how best to use my equipment to capture the image I had envisioned.

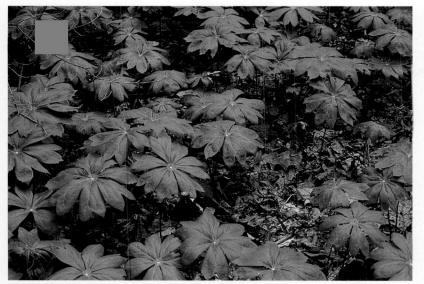

50mm F3.5 lens, 1/30 sec. at ƒ/11, Kodachrome 64.

28mm F3.5 lens, 1/30 sec. at ƒ/8, Kodachrome 64.

MAYAPPLES, McClure, Pennsylvania.

Anyone who has taken a spring hike in an Eastern forest has seen these palm-like mayapples. A traditional view (top) offers only the repetitive shapes of the leaves. A fresh perspective (bottom) comes from photographing from "a toad's-eye view."

camera equipment requires time and practice.

Always continue to experiment and be innovative, even after you've technically mastered your gear. Photography magazines, books, and workshop leaders are continuously presenting new techniques or new ways of doing old things. Try to photograph subjects in more than just one way, especially if you find yourself repeatedly attempting risk-free compositions. If an opportunity arises and you have the time, bracket techniques as you might bracket exposures. Try new techniques, such as using a slow shutter speed to convey motion, or using

fill flash instead of a reflector. Try different lenses. For example, when photographing an animal close by, use a wide-angle lens and include the landscape in your image rather than just doing another frame-filling portrait. Experiment with different perspectives, perhaps shooting from below your subject's level rather than at or above it. The more you try, the more you'll see, and the more you'll know the limitations and the capabilities of your equipment. Ultimately, you'll make better photographs.

Patience and persistence are vital ingredients for consistently successful wildlife photography. These qualities set great photographers apart from merely good ones. Whether you're waiting for a leopard to drop from its tree in the Masai Mara or for the wind to stop while you're shooting a black-eyed Susan in your nearest meadow, you must be patient. I have a classic example. Once, in a swamp in Florida, a group of photographers and I waited for a great blue heron to capture something it had struck at repeatedly. Time wore on until nearly three hours passed. Such comments as "watching grass grow is more exciting than this" from some of the group created an unrest that eventually lured all but three of us from the heron. Ten minutes after most of the group left, the heron slammed into the water, pulling up a greater siren, a huge aquatic salamander. It was *the* shot of the photo tour, missed by all but the three most patient photographers. The tenacity that keeps a good photographer behind the viewfinder when others quit is perhaps where "luck" is forged.

Obviously, patience is a trait all good wildlife photographers should strive to develop. Sometimes it is difficult to decide whether you're wasting your time when you're waiting for something to happen. I usually recommend staying with the subject you have, the sure thing, because there is no guarantee that moving on will produce anything more interesting. This is especially true when an animal appears interested in something, whether a mate, a rival, or a meal.

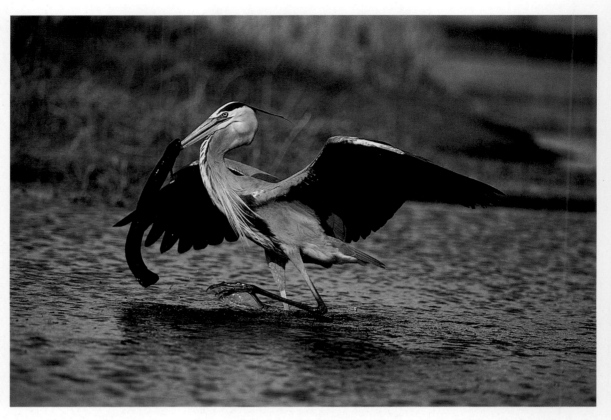

GREAT BLUE HERON
WITH SIREN,
Myakka River State
Park, Florida.
150-600mm F5.6 zoom
lens, 1/500 sec. at
ƒ/5.6, Kodachrome 64.

*Out of twelve
photographers, only
three of us had the
patience to wait the
extra ten minutes
required for this
hunting great blue
heron to catch a
siren, a huge aquatic
amphibian. When
action is likely, stay
with it. You could
get lucky.*

Opportunity also plays a role in making great pictures. The more you are in the field, the more time you'll have to experiment, practice, and find more subjects. Filming backyard subjects, or those found close to home, gives you the chance to return as often as is necessary to capture exactly what you'd envisioned. At the same time, you'll learn more about your subject and the area in which it lives.

Of course, better locales offer greater opportunities, and it is always worth the effort to seek out subject-rich habitats. This may not require very much work on your part, either. For example, in many state and national parks, the areas immediately around the camping or parking areas are so trampled by the passing crowds that there is really very little to photograph. Fortunately, few people actually venture beyond their cars or campsites, and often just a few hundred yards away the photographic opportunities become far more diverse.

Edges are great places to check, that is, the border between a forest and meadow, or meadow and stream or pond, anywhere two different habitats intersect. Here the common residents of either habitat may overlap, resulting in far more subjects than one would find deeper in the woods or in the middle of a meadow. One of my favorite edges is the dozen yards of meadow grass that borders some of my neighboring ponds and lakes. At dawn, the tall grasses shelter dragonflies and orb web spiders, and sometimes, if I'm lucky, I'll discover the nymph of a dragonfly just beginning its metamorphosis to the adult stage. Frequently, I'm pleasantly surprised to find a well-camouflaged frog or toad lying quietly only a few feet from where I am sitting.

Wildlife and nature photography is work. It takes effort to understand your equipment and an investment in time and money to find and get close to wild animals. It is not always easy to be patient, accept a disappointment, and then tackle a difficult shoot after experiencing one failure. It also takes a real willingness to stay open to ideas, to recognize opportunities as they arise, and to push your creative potential to see images that aren't immediately apparent.

AMERICAN
TOAD, McClure,
Pennsylvania.
100mm F4 lens,
1/60 sec. at ƒ/16
with manual flash.

*Don't overlook
wildlife in your own
backyard. American
toads are common
woodland and garden
animals that are
frequently ignored
because many
photographers seek
more exotic fare.
Although this toad
appears to be
laughing, actually it
was attempting to
gulp down the last of
three huge night
crawlers I'd provided.*

MASTERING EXPOSURE

Two things define successful photographs: a pleasing composition and a correct exposure. Compositional skills can be taught or may come naturally. Exposure is more democratic. Everyone must learn to understand exposure. Today's sophisticated cameras offer one or more methods to produce correct exposures. Depending upon camera type or model, such terms as *matrix*, *spot*, and *center-weighted* describe various exposure systems. Most cameras offer one or more exposure modes, including *programmed*, *aperture priority*, *shutter priority*, and *manual*. It is natural to assume that these modes or systems eliminate error and free you to concentrate upon composition, but that isn't entirely true. No exposure mode or system can think, and none can determine the tonality of your subject, whether it is white or black or a middle-tone gray. To the camera, all tonalities are the same.

There are a variety of ways to determine exposure, but all mechanical metering systems are designed to yield a pleasant, middle-tone value. That is an *18-percent reflectance*, or a middle gray between the extremes of tonality, bright white, and darkest black. You're probably familiar with a photographic *gray card*, which many photographers use to determine exposures. Gray cards work because they provide a ready exposure reference, although every color also has a middle-tone value that could be used to base an exposure.

Sometimes your subjects lie within a middle-tone range, and sometimes they don't. Consider North America's three bear species. Tawny-brown or gray-brown grizzly bears are close to middle tone. In contrast, polar bears range from pure white to a yellowish, creamy color. The average black bear's fur is coal black. To a camera's meter, all three bears should be exposed as middle tones, which would result in improper exposures for both the polar and the black bear. The polar bear, metered as an average middle tone, would be gray or underexposed, while the black bear, becoming a middle-tone gray, would be overexposed.

Sophisticated metering systems can adjust for varying tonalities if you override the standard exposure. To do so, you must be able to recognize what is, and what isn't, a middle-tone value.

DETERMINING A MIDDLE TONE

A photographic gray card is the perfect middle-tone value and can be used to base your exposures if the card and your subject are in the same light. This is critical, because a reflected-light reading taken off the card will be the basis for the exposure you choose for the subject. Gray-card readings won't be accurate if your card is in the sun and your subject is in shade, because the card will reflect considerably more light than the shaded object. An underexposed subject would result.

Using a gray card isn't always convenient. Obviously, readings from a gray card are difficult to do if you're inside a blind unless you've placed a card in the general area where you expect your subject to be. I'll frequently do just that if I'm filming at a bird's favorite songpost or at a den or burrow where I know my subject will appear. Readings are difficult, too, if you're trying to look through the viewfinder of a long lens and you're holding the card in front of the camera. You must also be careful not to shade the card with your lens or body, which might happen while you are looking through the viewfinder. If you do cast a shadow, the gray card will reflect less light than the subject, and a reading based on the card would result in an overexposure.

It often is more practical to substitute a middle-tone value that is in the same light as your subject. In fact, many wildlife subjects are middle tone.

If your subject isn't middle tone, or if it is impossible to take a reading, use a substitute. Nature offers many, such as cattails in summer, a great blue heron, or a whitetailed deer. You could also try gray tree trunks, the northern blue sky, most grasses, or even your faded blue jeans.

Although these examples are satisfactory gray-card substitutes, I recommend that you develop your own sense of tonality, so that you can recognize a broad range of middle tones by sight alone. I've found two easy ways to do so: Try metering something you consider middle

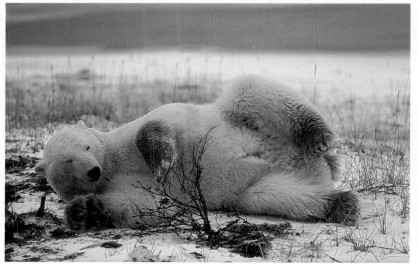

Because a camera reads for middle tone, only one of the three species of North American bears, the grizzly, will be exposed properly if you trust your camera meter.

POLAR BEAR, Churchill, Manitoba. 300mm F2.8 lens, 1/250 sec. at ƒ/5.6, Kodachrome 64.

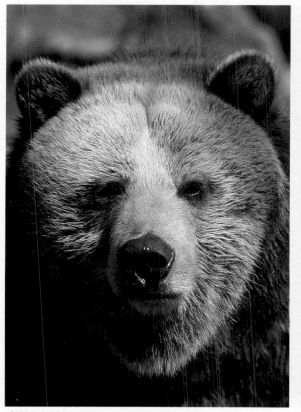

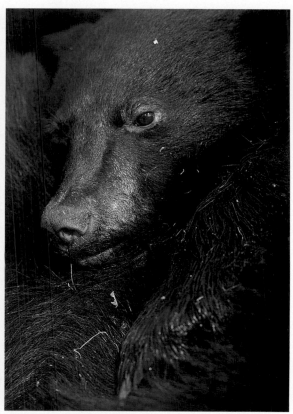

GRIZZLY BEAR, Philadelphia Zoo. 400mm F4.5 lens, 1/500 sec. at ƒ4.5, Kodachrome 64.

BLACK BEAR (at hibernating den), Pocono Mountains, Pennsylvania. 100mm F4 lens, 1/90 sec. at ƒ/8 with manual fill flash.

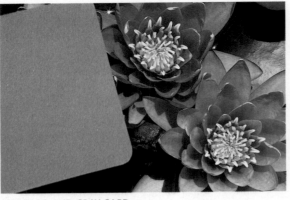

LILY PADS AND GRAY CARD.
100mm F4 lens, 1/60 sec. at *f*/16, Kodachrome 64.

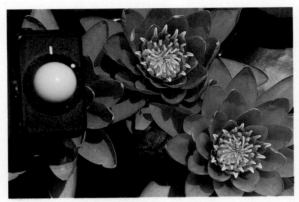

LILY PADS AND INCIDENT-LIGHT METER.
100mm F4 lens, 1/60 sec. at *f*/16, Kodachrome 64.

tone, then compare that exposure with one you obtain by metering a gray card placed in the same light. Over time, you'll find it easy to pick out tonalities that are close to middle tone in value. You can also practice by comparing your camera readings of subjects with those obtained by an *incident-light meter*. Incident-light meters read the light that falls upon their light-measuring face, usually an opaque white bulb. *Reflected-light meters*, present in all *single-lens reflex* (SLR) cameras, measure the light reflected from the subject. The two kinds of meters will give equivalent exposures. The incident-light meter reads 18 percent of the light that passes through the bulb, while the reflected-light meter reads 18 percent of light that reflects off an average or middle-tone subject. If the incident-light meter is in the same light as your middle-tone subject, the two readings should agree.

However, metering off a gray card or a middle-tone subject, or using the reading from an incident-light meter, won't guarantee a correct exposure if your exposure meter is improperly calibrated and inaccurately measures light. This problem can happen with the best of meters or cameras, even with brand-new models right off the shelf. This isn't evident with negative films, because errors in exposure can be corrected during printing. With slide film there is no chance for in-lab corrections, because the image obtained when the film is developed is the final result. You can't increase detail or decrease an exposure during a printing stage as you can with negative film. Slide film is also less forgiving in terms of exposure, and an exposure that is incorrect by more than a half stop is evident even to a novice. Overexposed images look thin or washed out, while underexposed images are often so dark that details in all but the brightest areas are lost. Although you might be responsible for this, it could be the fault of the meter.

If you compare four or five identical camera models or incident-light meters, you might find a difference of as much as two *f*-stops between meter readings. If this happens to you, don't panic—your meter isn't broken, and it won't have to be sent for repair. It just has to be recalibrated, which you can do. All you need is a middle-tone subject and a known quantity of light. If you're using an incident-light meter, the middle tone is the incident bulb. If you're using your camera's meter or a handheld spot meter, use a gray card. Finding a light source is easy—use the sun.

CALIBRATING YOUR EXPOSURE METER FOR "SUNNY *f*/16"

To check the accuracy of any reflected-light meter, take a reading off a gray card around 10 A.M. with bright sunlight falling over your shoulder onto the card. Avoid doing the test in winter, when the sun can be so low in the sky that its brightness will be as much as one *f*-stop less than it is in summer. Likewise, make sure the sky is really a clear blue, as even a slight haze can mask some of the sun's brightness, and

an inaccurate calibration will result. With your aperture set to $f/16$, focus at infinity. This is necessary, because some lenses increase in length as they near minimum focus, which decreases the light that passes through.

If you're using a zoom lens with a *floating aperture*, in which the f-stop and the amount of light that the lens transmits vary as the focal length is changed, set your zoom lens to its smallest focal length. Now you'll obtain the true light value for the lens. Floating-aperture zoom lenses, by the way, are identified by two f-numbers for their widest apertures. For example, a 35-70mm zoom lens with a floating aperture may be identified by an $f/3.5$-$f/4.5$ mark on the lens. Since the smallest aperture also changes, an $f/16$ aperture at 35mm becomes an $f/22$ aperture when the lens is set to 70mm.

Next, with the lens positioned at $f/16$, set the shutter speed at the reciprocal of the ISO film you're using. For example, with Kodachrome 64 film, that is 1/60 sec., the nearest you can come to the true reciprocal of 1/64. With ISO 100 speed film, that reciprocal is 1/125 sec.; at ISO 200, it is 1/250 sec. (or 1/180 sec. if your camera has half stops for shutter speeds). Because a film-speed rating may not have a true shutter-speed reciprocal, you may be off by a third of an f-stop. If so, fine-tune your calibration by adjusting the aperture: Set the aperture at the half-stop mark between $f/11$ and $f/16$ if your shutter speed is greater than the film speed, or between $f/16$ and $f/22$ if the shutter speed is lower than the reciprocal of the film speed.

With everything set, a meter reading off the gray card should give a reading of $f/16$ at 1/ISO. This metering check is so accurate as a basis for an exposure that it is called the *sunny f/16* rule. (Remember, this check is valid only under the proper conditions. You must have bright sunlight falling over your shoulder onto your middle tone.)

Unfortunately, your meter may not give you a sunny $f/16$ reading in bright, over-the-shoulder sunlight. If it doesn't, it is easy to correct. For example, if you're using ISO 100 film, your meter should read 1/125 sec. at $f/16$, with the ISO dial set at 100. If instead it reads 1/60 sec., then your meter is off. To correctly calibrate your meter, simply adjust the ISO setting to the 200 mark; this will make your exposure meter twice as sensitive to light. Now you will obtain the correct 1/125 sec. setting.

You can also calibrate your in-camera meter by using the exposure-compensation dial (if your camera has one). If your camera meter is reading too little light, set the compensation dial to the -1 position, which will add a stop of light to the exposure; now you'll obtain the desired 1/125 sec. shutter speed. Cameras differ, and some exposure-compensation dials are calibrated by +'s and -'s or by whole numbers and fractions, so be sure to check your camera's instruction manual for the method that applies.

Calibrating an incident-light meter is just as simple. Position the light-measuring bulb so that it points toward the sun. Remember, the bulb reads only 18 percent of the light that passes through it. If the meter needs correcting, you can do so either by adjusting the ISO as you would when fine-tuning your camera's meter or by adjusting a calibration dial if the meter has one.

The sunny $f/16$ rule is also a great spot-check if you're using *DX-coded* film, in which the correct film speed is bar coded onto the film cartridge and the camera automatically sets the

CALIBRATING FOR "SUNNY $f/16$"

1. Do this calibration on a brilliantly sunny day, around 10 A.M., with the sun shining over your shoulder.
2. Use a gray card or a middle-tone subject.
3. Set your shutter speed to 1/ISO, the reciprocal of the film speed. For ISO 64 or 50, that is 1/60 sec.; for ISO 100, use 1/125 sec.; for ISO 200, use 1/250 sec.
4. Meter the gray card. If the required aperture setting isn't $f/16$, adjust either the ISO dial, the EV, or the exposure-compensation dial until you obtain $f/16$.

SNOWY EGRET,
Everglades National
Park, Florida.
500mm F4.5 lens,
1/500 sec. at ƒ/5.6,
Kodachrome 64.

*Late in the day, the
sunny rules can't be
followed. Instead, I
took a reflected-light
reading off the egret's
breast, and then
overexposed one stop
to bring back the
whiteness.*

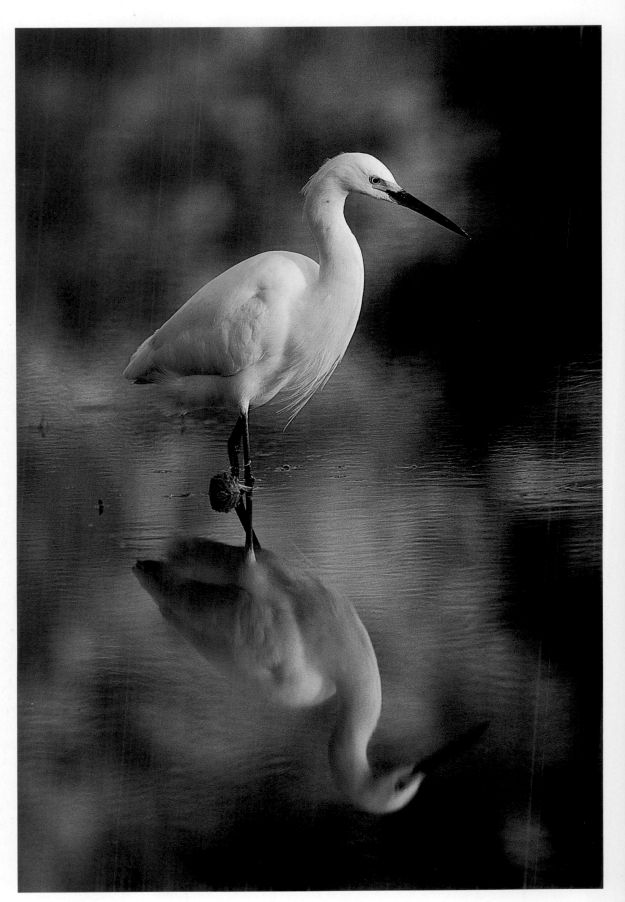

proper film speed. However, a camera can misread a DX cartridge and set an inaccurate ISO. Always double-check the setting by hitting the ISO button. An inaccurate film speed becomes quickly apparent if your camera meter's exposures deviate from sunny ƒ/16 or the equivalent exposures. If you've fine-tuned your camera's meter by changing the ISO setting, be careful when you change to a different film speed. Some cameras, such as the Nikon 8008, will maintain the ISO you've manually set and won't read the DX code unless you actually set the ISO mode to the DX setting. On more than one occasion, I've found myself shooting ISO 64 film when I've left my camera's film-speed setting at 125 for ISO 100 film. Again, make sure you read your manual because some cameras automatically set themselves to the correct DX-coded ISO whenever you change films.

Once you understand and accept the sunny ƒ/16 rule, you may ignore your meter when filming middle-toned subjects in direct sunlight. I do. Remember, you're not required to use ƒ/16 and a shutter speed that is the reciprocal of your film speed (1/ISO). Your subject might require a faster shutter speed or greater depth of field. If it does, adjust accordingly.

There are limitations to the sunny ƒ/16 rule. Within approximately two hours of sunrise or sunset, or during the winter months throughout much of the United States and Canada, this rule fails because the sun is low and the atmosphere masks some of its intensity. Thin, wispy cirrus clouds, faint fog, or smoke may also lessen the sun's intensity and make a sunny ƒ/16 exposure inaccurate. At high noon anytime near the equator or during summer in temperate zones, the sun is almost directly overhead and a sunny ƒ/16 reading is possible only if you're looking directly down at your subject. If you're facing your subject at eye-level, as you normally would, your subject will be top-lighted; you'll lose about half an ƒ-stop. If you're using an incident-light meter, then be sure to hold the face at your level, not flat and facing the sun, so that you will obtain an accurate exposure reading.

Some final points about calibrating your exposure meter: Once completed, you can trust your meter to yield accurate exposures on any middle-tone subject. Also, the degree of compensation required for one film speed applies to other film speeds, allowing you to expose those films accurately without doing another recalibration. Of course, changing the setting for the film's speed to achieve sunny ƒ/16 doesn't affect the actual development of the film. Your film won't require special processing if, for example, you doubled the film speed in order to obtain sunny ƒ/16, because you haven't really pushed the film. Finally, you won't have to continually calibrate your camera meter.

I suggest you do a sunny ƒ/16 spot-check if you haven't used your camera for a few weeks or on the first sunny ƒ/16 day you have when you're on a lengthy vacation or safari. I often double-check my meter when I'm shooting middle-tone subjects in sunny ƒ/16 light, which usually confirms the exposure I'm using. If it is off by only half an ƒ-stop or so, I don't worry, because the subject's tonality may be that much

COMPARING REFLECTED-LIGHT AND INCIDENT-LIGHT METERS

Tonality	Reflected Light	Incident Light
Middle	Should be accurate.	Should be accurate, but bulb must be in the same light as subject.
Whites	Two Methods: 1. Meter white, then open up one ƒ-stop. 2. Meter a middle tone, then close down one ƒ-stop.	Close down one ƒ-stop off suggested exposure.
Blacks	Meter a middle tone, then open up one ƒ-stop. Don't meter black.	Open up one ƒ-stop off suggested exposure.

different from a true middle tone. If it is off by one stop or more, I double-check the meter with a gray card. I mention this because I've seen photographers waste far too much time rechecking their meters, even when a great subject was only momentarily available.

Once you properly calibrate your exposure meter, you can trust it to correctly read middle-tone subjects in any type of light, not just the sunny $f/16$ conditions you use for calibrating. Just pick a middle-tone area that is in the same light as your subject and take a reading. If there is no middle-tone subject on which to base your exposure, take a reading from the palm of your hand and open up one stop. This works because your hand reflects about one stop more light than a gray card. Sometimes photographers are confused about whether you should open up or close down after metering your hand. If you think of your hand opening up to expose the palm to the meter, you'll remember to open up for the exposure.

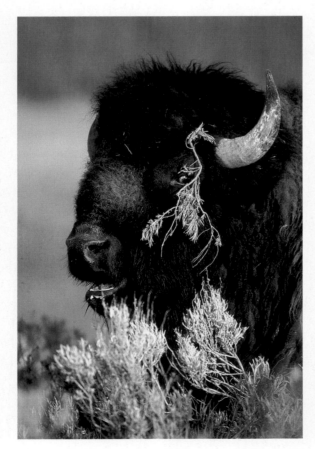

BISON WITH SAGE BRANCH, Yellowstone National Park, Wyoming. 300mm F2.8 lens, 1/250 sec. at $f/5.6$, Kodachrome 64.

With a sage branch stuck to its fur, the bison's rolling eye makes the image. Because sagebrush is lighter than middle tone and a bison is darker, I avoided confusion by using the wildlife equivalent of sunny $f/11$.

EXPOSURE COMPENSATION FOR SUBJECTS THAT AREN'T MIDDLE TONE

Some animals aren't middle tone, and exposures based on readings for middle tones won't be accurate. Bison, black bears, African buffaloes, and river otters are all darker than middle tone, and many birds, including swans, geese, terns, and egrets, are lighter than middle tone. A direct exposure reading off these subjects won't be accurate either. Exposures based on dark subjects overexpose, while those based on light subjects underexpose. If you meter a middle-toned area instead, you'll still have exposure problems with dark and light subjects. Dark subjects will be underexposed and lose all detail, while white subjects will reflect more light and be overexposed. In either case, some *exposure compensation* is necessary. You can do this several ways.

When determining an exposure for a dark or black subject, meter a middle-tone area, such as grass or a gray card that is in the same light, and then open up one stop from that exposure. In effect, you're purposefully overexposing the middle tone by one f-stop, while adding light and some detail to the dark subject. If you're using an incident-light meter, hold the meter in the same light as your subject and open up one f-stop from that reading.

I use two different methods when metering white, depending on how large the white area is. If my subject is large enough to cover the metering area, I'll take a reading directly off the white, and then purposefully overexpose by 1/2, 1, or 1 1/2 f-stops, depending on the lighting conditions. If the white subject is in the sun and appears bright white to me, I'll overexpose by 1 or by 1 1/2 f-stops. If it is in the shade, or if the light is overcast, white won't reflect as brightly and will need only a half-stop overexposure.

If I'm unable to take a meter reading off the white subject, I'll meter something middle tone that is in the same light, then close down, either a full stop for bright sunlight or a half-stop for shade or overcast skies. Remember, white reflects more light, so by closing down off the middle-tone reading, the white subject will be less

BLACK
OYSTERCATCHER,
Point Lobos State
Park, California.
500mm F4.5 lens,
1/250 sec. at ƒ/4.5,
Kodachrome 64.

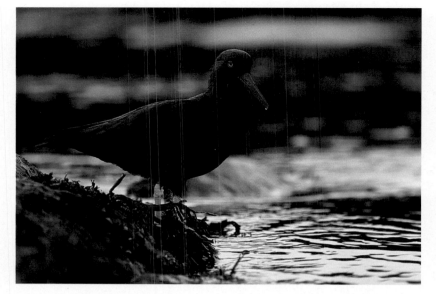

Black oystercatchers are black birds with near-middle-tone beaks and eyes. Biasing my exposure for the black plumage would have overexposed the beak. Instead, I based my exposure on some surrounding middle-tone rocks and opened up only 1/2 stop off that reading to compensate for the dark bird. When photographing a light subject, such as the white willow ptarmigan in the snow, I had to open up 1.5 stops from a direct reading off the snow to obtain the correct exposure. The snow and the white bird reflected a surprising amount of light, in spite of the heavily overcast conditions.

WILLOW
PTARMIGAN,
Churchill, Manitoba.
300mm F2.8 lens,
1/125 sec. at ƒ/2.8,
Kodachrome 64.

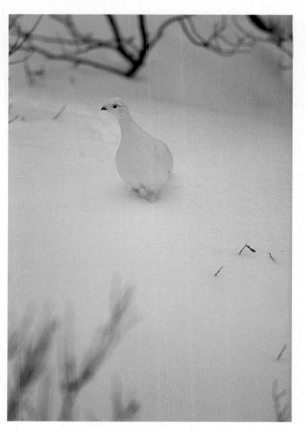

black; some obviously fall halfway between. For these subjects, I suggest compensating by only one half-stop for subjects in sunlight and about one-third stop for those in shade or under overcast skies, opening up or closing down as the subject's tonality requires. With practice, you may be able to look at a subject and decide what, if anything, you'll use to base your exposure.

For example, imagine metering a bison as it grazes in a snowfield. Faced with a black subject on a white background, you might choose an area on the bison's hump on which to base your exposure. The hump is darker than a true middle tone but lighter than the rest of the animal, and could serve as a workable compromise between the contrasting tonalities.

Some cameras feature *evaluative metering* (also called *matrix metering*), which divides the entire picture area into sections that are read individually and given a specific amount of emphasis for the exposure. The latest advancements in this technique have convinced some photographers that their camera meters can handle virtually every exposure situation. I'm not so sure. I suggest all photographers be able to recognize different tonalities by sight in order to base their meter readings. Work on developing this skill. Then, if you and your camera's programmed exposure agree, you won't be disappointed with your exposures.

bright and will have more detail. When I take an incident-light reading, I close down because this meter only reads for middle tones. Again, the middle-tone areas will be underexposed as I compensate for white.

Of course, not all nature subjects fit into the neat categories of exactly middle tone, white, or

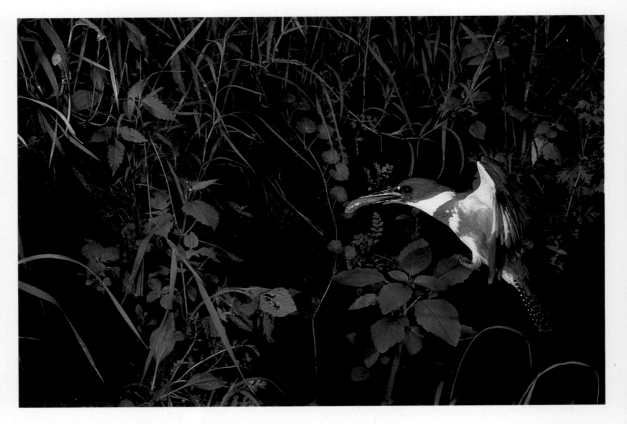

BELTED KINGFISHER
(with fish), McClure,
Pennsylvania.
50mm F3.5 lens,
1/90 sec. at *f*/16,
with three manual
flash units,
Fujichrome 50.

*An exposure based
on ambient light
with slow ISO films
might not provide a
sufficiently fast
shutter speed to stop
action. This is
especially true with
closeups, when even
a small movement is
significant on film.
For flying birds or
insects, an electronic
flash might be the
only solution.*

EQUIVALENT EXPOSURES: RELATING APERTURE TO SHUTTER SPEED

One of the worst mistakes beginning photographers make after discovering sunny *f*/16 is exposing all their film at *f*/16 at 1/ISO. Upon doing this, they discover that their old exposures were better. Don't become a victim of this! The sunny *f*/16 rule is only a guide for making exposures of middle-tone subjects under the proper conditions. Shutter speeds faster than 1/ISO, or apertures wider than *f*/16, may be required. If you're using ISO 64 speed film, a shutter speed of 1/60 sec. will be too slow to stop the motion of a bird crunching sunflower seeds at a backyard feeder. A shutter speed of 1/250 sec. or 1/500 sec. is required. Remember, however, that as you change the shutter speed, thereby reducing the length of time light reaches your film—you must compensate by allowing more light to pass through the lens during this shorter period of time. By opening up the lens two stops from *f*/16 to *f*/8 (for 1/250 sec.) or to *f*/5.6 (for 1/500 sec.), you'll have the same quantity of light reaching the film.

Each time you increase your shutter speed by one stop, you reduce the time that light has to reach your film by one half. This is often referred to as "a stop of light that is lost." To compensate, you must add a stop of light by increasing the aperture size, thereby opening up or making the aperture larger. An incorrect exposure will result if you changed only the shutter speed and not the aperture, or vice versa.

Photographers speak of fast and slow shutter speeds. Wildlife photography often requires speeds of 1/125 sec., 1/250 sec., or faster. You'll need at least 1/250 sec. to freeze the jaw motion of an elk chewing its cud, and at least 1/500 sec. to stop the motion of a great blue heron striking the water for prey. You can, of course, use slower speeds with animals if your subject is still or if you want a particular effect, such as intentional blurring where a sense of motion is implied.

The other part of the shutter speed/aperture relationship is just as critical. The *aperture*, designated by the *f*-number or *f*-stop, transmits a specific quantity of light. The larger the number, the smaller the aperture size. You might

think a large number, such as $f/22$, represents a large aperture, but the opposite is true because $f/22$ is a very small aperture opening. The aperture settings are identified by how many apertures, or openings of a particular width, can fit between the lens' focal point and the camera's film plane. If you think of it in this way, it is easy to see that if 22 openings of one width ($f/22$) and 4 openings of another ($f/4$) both fit within this area, then the relative size of the opening for the $f/22$ aperture has to be smaller. Likewise, the actual size of the aperture differs, depending upon the length of the lens in use. A very short 24mm wide-angle lens requires very tiny aperture openings to permit 22 apertures to fit within that space, while a long 500mm lens' $f/22$ aperture requires a much larger opening.

Almost all lenses have aperture settings of $f/4$, $f/5.6$, $f/8$, $f/11$, and $f/16$. Some lenses have larger apertures, designated by smaller numbers such as $f/1.4$, $f/2$, $f/2.8$, and many have the smaller apertures of $f/22$ and $f/32$. Increasing the numbers (from 2, 2.8, 4, 5.6, 8, 11, 16, 22, and 32) halves the amount of light passing through a lens each time, as the lens opening grows progressively smaller by 50 percent. When going from $f/8$ to $f/11$, you reduce the amount of light passing through the lens by exactly one stop.

Aperture size determines *depth of field*, the picture area from front to back that is in sharp focus. Large apertures (small f-numbers such as $f/2.8$ or $f/4$) yield little depth of field. Small apertures ($f/16$ or $f/22$) provide the greatest depth of field. At times, extensive depth of field is desirable, for example, when you are trying to photograph a group of animals together. Sometimes it isn't, because a shallow depth of field will isolate an animal from a busy or distracting background. As you change the aperture by one f-stop, the shutter speed must change by one also, to maintain the same exposure. Thinking in stops of light is convenient for adjusting both aperture and shutter speeds.

Always consider your subject's requirements or the composition when choosing an aperture or a shutter speed. Sometimes an image demands a particular shutter speed. Suppose you're photographing a ground squirrel barking an alarm in sunny $f/16$ light with ISO 64 film. You'll need a fast shutter speed to freeze the action. With ISO 64, the base exposure is 1/60 sec. at $f/16$. If you change to 1/500 sec., which is a good speed for stopping action, light has the equivalent of three stops less time to reach the film. You have to open up the aperture three f-stops to compensate. Opening up from $f/16$ to $f/11$ (one stop), $f/8$ (two stops), to $f/5.6$ (three stops) results in the correct equivalent exposure. Cameras using a shutter-priority exposure system operate in this way automatically.

It is very important to remember which way a shutter-speed dial or aperture ring turns when working in stops of light on manual mode. In the previous example of the ground squirrel, had you used 1/500 sec. but turned the aperture ring the wrong way, you would've underexposed the image by four or five stops. In practice, this is easy to check by simply noting if an underexposure is indicated in the camera. If it is, you can recheck your settings to ensure that you've turned the aperture ring correctly.

SUNNY $f/16$ EQUIVALENTS FOR ISO 64 FILM

Under sunny $f/16$ conditions, any of the following aperture and shutter speed combinations can be used for a correct exposure with a middle-tone subject:

$f/32$	1/15 sec.
$f/22$	1/30 sec.
$f/16$	1/60 sec.
$f/11$	1/125 sec.
$f/8$	1/250 sec.
$f/5.6$	1/500 sec.
$f/4$	1/1,000 sec.
$f/2.8$	1/2,000 sec.
$f/2$	1/4,000 sec.

WILDLIFE EQUIVALENTS OF SUNNY ƒ/16, SUNNY ƒ/11, AND SUNNY ƒ/22

The recommended shutter speeds required for sunny ƒ/16, ƒ/11, and ƒ/22 are frequently too slow for many wildlife subjects. Faster speeds than 1/60 sec. are necessary to stop an animal's motion, but sometimes there is little time available for you to adjust both shutter speed and aperture from a basic exposure setting. Instead, I recommend that you memorize the wildlife equivalents given below for "sunny ƒ/16, ƒ/11, and ƒ/22" for the film speeds that you use. Just remember, you'll need the same brilliant sunshine when you use a wildlife equivalent as you would need when using the traditional sunny rules.

Film Speed	Middle Tones	Blacks	Whites
Base exposure	1/ISO ƒ/16	1/ISO ƒ/11	1/ISO ƒ/22
25	1/250 ƒ/5.6	1/250 ƒ/4	1/500 ƒ/5.6
50 or 64	1/500 ƒ/5.6	1/250 ƒ/5.6	1/500 ƒ/8
100	1/500 ƒ/8	1/500 ƒ/5.6	1/500 ƒ/11
200 *	1/500 ƒ/11	1/500 ƒ/8	1/1,000 ƒ/11

* Although the wildlife equivalent is given, I suggest avoiding ISO 200 or faster films under sunny conditions because of the high contrast most of these films exhibit. Use a slower film speed instead.

CHECKING ESTIMATED EXPOSURES AGAINST IN-CAMERA METER READINGS

Your camera meter's and your estimated exposure will differ with all but middle-tone subjects. When estimating an exposure via a sunny rule, ignore the exposure determined by your camera.

Tonality	Estimated Exposure	Reflected-Light Reading
Middle Tones	Sunny 16 or equivalent	The meter should agree.
Whites	Sunny 22 or equivalent	The meter will indicate that the settings used will produce an overexposed image. Don't trust your meter.
Blacks	Sunny 11 or equivalent	Your meter will indicate you're making an underexposure. Don't trust your meter.

ESTIMATING EXPOSURES IN THE FIELD

In wildlife photography, seconds count, and often there isn't time to take a reading, count off ƒ-stops, and adjust shutter speeds and apertures. Instead, under sunny ƒ/16 conditions—bright skies with over-the-shoulder sunlight—your base exposure for a middle-toned subject, such as a gray card, should be 1/ISO at ƒ/16 or an equivalent exposure. Memorize the "wildlife equivalent" for your ISO film, using 1/500 sec. as a standard shutter speed, and base your exposure on that (see the box on the left).

Because black subjects reflect less light, the correct exposure is made by reading a middle tone and opening up one stop. Under the same conditions as sunny ƒ/16, that is, bright, over-the-shoulder sunlight falling upon a dark-toned or black subject, use 1/ISO at ƒ/11 or the wildlife equivalent as your base exposure. Call this the *sunny ƒ/11 rule.* With ISO 64 under sunny ƒ/16 conditions, 1/60 sec. at ƒ/11 could be used. Memorize the wildlife equivalent of sunny ƒ/11 as well. For ISO 64, it is 1/250 sec. at ƒ/5.6 or 1/500 sec. at ƒ/4. You may need to know both, depending on the minimum apertures of your longer lenses.

White or very light subjects reflect more light, and just as you compensate by metering a middle tone and closing down, you can use the *sunny ƒ/22 rule,* 1/ISO at ƒ/22. I photograph many white subjects, including egrets, snow geese, and swans, and the sunny ƒ/22 wildlife equivalent is especially handy. For ISO 64, 1/60 sec. at ƒ/22 is 1/500 sec. at ƒ/8.

The wildlife equivalents suggested in the box on the top left probably differ dramatically from what your camera meter would recommend. For example, let's say you want to photograph a middle-tone duck in bright sunlight that is swimming in a still pond reflecting the black shadows of a forest or a cliff. A camera-meter reading based on the black water would overexpose the duck. Take a leap of faith and a step toward controlling your photography by following a sunny rule. Disregarding your meter, you should say to yourself, "This is

*A meter reading
of the bird could be
difficult with the
contrasty light and
the dark background.
I estimated the
exposure by opening
up two stops for
backlighting, and
then another stop to
compensate for the
dark subject. Because
I was shooting
almost directly into
the sun, some images
were marred by
slight lens flare.*

sunny *f*/16 light. I know what the exposure is. My camera meter is wrong!"

Consider some compensation for middle-tone subjects smaller than 1/9 of your viewing area if the rest of the frame is not middle tone. Close down by one half-stop if the background is white. You have a choice with dark backgrounds: open up one half-stop if the background detail is important, or leave it as it is to create a more dramatic image. Do the same with small black or white subjects set against a middle-tone background. Open up for black and close down for white, but do so by only one-half a stop. In each case, you can be sure the estimated exposure will differ from the one your meter suggests.

You won't have the sun over your shoulder in every photographic opportunity, so the basic sunny rules won't always apply. As a rule, open up one stop off the appropriate sunny rule when filming a side-lit subject, adjusting for black or white accordingly. A side-lit white snowy egret, for example, may have a base exposure of 1/500 sec. at *f*/5.6 with ISO 64, instead of the *f*/8 you would use if it were front-lighted. Back-lit

subjects require more compensation. Open up two stops if you wish to preserve the effect of backlighting and have a slightly underexposed subject. Open up three stops if you want full detail in the shadowed areas.

Backlighting in early morning or late evening light can create magnificent *rim lighting* on mammals and birds, in which the outline of fur or feathers catches these rays of sunlight to create golden halos. Determining these exposures can be difficult because there might not be a middle tone and the sunny rules won't apply at this time of day. Depending upon how low the sun is to the horizon, you'll lose between one and five stops. For example, on a clear day in flat country, you'll lose five *f*-stops off sunny *f*/16 in the last two or three minutes before the sun drops below the horizon. In high country, mountains may block the sun much earlier and you may lose only three stops.

In order to achieve a backlighting effect, I find it easiest to meter something I perceive as middle tone in that light. Then I either go with the reflected-light reading or close down one

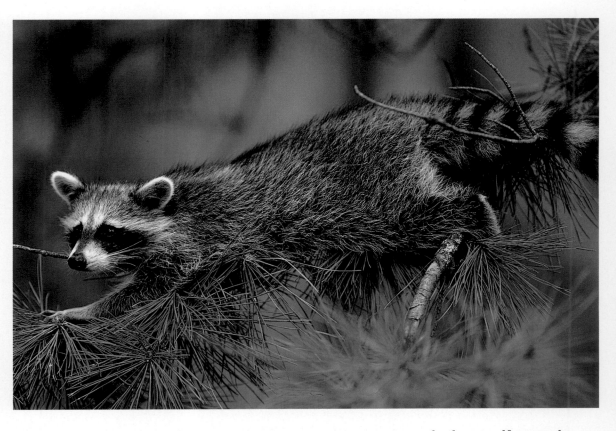

RACCOON, Pine
Barrens, New Jersey.
300mm F/2.8 lens,
1/250 sec. at ƒ/5.6,
Kodachrome 64.

*I made a reflected-
light reading off the
middle-tone fur
of the raccoon. This
agreed with my
estimated exposure
of one stop off sunny
ƒ/16, since the light
was cloudy bright.*

stop. However, if grass or other vegetation is in the picture, I do the opposite. Grass glows when backlighted, and after using it for my base reading, I'll open up one stop. This overexposes the grass, bringing back its brightness and translucence.

Most photographers agree that the light of dawn is exquisite and unique, frequently the best light of the day. You need practice to estimate exposures in the day's first half hour of light, but it is possible. As the sun rises, estimating exposures becomes easier, and within an hour after sunrise, the light is usually within a stop of sunny ƒ/16. In the next hour, sunlight reaches its full intensity. This holds true regardless of where you are—whether at the equator or on a mountaintop—provided the sky is clear. In much of the eastern United States, however, high humidity and industrial pollutants reduce sunny ƒ/16 by a half stop.

With practice, it isn't too difficult to learn to read different types of light without a meter, at least when the sunny rules normally would apply. If you have an incident-light

meter, it is easy to check yourself as you do. But there are times when obtaining a meter reading is impractical, too time-consuming, or simply impossible. Under ideal conditions, a meter reading isn't necessary and you can make some subjective judgments about the intensity of light.

When cloudy bright skies obscure the sun and eliminate shadows, open up one ƒ-stop off any of the sunny rules. If you expose a black animal for 1/250 sec. at ƒ/5.6 under sunny skies, use 1/125 sec. at ƒ/5.6 for cloudy bright skies. Under overcast skies with thick cloud cover, open up 2 or 2.5 ƒ-stops. Although shutter speeds or depth of field may suffer, this light eliminates contrasty shadows and is ideal for mammal portraits. As an example, using ISO 64 film, a sunny ƒ/22 egret would be exposed for 1/500 sec. at ƒ/8 in sunlight, but in overcast light you should change to 1/500 sec. at ƒ/4. In heavy overcast skies, when rain is likely, you'll lose at least three ƒ-stops. At such times, you'll need a faster filmspeed than you normally would use to capture fast-moving animals.

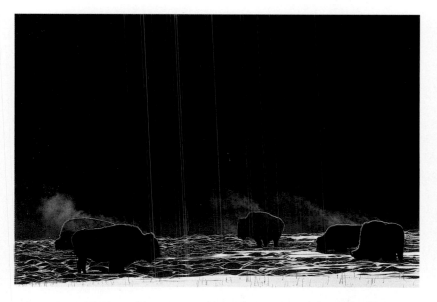

BISON, Yellowstone
National Park, Wyoming.
300mm F2.8 lens, 1/250 sec.
at ƒ/11, Kodachrome 64.

*You must remember that color
slide film can't accurately
record details in both black and
white. Looking at this scene,
you might be tempted to expose
for the bison because it is your
subject; that, however, would
grossly overexpose the steam.
I recognized this, and metered
the steam instead. Then I
purposefully overexposed by
one ƒ-stop to make the steam
bright again and turn the dark
buffalo into a silhouette.*

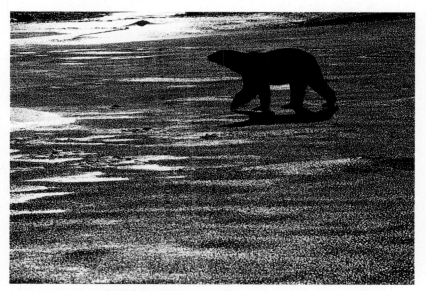

POLAR BEAR,
Churchill, Manitoba.
300mm F2.8 lens, 1/500 sec.
at ƒ/16, Kodachrome 64.

*Backlighting and reflections can
present troublesome exposure
problems. Because my camera
was really metering multiple
reflections of the sun on the ice, a
direct reading of the scene would
have been extremely underexposed.
For this exposure, I metered the ice
and sun sparkles, and then opened
up by 1.5 ƒ-stops to make the ice
and the entire scene bright again.
The image captured the white
polar bear as a "black" bear.*

EXPOSING FOR SILHOUETTES

Silhouettes are possible when the area behind
your subject, whether sky, sea, or landscape,
receives more light than your subject. If there is
more than a two-stop difference between the
subject and the background, it is often prudent
to expose for the background. This underexposes
the subject and creates a silhouette.

Exposures determinations must be made in-
camera, rather than by estimating, because the
degree of brightness of the background can vary
dramatically. This depends upon the amount of
moisture or dust in the air, the angle of the sun,
and the background's basic tonality, which may
range from a bright, hazy mountain landscape to
a brilliant, crystal-clear skyline. When making
your reflected-light reading, exclude your
subject and base your exposure solely on the
background. If you don't, the dark subject will
affect the exposure and overexpose the
background.

Water backgrounds can be difficult if the water
reflects the sun in multiple highlights. Decide if
your image can be improved by minimizing these
highlights. If it won't be, and if these highlights
fill your viewing area, consider opening up two
or three ƒ-stops off your camera reading, in
order to avoid underexposing. The in-camera

meter will try to make these bright sparkles a middle-tone gray, and you must bring back this brightness because the sun's highlights should be bright. Overexposing will do exactly that.

Bright skies are less of a problem. Meter the brightest area of sky that will appear in the final image, then deliberately overexpose by one *f*-stop. Because your meter reads this area as a middle tone, overexposing will bring back the brightness of the scene.

Even if you are including the sun in your photograph, exclude it from your field of view while you are taking the exposure reading. This will prevent severe underexposures; otherwise, the bright sun will bias your reflected-light reading. After taking a reading off the brightest area of the sky, recompose and place the sun back in your picture. Close down a stop if the sun is high and bright, but only close down a half-stop if the sun is low and orange-colored. (Be careful not to look directly at the sun, especially if you're using a telephoto lens, or you'll risk serious injury to your eyes.)

Also, don't align a silhouetted subject against another, unnoticed silhouette. That is easy to do if you are concentrating on the foreground and neglecting the background. You might not think the outline of something as unmistakable as an elephant could be lost but it can be, as I'll show later, by stacking one up against another. The

two black images merge as one to create a featureless, unattractive blob.

Take time to review the different ways you can achieve proper exposures. Test out the ideas and make notes so that you will understand and master the techniques that work best for you. No one method can be used every time, but each of the techniques has its place.

In reviewing this section on exposure, you may be confused because one method contradicts the procedures used in another method. Read more closely and you'll see that this is simply because of the tonality you metered. What you've based your initial exposure on will decide whether you'll then open up or close down. Remember, a meter can't "think," but if it did, it would think everything it reads should be a middle-tone gray. You know that not to be true, and you must adjust accordingly.

I don't like to recommend *bracketing*, the practice of firing multiple frames at different exposures to insure one good exposure. Sometimes there is little choice, especially when you don't have the foggiest idea of what to base a meter reading on. But don't rely on bracketing. You'll waste film, of course, but more important, you could miss the photograph of a lifetime when you bracket a shot simply because you haven't taken the time to master exposure.

COMMON GRACKLE, Lily Lake, Cape May, New Jersey.

Film choice is a matter of personal preference. In this series of three exposures, I used three popular types of slow ISO film. The first photograph was made with Fuji's Velvia. I found the resulting image objectionable because the grackle's iridescent plumage appeared an electric blue. The second photograph was made with Kodachrome 64, which offered a truer color. The third was made with Fujichrome 100. I like the color of the Fujichrome 100 film; it is more intense than the Kodachrome and more natural than the Velvia.

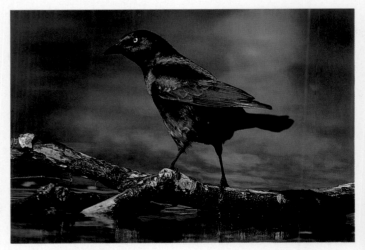

Fujichrome Velvia.

CHOOSING YOUR FILM

Most professional nature photographers use slide film because their markets demand it. Slide film requires exact exposures because the film can't be corrected during a processing stage.

As you probably know, the ISO represents a film's sensitivity to light. Low ISO numbers refer to "slow" films that are less sensitive to light than are "fast" ISO films. Doubling or halving an ISO number doubles or halves the film's sensitivity to light. Thus, ISO 50 film is half as sensitive to light as ISO 100, but it is twice as sensitive as ISO 25. Faster films permit faster shutter speeds and smaller apertures than slow films used in the same light. All films register sharpness and color by their grain structure, and slow-speed films have the greatest sharpness. Fast films have more grain and show more contrast.

In nature and wildlife photography, ISO speeds of 25, 50, 100, and 200 are most frequently used. Most nature photographers use Kodak's Kodachrome 25 or 64, Fuji's Fujichrome 50 or 100, or Fuji's Velvia 50. All of these have merits, and most photographic magazines devote at least one article each year to the great debate on film selection. I find Kodachrome 25 too slow for most of my needs, although its grain and sharpness exceed Kodachrome 64, my film of choice. I think Kodachrome's color is more accurate than Fuji's, but Fuji's color is often more dramatic and frequently prettier. Which film is for you? Try a few rolls of each film that you think might best suit your needs, both in terms of color and film speed, and then decide.

When faster films are necessary, Fuji's 100 film can be *pushed*, or purposefully set, to ISO 200. This pushing doesn't make your film any more sensitive to light, but does allow you to shoot the film as if you were using a faster film. Pushed film requires special processing, which adds a few dollars to normal developing costs. Alternatively, Kodachrome 200 is developed at normal processing costs and the grain and contrast are about the same as Fuji's when pushed. Some custom labs also offer special push processing of Kodachrome 200 when faster film speeds are needed. If even faster films are needed, you could try special high-speed films, but the grain and contrast in your pictures will suffer.

Film can also be *pulled*, or developed as if the film was actually a slower ISO speed. Although film normally is not pulled on purpose, this developing option is one way to salvage film that was accidentally exposed at an ISO less than its true value. Again, the extra effort involved in processing pulled film makes it a custom service that requires an additional developing charge.

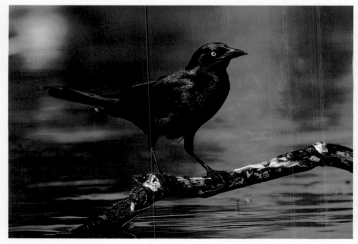

Kodachrome 64.

Fujichrome 100.

THE CORMORANT AT SUNSET

It is late evening at Sanibel Island's J. N. "Ding" Darling National Wildlife Refuge. You spot a double-crested cormorant drying its wings, perched upon one of the dead snags dotting the water impoundment. Behind the bird, the water reflects the flat, gray evening sky, but to the bird's right, the water sparkles with the bright orange reflection of the setting sun. Immediately behind the cormorant, weathered black branches snake toward the sky. As you watch, the cormorant tilts its tail upward and eliminates in a high arch. Birds frequently excrete shortly before flying off, as if they're lightening their load for lift-off. It is prudent to set up for a flight shot if you observe this behavior. Cormorants are not powerful or agile fliers and generally fly some distance in the direction they are pointed after takeoff.

Challenges:
- From your perspective, what effect will the background branches have on the composition?
- How could you frame the cormorant against the sun's reflection in the pond?
- Assuming you did this, how would you expose for this picture?

This scenario is typical of the images encountered while driving through a national wildlife refuge. Initially, the brightness of the sun's reflection might catch your eye, although bird photographers are likely to notice the bird first. Incorporating both within your photograph could make a striking, colorfully graphic image.

The branches behind the bird could severely distract the viewer by merging with the silhouette of the cormorant, thus destroying its outline. We see three-dimensionally, even when looking through a camera, and people are capable of mentally separating silhouetted shapes. But film is a two-dimensional medium that can't do this; therefore, the bird and the branch must be separated. A simple shift of perspective, moving either right or left, might suffice while also aligning the perched bird with the sun's reflection, provided the bird remains perched.

If you include the sun's reflection in your photograph, your exposure must be based upon this brightest area within your frame. Because you're really metering multiple reflections of the sun, you must be careful not to damage your eyes. Don't attempt to compensate for the cormorant and give the bird detail; that would overexpose the background. Instead, let the bird fall into place as a silhouette. Shutter speed won't be a problem because you're metering reflections of the sun, an extremely bright area. Thus, you'll be able to stop the flight of the bird, at a 1/1,000 sec. or 1/2,000 sec. shutter speed, even without panning.

Panning, or following the motion of your subject, would definitely be necessary if you are using a slower shutter speed. This is also true if a moving subject is close to your lens and fills most of the frame, because relative movement is magnified. At such times, a frame-filling flying bird will be sharper at a slow shutter speed with a panned camera than it would be with a fast shutter speed and a stationary camera. Of course, images will be the sharpest when using a fast shutter speed while you pan.

For this photo I used a 500mm lens, prefocusing on the cormorant's assumed flight path. I metered the sun's reflection, then overexposed, or opened up, by one *f*-stop to bring back the brightness of the sun's reflection. The reflection was still bright enough to permit an *f*/8 aperture, which gave me a small amount of depth of field. The bird's perch was out of view as I prepared to take the photograph. As the bird launched and entered my viewfinder, I fired, counting on my minimal lag time to frame the bird against the sun's reflection. In this case, it worked.

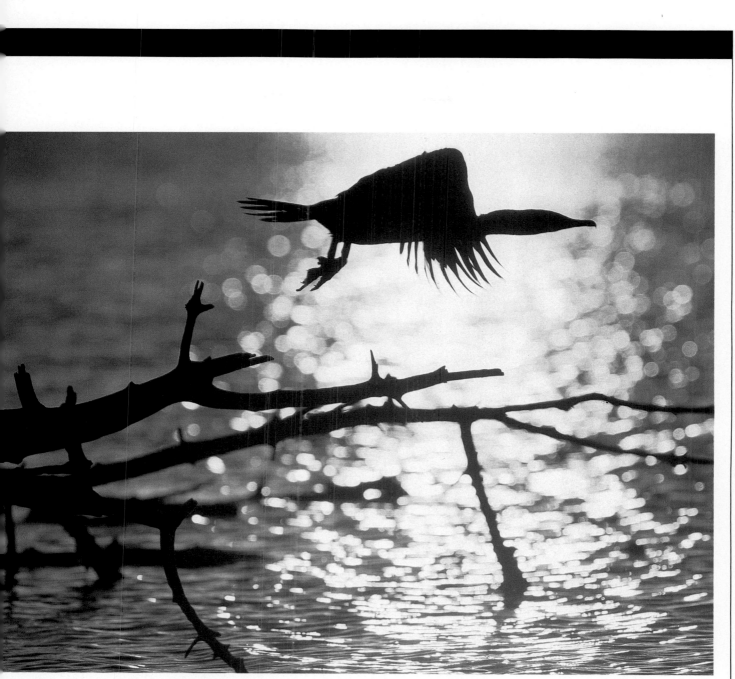

500mm F4.5 lens, 1/500 sec. at ƒ/8, Kodachrome 64.

PART 2: THE EQUIPMENT

SAW-WHET OWL HUNTING DEER MOUSE, McClure, Pennsylvania.
100mm F4 lens, 1/60 sec. at ƒ/8 with manual flash and Dalebeam, Kodachrome 64.

CAMERAS AND CAMERA HANDLING

Everyone associated with photography has been asked about their camera choice, sometimes out of idle or professional curiosity and sometimes, perhaps, out of hope. Many photographers become so dissatisfied with their images that they continually seek improvement by buying new gear. The answer to their dilemma doesn't necessarily involve their choice of equipment; any camera can be used to make great images as well as poor ones. The people behind the camera, and how they see and execute their vision, make the photograph. The camera is only a tool.

This tool can be used properly or improperly, with either a great deal of dexterity or with an embarrassing amount of fumbling. It is truly not the type of camera you use that makes the difference in your photography—it is how you *use* that camera: how cognizant you are of proper technique and how methodical you are when handling it. Developing good camera-handling skills will make a difference in the images you capture.

As a tool, some cameras are more efficient, durable, and useful than others. Unfortunately, many of today's cameras are so complex that all you need to do is depress the shutter button; focus and exposure are set automatically. The camera for the Ph.D., "push here, dummy," has come of age. Most nature and wildlife photographers use 35mm SLR cameras. There are many accessories available, with a host of

YELLOW-BILLED MAGPIE, Sunol County Park, California. 300mm F2.8 lens, 1/250 sec. at f/4.5, Kodachrome 64.

I set cameras in manual mode with manual focus for total reliability. The dark background and the clutter of branches around this magpie would fool the exposure systems and autofocus sensors of most automatic cameras.

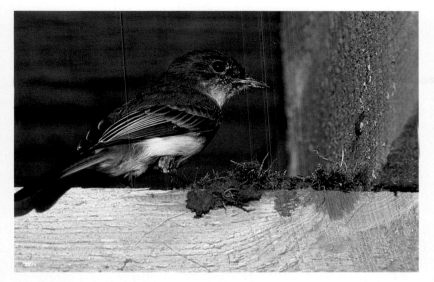

PHOEBE, McClure, Pennsylvania. 300mm F4 lens, 1/125 sec. at *f*/11 with TTL flash, Kodachrome 64.

I used the trap-focus feature of a Nikon 8008S to take this photograph of a phoebe beginning to build its nest. Although convenient, the trap-focus feature requires that some part of the subject is centered in order to trip the shutter.

manufacturers offering gear in almost every price range. The variety can be bewildering so you should carefully consider what you actually need.

CHOOSING YOUR SYSTEM

Today's 35mm SLR cameras can roughly be divided into two types, those that offer autofocus and those that do not. Both types are available in many models with one or more exposure systems. Autofocus cameras represent the latest in camera technology and are the fastest sellers. Not so long ago all cameras focused manually. Working without autofocus can be difficult in certain situations where focus might be missed, either due to the subject's actions, a difficulty focusing in dim light, or the photographer's poor vision. Before the introduction of autofocus, photographers had managed to get by, at least most of the time.

The availability of autofocus cameras offers the option of continuing with the old or accepting the new. Consider using autofocus cameras if you know that you have trouble focusing, or when editing, if you're disappointed with images you fully expected to be sharp. Autofocus can help photographers with poor vision or those who are otherwise unable to discern a sharp image in their viewfinder.

Autofocus is fast. On stationary subjects, it locks into sharp focus faster than most

photographers can focus manually. Although the focusing sensor requires your subject to be centered, this can be changed easily prior to taking the photograph by locking focus and recomposing. Most cameras lock onto a set focus but can be repositioned, provided that you maintain slight pressure on either the shutter button or a special focus-lock button.

I don't consider autofocus to be the panacea for all your focusing problems, because it can create some new ones. Again, centering can be troublesome because most autofocusing brackets are located dead center in the viewfinder. Twigs, branches, blades of grass, and other obstructions between you and your subject can fool the autofocus sensor. Running or flying animals can travel faster than the autofocus can function, even with cameras offering predictive capabilities. And moving subjects must be followed within the focusing brackets to prevent the lens from *tracking*, when the lens focuses back and forth as it seeks the subject. While tracking, something as large as a frame-filling flying pelican can disappear within the viewfinder if the lens tracks in the wrong direction. Fortunately, many autofocus lenses have focus limitations that can be set to restrict the amount of tracking. Those that don't, however, can be very frustrating to use.

Manufacturers recognize the limitations of autofocus and offer a manual-focus option for most lenses. Sometimes focusing manually is the only solution for photographing wildlife. I like to make the analogy that autofocus on a camera is like the reverse gear on a car. Most of you don't drive on a highway in reverse, but you do use that gear when it is required. Use autofocus the same way, when it will work best for you.

Some autofocus cameras offer three features that are especially useful for photographing wildlife. One is *trap focus*, where the camera doesn't fire until something, hopefully your subject, passes at a preset focusing distance. This feature could be ideal at remote or unattended photography of nests, bird feeders, den holes, or game trails. Trap focus does, however, have some limitations. A fast-moving

WHITE-BACKED
VULTURE, Masai Mara
Game Reserve, Kenya.
300mm F2.8 lens,
1/500 sec. at ƒ/8,
Kodachrome 64.

Although this bird's large size and steady flight might have permitted a track-focusing camera to keep pace, I manually focused on the vulture. Following animals in flight is always difficult, especially when you are trying to keep a horizon straight. Having a grid-focusing screen definitely helps.

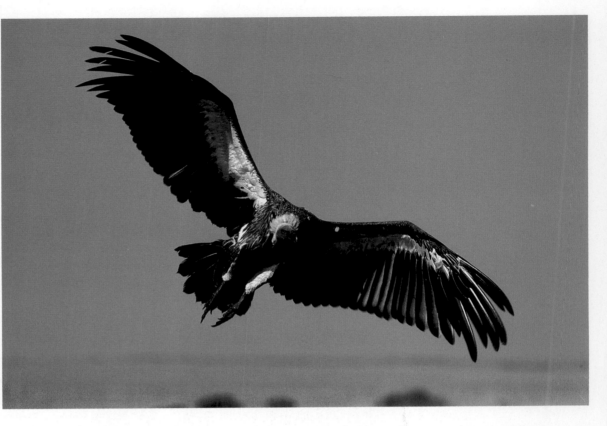

animal can pass through the focus point before the camera fires. Also, you have no control over composition; you might shoot a roll of film with the subject's head cut off or pointed the wrong way. Although a few cameras offer trap focus as a standard feature, in most models it is available only as a costly accessory databack.

A second useful feature of autofocus is known as *predictive*, or *track*, *focusing*, depending on the camera manufacturer. With this system, the lens maintains focus even after the camera's reflex mirror flips up, when the image is momentarily lost from view. Because the camera's mini-computer is tracking the speed of the moving object, the camera is able to predict, in theory, where the subject will be. Some track- or predictive-focusing mechanisms work better than others, but most would be severely challenged by a pigeon-sized bird sweeping toward you at 40 miles per hour (mph). That is, if you can even keep the bird within the focusing sensor! (Note: As this goes to press, the Minolta 7xi Autofocus claims track focusing capable of following a subject traveling at 185 mph!)

On one occasion I tested a new camera model's track- or predictive-focusing capabilities on a dog I coaxed into running toward me. Although the lens tracked when the dog was some distance away, it couldn't keep up as the dog neared, with the result that my images were soft or very blurry. I would have had a better chance at capturing a sharp image of the dog at the closer distances had I prefocused on a spot and taken the photograph as the dog entered that focusing zone. This is similar to using the trap-focus feature of some autofocus cameras, with one exception: By focusing manually, I have to anticipate and react at the instant *before* the dog enters the area of sharp focus. With an automatic trap focus, the camera fires as the dog enters this area, but in all likelihood, the dog will have passed that focused area by the time the mirror flips up and the camera shutter opens.

Later, on a real "shoot" in the Galapagos, I gave the track-focusing feature of my camera another workout. My subject was a group of relatively slow-moving great frigatebirds that were swirling above an isolated beach. To be honest,

I'm not sure how well the camera would've tracked because the problem here was attempting to keep one of the birds within the focusing brackets of the viewfinder. That proved so difficult that I switched back to manual focus to obtain sharp images.

Slower-moving and larger subjects are easier to track. Having the track-focus option may occasionally make the difference in successfully photographing animals or birds, especially those that are flying parallel to your film plane.

An autofocus camera's third useful feature is *focus confirmation*. Most autofocus cameras have a liquid-crystal display (LCD) that shows an in-focus symbol when the area within the focusing brackets is sharp. This feature is useful for photographers who wear glasses and for photographing in dim light when sharpness is difficult to determine.

Before the choice of either auto- or manual focus was available, photographers only had to decide which type of exposure mode they needed. Most modern cameras offer various manual, automatic, and programmed modes. Using manual mode, you select the shutter speed and aperture combination that you need to properly expose the film. The manual exposure mode requires a fairly thorough understanding of exposure, but until recently, this knowledge was expected of any SLR camera user. Cameras with automatic modes include three basic types: completely automatic, shutter-priority, and aperture-priority modes. When set on automatic mode, the camera selects both aperture and shutter speed. You may not be happy with the camera's selection, because you may have needed a faster shutter speed or smaller aperture.

The other automatic modes address this. In shutter priority, you select the shutter speed, and then the camera sets the corresponding aperture that is required. Be sure to have enough light for the shutter speed that you've selected. If you don't, you can opt either to use a slower speed or to not waste a frame. In aperture priority, the camera sets the shutter speed after you've selected the aperture. This mode is useful

in action photography with a fast lens set at the widest aperture because it insures that you'll always be using the fastest possible shutter speed. It is probably the wisest choice for remote photography if the *ambient*, or *available*, light is continually changing.

Programmed modes work similarly to automatic modes, although you may have the option of choosing from a few set programs that offer a bias toward stopping action or providing maximum depth of field. This mode differs by camera manufacturer, requiring you to either set a mode selector switch on "P," or program mode, or the shutter-speed dial and the aperture on "A," or automatic. The camera's exposure meter determines the correct shutter-speed and aperture combination based on a programmed set of conditions. To be honest, I've never shot any of my cameras on a program mode. I don't wish to lose the creative control that manual, or even shutter- or aperture-priority modes allow, and I doubt that I would be satisfied with the camera's selection of settings. Program mode may be fine for home use, parties, snapshots, and the like, but in my opinion a program mode is not a serious option for nature or wildlife photographers.

The following scenario illustrates your shooting options with the various exposure modes available. Let's say you're photographing a white-tailed deer as it slowly walks through an open forest in the late afternoon. The deer is middle tone in value, and metering the deer, you obtain an exposure reading of 1/60 sec. at $f/4$ for ISO 64 film. You're using a 300mm $f/2.8$ lens mounted on a tripod. What are your options? Will 1/60 sec. stop the deer's motion? What exposure mode would produce the best result?

A shutter speed of 1/125 sec. might stop the deer's movement, but 1/60 sec. will not. In the manual mode, you have to set the aperture at $f/2.8$ and the speed at 1/125 sec. If you're excited, you could forget to do either or both. In shutter priority, if you have the camera preset at 1/125 sec., the aperture will adjust automatically to the required $f/2.8$. In this mode, a mistake is

PRONGHORN ANTELOPE, Yellowstone National Park, Wyoming. 300mm F2.8 lens, 1/250 sec. at ƒ/4, Kodachrome 64.

Regardless of the camera system you use, you must be able to recognize situations where you need to take control. An automatic exposure may have overexposed this scene as the meter attempted to bring detail into this photograph of a back-lit pronghorn. Instead, I made a manual exposure reading off the bright grasses, then overexposed one half ƒ-stop to make the grasses lighter than neutral.

less likely to occur. For example, if you have the shutter speed set at 1/500 sec., the camera will signal an underexposure.

In aperture priority, you can preset the aperture to ƒ/2.8 to ensure having the fastest possible shutter speed. However, if you err and have the aperture set at ƒ/5.6, you'll shoot at 1/30 sec. This is probably too slow to yield a satisfactory image.

In a programmed mode, the camera will select an option you may or may not like. Although it is a personal choice, I'd suggest using manual or shutter priority. You'll have to determine the shutter speed, but you'll be more likely to stop the deer's movement than if you trust an aperture-priority mode to set a shutter speed that may be too slow for your needs.

Remember, no exposure system offers a selection where the camera meter thinks for you and automatically selects the correct tonality on which to base your exposure. You must do this. Because I learned my craft when there was only one exposure mode available, I'm comfortable using my camera on manual. But that is a

personal choice and I've encountered very competent photographers who use one or more of the other systems.

All of the above exposure modes can be used in various metering modes where you select how much picture area is considered for the exposure. In an *averaging* mode, the entire picture area is read, although an emphasis is placed on the central section. *Center-weighted* systems work similarly. *Evaluative,* or *matrix,* metering is even more sophisticated. In these modes, the entire viewing area is divided into blocks that are given a predetermined influence on the exposure. This provides a reasonable chance of obtaining correct exposures, even when you can't determine a subject's tonality. But the metering system can be fooled, as for example, when you're filming a white subject on snow or a dark subject against a dark background.

In *spot metering,* only a small central area ranging from 3-12 percent is read. Wildlife photographers often deal with small subjects, and many find the spot meter ideal. When a telephoto lens is used, a spot meter makes very precise

LOWLAND GORILLA,
Miami Zoo, Florida.
500mm F4.5 lens,
1/250 sec. at f/5.6,
Fujichrome 100.

*Familiarity with
your equipment
comes with practice,
and after that your
creative potential
expands. I moved
around this
gorilla enclosure
until I found some
vegetation that
partially obscured
the ape. By using my
depth-of-field
preview button, I
determined the
distance necessary
to frame the gorilla
with a pleasing
halo of out-of-focus
branches.*

WHY AREN'T YOUR IMAGES SHARP?

A transparency's sharpness can be determined by studying a slide with an 8X optical lupe or with a reversed 50mm lens. Check for sharpness by examining the edges of your subject, especially around the eyes or the faces of animals. If your images aren't sharp, consider the shutter speed used, the tripod, the lens length, and any physical factors. If your subject was still and you were rock-steady, then camera shake may be at fault. To eliminate camera shake, brace your camera and avoid specific slow shutter speeds, or only use a camera with mirror lockup when using a slow shutter speed or a super telephoto lens.

exposure determinations possible. For example, a 500mm lens offers about a 5-degree angle of view, compared to the 46 degrees a 50mm lens offers. If your spot meter reads only 3 percent of this 5-degree angle of view, you'll be reading an extremely limited area. Spot metering on manual mode is the method I use to determine ambient exposures in-camera 90 percent of the time.

ACCESSORY FEATURES FOR SLR CAMERAS

If your SLR camera is less than ten years old, it probably doesn't have a mirror-lockup lever, a power-cord (PC) socket, or a mechanical-release socket. It may also lack a depth-of-field preview button, something I consider essential for any serious wildlife or nature work. Today, only "professional" cameras incorporate all of these features. If your camera lacks one or more of these accessories, don't despair; depending on how you work, you might not need them. In choosing an SLR camera, decide which features are important for you to have. Here's a quick rundown of what's available.

Interchangeable focusing screens. Many cameras offer optional screens to replace the split-image Fresnel focusing screen that is standard with most cameras. Split-image screens darken when used with slow telephoto lenses or with macro equipment. Replace your standard screen with an all-matte grid screen, sometimes called an *architectural grid*. This screen doesn't darken when used in low light and can also be used to keep horizon lines straight, trees vertical, and other visual hazards correct by aligning them with the inscribed grids.

Depth-of-field preview. You focus and compose with the lens at its widest aperture opening. At the moment you fire, the aperture closes down to the predetermined *f*-stop. Most cameras have a button or lever that manually closes down the lens aperture. This enables you to see the depth of field and the degree of sharpness present in the out-of-focus areas before you actually take the picture.

Although many lenses have depth-of-field scales inscribed on the barrels, it is impossible to visualize the effect a particular amount of depth has on your composition. Incredibly, some inexpensive electronic SLR cameras lack a depth-of-field preview button. This button is essential for critical macro and landscape photography. Also, it is useful for photographing birds or mammals with a telephoto lens.

Mirror lockup. Most SLR cameras have a hinged mirror that flips up the instant before the shutter opens. At fast shutter speeds this happens so quickly that you might not notice the momentary viewfinder blackout. This mirror movement slightly shakes the camera, although at fast shutter speeds this tremor won't affect image sharpness. At slow speeds, this shake can significantly reduce image quality, especially if you're using macro or telephoto lenses.

The vibration caused by the mirror lasts about 1/15 sec., and exposures made at 1/15 sec., 1/8 sec., and 1/4 sec. record it. Shutter speeds faster than 1/15 sec. or slower than 1/4 sec. progressively reduce the effect of the tremor on your image. There is no mirror shake if the mirror is manually locked up before exposure, but only a very few professional cameras, namely Nikon's F3 and F4, Contax's RTS III, Pentax's LX, and Leica's R6, permit this. Mirror shake is eliminated in Canon's EOS RT by a stationary

pellicle, a two-way mirror that simultaneously transmits approximately two-thirds of the light to the film and one-third of the light to the camera's viewfinder. On a few cameras, including Nikon's FM2 and Canon's EOS 10S, activating the self-timer locks up the mirror.

You can also reduce camera shake by placing some additional weight on the camera. This will absorb some of the vibration created by the flipping mirror. Place a small sandbag onto the camera's *pentaprism*, the block-like top of the camera where the viewfinder is located, to cancel out these mirror-induced vibrations. A half-pound cloth bag of birdseed works fine for this. Additionally, you can reduce camera shake by supporting both the camera and the lens on separate tripods, but this is cumbersome to do.

Self-timer. This feature lets you include yourself in your photograph, which can add scale or a center of interest to a scene. As mentioned, the self-timer can increase image sharpness if the mirror automatically locks up when the timer is used. Regardless, using a self-timer provides time for vibrations (induced by hand-tripping the shutter) to dissipate, and image sharpness will improve.

Cable and electronic releases. Some people abruptly depress the shutter button; others are so excited by what they're shooting or so out of breath after reaching their subject that they're shaking as they depress the shutter. In any case, image sharpness suffers.

Releases separate you and your shaky fingers from the shutter button. There are two types of releases. Inexpensive cable releases screw into the shutter button or into a special receptacle on the camera body. They are available in a variety of lengths, although I find the shortest ones the most convenient to use and the cheapest to replace. Electronic releases plug into a special socket in the camera body. These releases are considerably more expensive and are usually longer than is necessary to simply trip a shutter. Unless they are shortened somehow, they are likely to snag on something and break.

Either type of release works, but don't assume you're always required to use one. Sometimes they're not necessary, especially if you're properly braced and your body weight adds to the total mass of the camera and lens. This is especially true when you're photographing in windy areas or when you're using a *motordrive*, where the continuous slapping of the mirror can create a vibration.

Use a release when you are using shutter speeds less than 1/30 sec. with any lens, and under 1/60 sec. when using macro or telephoto lenses. Consider using a release and a self-timer together if you're trying to position mirrors, reflectors, or flashes on a macro subject and you need an extra "hand." The remote release frees you from the viewfinder and lets you get closer to your subject, while the self-timer gives you the time to align everything before the camera fires.

Releases are easily lost if they fall out of their sockets. You'll locate a dropped one more easily in the field if you tie strips of fluorescent surveyor tape to each one.

Motordrives and motorwinders. Both power motorwinders and motordrives advance film and cock shutters automatically. Power winders advance film between one and three frames per second (fps), while the heavier, bulkier motor drive does so at up to six fps. Both types allow you to keep firing without moving your eye from the viewfinder or your finger from the shutter release, and both provide the potential to overshoot. You can fire 36 frames in less than 7 seconds with a motordrive. Amateurs or those on budgets probably don't need multiples of nearly identical frames.

Motorwinders and motordrives can be useful in photomacrography, where exact alignment or a critical composition is required, because advancing the film by hand could move or misalign the camera. They are also necessary for remote photography, as they permit continuous shooting until a roll of film is exposed. They are especially useful in bird and mammal

photography, where peak action or interesting poses can occur repeatedly. However, neither guarantees that you'll capture peak action. For that you need timing, anticipation, and luck.

For example, let's say an African chameleon is about to snatch a grasshopper from a branch with its long, sticky tongue. The chameleon takes only fractions of a second to part its jaws, then blast out and retract its body-length tongue with the captured insect attached. You hope to record the strike, that instant when the tongue is stretched farthest in capturing its prey. There is sunny f/16 light, and you're shooting at 1/1,000 sec. at f/4 with a motordrive firing 6 fps. Can you capture this action?

If you fire the instant the lizard's jaws begin to part, at six fps you'll record only 6/1,000 of a second's time. The other 994 parts of the second

elapse as the film advances five times. A lot can take place during that time, including the strike you hope to capture.

It is difficult to capture such a fast-moving event without an electronic assist like the Dalebeam described on page 94. But you'll have a better chance of capturing the action if you anticipate and fire just as the tongue shoots forward. It is frustrating work, but it can be done. Your chances are significantly greater if you try to anticipate the peak action.

Many electronic cameras have built-in power motorwinders, although some cameras will also accept a motordrive as an accessory. Built-in motorwinders or motordrives are not only convenient but also quieter than accessory units attached to the camera. A quiet film advance is less likely to frighten a skittish animal.

Power sources and batteries. Although there is no standard power source, the 1.5 volt AA battery is used in many cameras and is available nearly worldwide. You should use a camera that can be powered by AA batteries at least as a backup if other energy sources, such as rechargeable nicad batteries, aren't available. Carry spare batteries with you. Some batteries, including the increasingly popular lithium batteries, are expensive and not easily found in remote corners of the United States or elsewhere.

It is always wise to conserve battery power. Autofocus eats up batteries, especially if you use a focus-confirmation beeper. Sometimes it is just as efficient to focus manually. Automatic film rewind also uses considerable energy. If you have the option, rewind by hand, especially if you're running low on batteries in an area where finding replacements may be difficult. (There is another good reason to rewind film manually. Automatic film rewind can generate static-electricity marks on film in extremely cold, dry weather. A slow rewind, done by hand, is less likely to do this. However, if your camera lacks a manual rewind and you're photographing in extremely cold, dry weather,

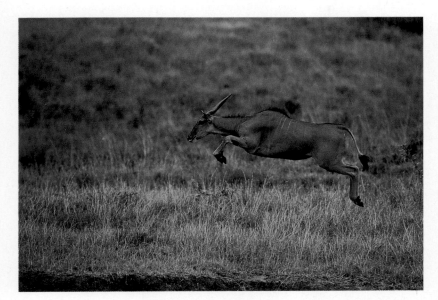

ELAND, Nairobi National Park, Kenya. 300mm F2.8 lens, 1/500 sec. at f/2.8, Kodachrome 64.

A motordrive allows you to keep your eye to the viewfinder while you're shooting. If I hadn't had one, I would've missed most of the sequence of this frisky eland.

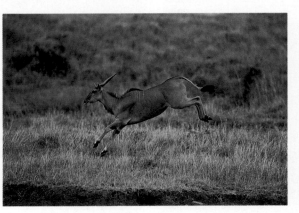

*Although I used
a motordrive, I was
able to capture the
outstretched tongue
of this chameleon
by anticipating
the event. Even
when you're using
a motordrive, don't
expect success on
the first try!*

consider warming up the camera by placing it inside your jacket for a short time before you rewind the film.)

DX film coding. Most electronic cameras use DX-coded film, whereby the film speed and the number of frames are set automatically. DX-coded film is useful if you shoot many different speed films and might otherwise forget to set the ISO for each new film. Also, be sure you don't scratch or cover up a DX code by accident. Some cameras, like the Nikon F4, will not operate if the DX-code area is covered, unless the ISO is manually set. Additionally, a camera can misread a DX code. It is always wise to check that your camera is reading the correct code by depressing the ISO set button immediately after a new roll is loaded.

Cameras accepting DX-coded film frequently have tiny film windows in the back of the camera to provide a visual check of the loaded film. This feature may prevent shooting with an unloaded camera. Even without a film window, you can check for loaded film if your camera has a rewind knob. Turn the rewind knob until you feel tension, then watch to make sure the knob rotates when you trip the shutter and advance to the next frame. If the rewind knob doesn't rotate, either the camera is empty or the film leader is off the sprocket.

Double-exposure capability. Most cameras offer some method for making double exposures, but electronic cameras make this simple. You'll rarely use this feature for wildlife or nature work unless a special effect is required.

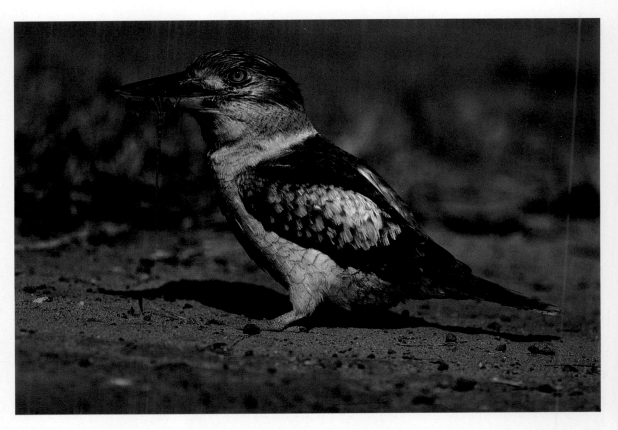

KOOKABURRA
(with lizard),
Kakadu National
Park, Australia.
500mm F4.5 lens,
1/250 sec. at *f*/8
with TTL teleflash,
Kodachrome 64.

A fast flash-synchronization speed is useful for fill-flash work in daylight. Firing a motordrive burst as the bird dropped down onto the lizard, I exposed film faster than my flash could recycle. This frame was exposed solely by natural light. I based the exposure on sunny f/16.

Electronic flash. Modern electronic cameras offer through-the-lens (TTL) flash control, a real advantage over other flash systems. Flash units synchronize with shutter speeds at a specific limit, 1/60 sec. or 1/90 sec. in many mechanical cameras and up to 1/250 sec. with most electronic cameras. The electronic camera's faster *sync speed* has some definite advantages over the mechanical camera's slow speed. The faster sync speed allows you to use your flash in bright sunlight when the ambient light is brighter than the flash's light. With ISO 100 film, the base exposure for sunny *f*/16 light is 1/125 sec. A flash-sync speed of 1/60 sec. would require an aperture of *f*/22 or smaller, in order to be correctly exposed for the ambient light. Unfortunately, many wide-angle lenses and some 50mm lenses stop down only to *f*/16, and an overexposure would result if the camera were set at the slow sync speed of 1/60 sec. However, by using a faster shutter speed and basing your exposure on the natural light, you can simply use your flash's light to fill in the shadows created by bright, ambient light. This technique,

known as *fill flash*, is very useful in reducing the typical contrasty images encountered at high noon when the top of your subject is sunlit and the lower half is in deep shade. The shadows are "filled in," hence the term fill flash.

Many cameras fire a flash off a *hotshoe*, a little bracket usually mounted on top of the camera's pentaprism and designed to accept the grooved foot of a small flash unit. These flash units have special connector pins that match the contact points on the camera hotshoe. This eliminates the need for a special power cord (PC) to connect the camera and flash. Additionally, some cameras also offer a PC socket to allow flash units made by a variety of manufacturers to be used. Cameras without PC sockets can be used with flash units that require a PC socket. All that is required is a universal adapter mounted onto the camera hotshoe.

Technology changes so rapidly that today's strongest recommendation may be obsolete within a year. Thoroughly evaluate what you need for your type of work, then decide upon a specific camera and the various accessories.

WHAT FEATURES DO YOU NEED IN A CAMERA SYSTEM?

Useful Features	Comments	Useful Features	Comments
AA battery power	These batteries are available virtually everywhere.	Manual film rewind	Very handy in cold weather.
Aperture priority	For landscapes, plants, macro. A benefit when using an unmanned camera in remote work. Useful for action sequences when fast shutter speeds are needed.	Matrix/Evaluative	For all shooting, as a backup for spot metering, and for fill-flash techniques.
Autofocus	For wildlife moving at moderate speeds that elude success with manual focus.	Motordrive	Extremely useful in serious wildlife and bird work.
Automatic rewind	For wildlife photography; facilitates fast reloads.	Nicad batteries	For wildlife and scenics in cold weather; nicads last longer than AA batteries.
Averaging mode	For general scenics.	PC socket	For inexpensive compatibility with many flash systems, off-camera flash, studio setups.
Cable-release socket	Mechanical releases are inexpensive to replace.	Power winder	Convenient, especially with wildlife.
DX film coding	Handy for the forgetful or hurried.	Self-timer	A substitute for a cable release at slow speeds, and for self-portraits.
Film window	Same above; will prevent shooting 50 exposure rolls.	Shutter priority	For wildlife when the light is fairly constant.
1/250 flash sync	For outdoor, fill-flash, and teleflash work.	Spot metering mode	For wildlife, macro, and landscapes, to isolate and read middle tones.
Hotshoe flash mount	For fill-flash and some macro work.	Trap focus	For remote photography of wildlife at nests or dens.

Essential Features	Comments	Essential Features	Comments
Depth-of-field preview	I wouldn't purchase a camera without this feature.	Mirror lockup	For serious macro, landscape, and super telephoto work.
Electronic release	For remote photography.	Predictive focus	I don't think autofocus is especially useful without this feature.
Manual exposure	For serious nature and wildlife when exposure control is needed.	TTL flash	I wouldn't buy a new camera without this feature. Useful for teleflash photography of wildlife, aquarium, and zoo photography, macro, and candid portraiture.
Manual focus	Standard in almost all camera systems.		

THE HIPPO POOL

On an overlook above the Mara River in Kenya's Masai Mara Game Reserve, you encounter a pod of 60 or 70 hippopotamuses sleeping through the midday heat. From your vantage point, the hippos are undisturbed by your presence. You hope to capture the tranquil scene of the resting animals.

Challenges:
- Would it be more effective to film the herd from the water level or from the higher vantage point?
- What exposure is required?
- What is the minimum shutter speed you can safely use to capture any movement, while still achieving the desired depth of field?
- What lens will work best?

The area I've described was one of the best for filming hippos, at least before another tourist lodge was built along the banks of the Mara River. Now that area is deserted by wildlife and only a few scattered hippos occupy that section of the stream.

Whenever possible, I like to film wildlife at its level, but a water-level view of the hippo herd was ineffective. From water level, too many hippos appeared "soft" because of the shallow depth of field of my 300mm telephoto lens. To maximize the depth of field, I had to get above the hippos, where my film plane was closer to being parallel with the herd of hippos. Fortunately, the high river bank permitted this.

The hippo's dark skin was a perfect example of sunny f/11, so

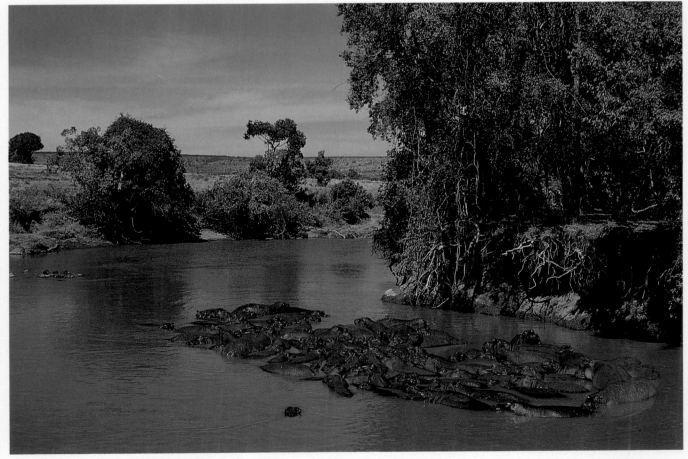

35-70mm F2.8 lens, 1/60 sec. at f/11-16, Kodachrome 64.

my base exposure was 1/250 sec. at ƒ/5.6 or 1/60 sec. at ƒ/11, using Kodachrome 64. Because the hippos were fairly still, I chose a slow shutter speed to maximize my depth of field. I used 1/15 sec. at ƒ/22. To guarantee image sharpness, I used an old Canon F-1 camera that had a mirror lockup, and I tripped the shutter with a cable release. Without mirror lockup, using 1/15 sec. speed with a 300mm lens would have produced a soft image because of camera shake. If a hippo didn't move or a fight didn't break out within the pod, I was confident I could obtain a sharp image with this technique.

To decrease the angle between my film plane and my subjects, I extended my tripod legs to their maximum height of six feet, which provided as close to an aerial perspective as I could obtain from the river bank. Because the hippo pod extended out from the pod in an irregular and unattractive manner, I used a 300mm lens to isolate the center area. In this way, various parts of hippo bodies both filled the frame and extended out of the picture area.

Fortunately, the hippos continued sleeping during my exposures, although a few fights occurred within minutes of the shoot. Hippos, by the way, are extremely dangerous animals and are responsible for more native deaths than any other large mammal of Africa. I was happy to have a steep river bank between the herd and me.

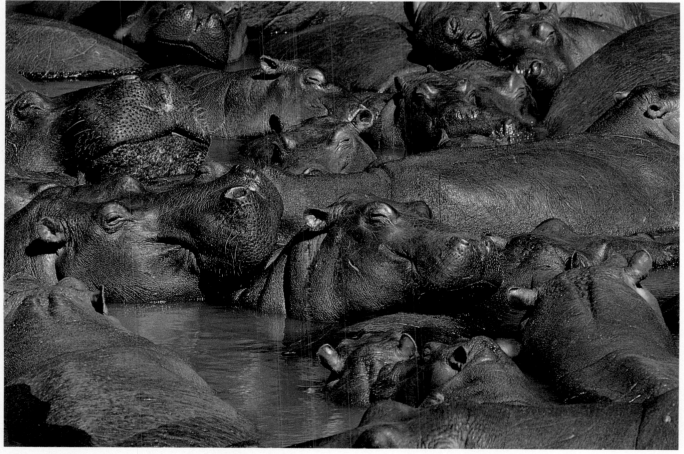

300mm F2.8 lens, 1/15 sec. at ƒ/22, Kodachrome 64.

SOLID SUPPORTS FOR RAZOR-SHARP IMAGES

Most serious nature photographers use tripods. Beginners often don't, and if they do use a tripod, they often use one that is inadequate for their equipment. Don't buy a tripod that is too light, too short, or too limited in its controls for convenient use. An adequate tripod is as essential as any camera or lens. Buy a good one and use it.

Using a tripod is not always easy. Tripods can be cumbersome and awkward to set up. They can be a bother to carry or to pack for a trip, and all seem to grow heavier after a long day in the field. Despite these disadvantages, a tripod is worth the effort. A sturdy tripod yields razor-sharp images with even the heaviest lenses. It gives you the opportunity and the time to scan the edges of your viewfinder when you are fine-tuning a composition. When you photograph wildlife, a tripod will keep you poised and ready to shoot.

CHOOSING A TRIPOD

Selecting a tripod is a bit less confusing than deciding on a camera system because there are fewer features to consider. The correct choice makes using one a pleasant experience or, at the very least, a habit you can develop.

Sturdiness. A basic rule about tripods: the heavier the tripod, the sturdier it usually is. To determine how sturdy a tripod you'll require, think about the equipment you own now as well as the heavy or long lens you might be adding later. When you shop for a tripod, bring along your heaviest lens or borrow one at the store. You can determine the tripod's sturdiness by mounting the equipment and working the controls. Raise the legs to their full height, then lightly tap the front of your lens. If the lens wobbles, try a heavier tripod or tripod head. Sturdy tripods aren't tiny or lightweight; my tripods are about an inch in diameter at their smallest, but they're capable of holding my big lenses. If you must order a tripod, consider buying the models most serious amateurs and professionals use: a Gitzo 320, a Gitzo 241 Pro Reporter, or a Bogen 3021 Series tripod. They're sturdy, not especially heavy, and very adaptable.

Don't buy a sturdy *monopod*, a one-legged support, in an attempt to save weight. There are too many advantages to using a tripod that aren't available when using a monopod, including being able to simply set it up and leave it. Some

ANTELOPE GROUND SQUIRREL, Organ Pipe Cactus National Monument, Arizona. 200mm F4 lens, 1/30 sec. at ƒ/8, Kodachrome 64.

I didn't use a tripod for this closeup of an overheated ground squirrel. Instead, I rested the camera and the 200mm lens directly on the ground. I slightly elevated the lens with a small stone beneath the front of it to remove the foreground blur picked up at this low angle. Unfortunately, I couldn't position both of the squirrel's eyes within the same plane of focus, so only one is sharp.

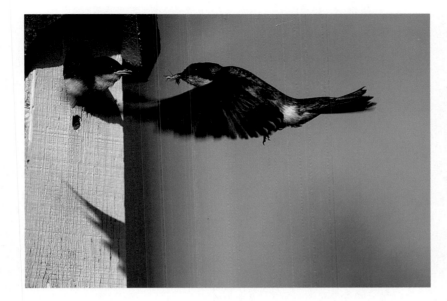

TREE SWALLOWS,
McClure, Pennsylvania.
300mm F2.8 lens with
1.4X tele-extender, 1/500 sec.
at ƒ/4, Kodachrome 64.

A tripod keeps you ready for action, another advantage when long waits are required. I waited inside a blind a few feet from the nest box, and as the bird entered my view, I tripped the shutter. I had my composition and focus preset, and by using a sturdy tripod, I could be sure nothing would change between each series of pictures. I based the exposure on sunny ƒ/16.

photographers use monopods when following moving subjects over long distances because they can set up the lightweight supports quickly. I don't recommend this. Although a three-legged tripod is heavier than a monopod, you can use your tripod like a monopod and enjoy the same amount of mobility and speed. Just extend one or more of the legs to a comfortable length while you keep the other legs folded in. Should the subject you're following suddenly stop, you'll be able to unfold the tripod legs and enjoy the increased stability. A monopod can't do that!

Don't spend all your money on cameras and lenses, then skimp when buying your tripod. On a Galapagos Islands trip, a person tried supporting an expensive 300mm F2.8 lens and motordriven camera on a tabletop tripod. After catching his gear three times when one of the pencil-thin tripod legs collapsed, he admitted his foolishness in attempting to save money on this essential piece of gear. Unfortunately, he was stuck with an inadequate tripod for the remainder of the trip.

Maximum working height. For maximum stability, your tripod should be as tall as you are because most people shoot pictures from a standing position. Most tripods are not tall enough to allow this unless the center column is elevated. When you elevate the center column, you are, in effect, mounting your camera on a monopod that is supported by a tripod. This introduces instability. Avoid raising the center column and you'll maintain a rigid, sturdy camera support.

Buy a tripod that enables you to stand upright and see through the camera's viewfinder without having to extend the center column. Such tripods are more expensive and heavier than those with center columns providing the required height. However, it is worth both the price and the extra weight for the stability you'll enjoy.

Minimum working height. Many wildlife subjects are found at or near ground level, and your most effective compositions may be at your subjects' level. Unfortunately, many tripods don't drop low enough to allow this. Buy one that does. Tripods that can be used at ground level usually have legs that extend independently to a near-horizontal position. The new Gitzo 241 Pro Reporter is sturdy, fairly lightweight, and doesn't need alteration to be used virtually at ground level. Unfortunately, most tripods capable of reaching ground level have a long center column, which gets in the way unless it is removed or replaced. Some of these, like the Bogen 3021 tripod, have a two-sectioned center column, which can be lowered when the lower half of the center post is removed with an *alum wrench.* Fortunately, one is supplied with the tripod.

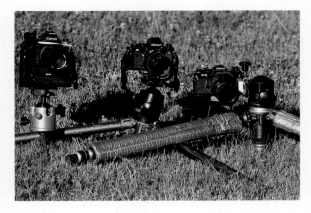

A good tripod should extend to your standing height and drop to ground level, too. Our favorite tripod is the Gitzo 320 shown here. For greater comfort for when she's carrying the tripod and a heavy lens, Mary Ann has added pipe insulation to the legs.

Ball heads provide tremendous flexibility and are easy to use. You can control all your camera's movements with a single knob. With the camera on the right, I've incorporated the vertical slot on a ball head with the rotating tripod lens collar to achieve a horizontal format at the lowest possible angle.

My tripod of choice, the Gitzo 320, requires purchasing an accessory short post to reach ground level, unless you cut off the unnecessary length of the standard center column with a hacksaw. I wouldn't do that because you may need the additional height of the longer center column at some time. In the field, I sometimes use my center column for scenics when I'm shooting from on top of the hood of my car. In the studio, I frequently use the center column to save floor space that would be otherwise occupied by extending the tripod legs to a greater height. (I don't have to worry about camera instability when I'm using electronic flash because the flash's illumination produces the necessary sharpness.)

If your tripod doesn't reach ground level when its legs are extended, there are other, less satisfactory ways to reach ground level. Reversing the center column is the least advantageous because the camera will become instable, as it would with a raised center column. Additionally, you might not fit between the legs of the tripod to use your viewfinder if you're large or if you're

wearing heavy winter clothes. Finally, if you're using a wide-angle lens, the angle of view could include a tripod leg. (See page 57 for some practical ways you can shoot at ground level without using a special tripod like the Gitzo.)

Tripod head. You can usually purchase better-quality tripods without an attached head; however, the tripod head is permanently attached to inexpensive tripods. Nevertheless, all tripod heads should allow movement in several directions. *Pans*, left-to-right movements, and *tilts*, vertical movements, should be accomplished easily with whichever head you use.

My favorite head is a ball head, in which a single knob controls all movements. If you use long or heavy lenses, as I do, try the Arca Swiss Monoball, either the standard old style or the newer, smaller B-1 ball. Foba and Studio Ball make a ball head that functions similarly to the old Arca head.

Other head styles have separate handles or levers for each movement. Some, like the Bogen 3047, can provide very precise control in scenic or macro photography, but I find these awkward to use when I'm photographing wildlife. Often, a number of movements occur simultaneously as I'm moving the camera from left to right and from a lower to a higher position. I've found this action difficult to perform with a three-levered tripod head. It is less of a problem when using three hands, but I have only two. Finally, I wouldn't recommend purchasing different heads for specific functions. Invariably, you'll find yourself with the wrong head at the wrong time.

Mounting mechanism. Cameras (and lenses equipped with tripod mounts) are either mounted directly onto tripod heads or onto special plates or plugs that fit into quick-release mechanisms fitted for tripod heads. I prefer quick-release mechanisms; they enable you to quickly change bodies or lenses if each piece of equipment has its own plate. This is especially useful if you're rushed. Otherwise, when you hurry to change your gear, you can strip the mounting threads or

Image sharpness requires a rock-steady tripod and a shutter speed that can stop the motion of your subject. Spider webs with dew make attractive subjects, but in such vast flatlands as the Everglades, winds rise within minutes of sunrise. I had to be careful to align the subject plane with the film plane to maximize the depth of field. I would have preferred greater depth of field, but the camera I was using didn't have a mirror lock-up, and a slower shutter speed would have registered camera shake. I based my exposure on the backlit fog and overexposed one-half f-stop.

attach the camera improperly. All of my cameras and lenses have their own plates. My longest lenses have special, custom-made, quick-release plates that offer greater support and stability than their factory-designed tripod mount provides.

Most photographers, myself included, carry their tripod and gear slung over their shoulders. But there is always the chance that the gear will unscrew and fall off the tripod head. Check the tightness of your mounts periodically. Make it a habit to have either the camera or the lens strap wrapped around a locking knob on the tripod head or clamped inside the tripod legs. Each year, a workshop participant who observes this rule saves his or her big lens or camera when it unexpectedly falls off the tripod head.

Leg locks. Tripod legs lock via the tightening of either a threaded collar or a locking lever. Screw collars are more secure but are slower and more likely to get stuck with sand, salt, or mud. Levers are faster and less likely to jam, but they may lose locking tension over time and they're more easily snapped or broken off.

USING YOUR TRIPOD EFFECTIVELY

Tripods are to use and to move. Don't anchor yourself to the spot where you first place your tripod. Often the best perspective is just inches

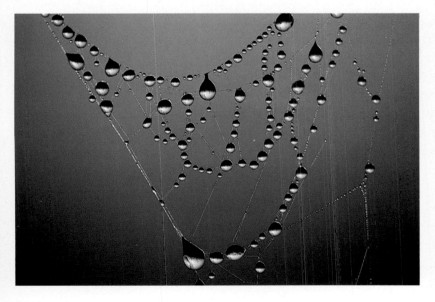

away from where you're positioned; sometimes it is dozens of feet away. First scout your "shoot" without your tripod—look for the best angle—then set up your camera. For example, along the narrow canal lining Anhinga Trail in Everglades National Park, snakelike anhingas regularly hunt for fish. Invariably, it seems that just before catching a sunfish, the bird swims down the canal and out of the view of the many waiting photographers. Instead of following along to capture the peak action, the photographers all too frequently complain about their bad luck. Remember, tripods have legs and so do you. When animals move, follow your subject with your gear.

You should use your tripod at varying heights, depending on the demands of your subject and the composition. Examine a scene from every angle and perspective for the ideal location before you set up, rather than after you've positioned the tripod and you're behind your viewfinder. Also, be sure to check all of the locking mechanisms before stepping away from your gear. I'm sure I'm not alone in occasionally forgetting to do this, having a tripod leg slip, and crashing an expensive camera to the ground.

When working with a shy or elusive animal, anticipate the working height you'll need before approaching your subject. If you're photographing shorebirds, collapse the tripod's legs to their minimum height before you begin to work in close. However, if you are working in sand or mud where the legs will sink in a few inches, extend the lowest sections of the legs out far enough to keep the screw collar or locking levers clear of this surface. Additionally, if you immerse your gear in salt or muddy water, rinse the legs off with fresh water as soon as possible to keep them from gumming up.

Often, in national parks such as Yellowstone, you first spot game from the road. An animal may remain in an opportune spot for only a few moments, and time is precious. You'll have a better chance of getting to your subject quickly if you don't collapse the legs between stops but keep them at the length you normally use for

The slap of a mirror can cause camera shake. Here I've reduced the chance of this happening by supporting the camera on a Bogen Magic Arm and by adding weight over the lens and the camera's pentaprism. If your lens is tripod-mounted, add weight at the center of gravity, that is, on the top of the lens, not the camera. Otherwise you could stress or break the lens mount.

A camera can also shake violently in high winds, when the heavy lens acts like a sail. By resting both elbows upon my knees or the tripod, and by keeping the tripod legs short, a strategy I call the "maximum stability stance," I'm able to add my body mass to the system to increase its stability. (photos: Mary Ann McDonald)

shooting. If that is not possible, set the legs to the required height before you reach your subject, instead of waiting until you're ready to shoot.

Don't use your tripod as a brace or crutch when rising from a sitting or a kneeling position. Even a sturdy tripod will bend and the locking levers will snap if enough weight is placed on them. For the same reason, be careful not to lean on a tripod when in deep snow. Keep in mind that in time, any tripod's leg-locking mechanism may weaken or slip. Although professional repair may be necessary, you can temporarily secure a loose leg by wrapping gaffer's or utility tape below the joint to prevent the leg from sliding up. The tape can be stripped off and reapplied a few times before it loses its adhesive strength, but I wouldn't suggest leaving your gear unattended, just in case.

PROBLEM SOLVING FOR STEADINESS

Although a tripod is invaluable for razor-sharp images, adverse terrain, wind, bizarre angles, or very mobile subjects can make using one difficult or impossible.

Wind. A steady or gusting wind can shake the sturdiest camera or tripod, making sharp images soft or fuzzy. You can add weight to the bottom of the tripod to increase the unit's total mass, but this does little to stop your camera and lens from shaking. To minimize shake, add weight to the top of your gear over its center of gravity. In other words, place the additional weight over the part that is attached to the tripod. Don't put weight on a lens if the camera is mounted to the tripod. This will damage the lens mount.

If you're using a long lens with a removable or telescoping lens hood, you may be able to reduce the wind's vibration. For example, the hood of my 500mm lens extends about six inches past the front element and acts like a sail, shaking my lens violently when I'm working in a strong wind. By removing the lightweight hood, I'm able to significantly reduce the surface area exposed. I suggest removing the hood only if there isn't a danger of lens flare or of windblown particles of sand or grit scratching the front element of the lens. Either is unlikely to occur if the sun and the wind are to your back.

Vibrations. Besides locking up the camera mirror, there are other ways to dampen vibrations caused by mirror slap, the action of the mirror flipping up during exposure. Some photographers use two tripods with 600mm or longer lenses, placing one tripod beneath the lens and the other beneath the camera. This method works, but it is very cumbersome; it is most useful with stationary subjects.

Alternatively, you could use a camera and lens brace specifically built for these purposes. L.L. Rue's Four Seasons Foto Sharp lens-stabilizing system provides sharpness and mobility without the awkwardness of using two tripods, although the brace costs as much as many tripods will. A more affordable alternative is a Bogen Magic Arm and Super Clamp. An adjustable brace supports the camera by clamping onto a tripod's leg or onto the center post. With a beanbag or sandbag resting upon the camera's pentaprism, vibrations are significantly dampened.

MAKING A BEANBAG SUPPORT

Although many beanbag supports are commercially available, it is easy to sew your own. I suggest that you make a bag about the size of a large brick (about 2 × 4 × 12 inches). Use a zipper closure—not velcro—to make the bag spill-proof. Fill the beanbag with birdseed, and you'll have a handy source of natural bait should it be needed. If you make several bags, fill each one with different amounts of seed so that they can be easily stacked or wedged together if you need to raise or brace a long lens.

DUNLIN, Reed's Beach, New Jersey. 500mm F4.5 lens, 1/250 sec. at *f*/8 with TTL teleflash.

A little, ground-level mini-pod provided the "sand-level" view of this dunlin. Crawling toward an animal on your belly can be difficult when you're carrying a heavy tripod, but it is a fairly easy task with a little mini-pod. I don't recommend a table-top tripod for this, however, because they're too lightweight to support a large ball head.

I often use this short but sturdy tripod made out of welded sections of iron when I'm photographing in sandy areas where I must be low and where the sandy substrate could ruin the collars on my standard Gitzo 320. This sturdy tripod allows me to support both the front end of the 500mm lens and the camera while resting both elbows on the ground. (photo: Mary Ann McDonald)

Low Angles. For a dramatic or an intimate perspective, I often try to film at my subject's level. This is sometimes difficult to do, especially with small, ground-hugging subjects. To obtain a low perspective, you can remove the tripod head. This eliminates some inches by placing the head directly on the ground. Using the grooved slot on a ballhead eliminates another few inches. On lenses with tripod collars, mount the lens to the tripod head, and if you need a horizontal format, shift the ballhead system into the vertical groove and rotate the lens and camera inside the lens collar.

If you must be even lower, rest the camera directly on the ground. This works best with horizontal compositions because the camera baseplate provides additional support. You may need to elevate the front of your lens with a twig or stone to clear the foreground. Anything can work as a solid camera or lens support. On more than one occasion I've used one of my shoes as a low-level support for my 200mm macro lens. Hand-holding your camera at ground level works if your hands can rest on the ground and support the gear. Use smaller lenses and faster shutter speeds for your sharpest images with this technique.

If you need to be midway between ground level and your tripod's minimum height, brace the tripod and camera on a rock, log, or your gadget bag. Make sure you weigh down the end of the tripod to prevent it from tipping forward. After you've decided on your composition, lock the head and use a cable release to ensure that your gear neither slips nor moves.

Other supports. At times, using a tripod is impractical or impossible. At many National Wildlife Refuges, shooting is most easily done from a car, and it is mandatory on an African safari. Although you can use a tripod inside a car, it is easier simply to use the vehicle as your camera support. Turn the engine off and put your lens on a jacket or beanbag draped over the window. I frequently carry one or two brick-sized beanbags in my car, on which I rest my lens.

L.L. Rue's Groofwin pod is a great support for photographing from a car or truck window. A ball head could be attached, but I prefer resting my lens on a beanbag for the increased surface area it provides. (photo: Mary Ann McDonald)

LEOPARD ON TOPI CARCASS, Masai Mara Game Reserve, Kenya. 300mm F2.8 lens, 1/250 sec. at ƒ/4, Kodachrome 64.

Shooting from inside a car, I used a Groofwin window bracket to brace my camera and give me a low camera angle. The exposure was based on some middle-tone areas outside the picture frame.

When photographing from a vehicle, I use a special window bracket, called the Groofwin, as my support. Marketed by L.L. Rue, the Groofwin is a flat, sturdy, adjustable brace that accepts a tripod head. I prefer to use only beanbags as camera and lens rests for the Groofwin because this minimizes the metal-to-metal contacts and potential vibrations that adding a tripod head produces. This system is sturdy. Using this method, I've shot razor-sharp images using shutter speeds of 1/125 sec. with a 500mm lens, with three other photographers in a safari van.

You can use a tripod on a boat, provided the engine is off. If not, you must hand-hold the camera or use a shoulderstock. Stocks provide an extra measure of stability beyond hand-holding, because you use your shoulder as well as both your hands for bracing. Whether you're hand-holding or using a stock, think about limiting yourself to shutter speeds no less than the reciprocal of the focal length of the lens you're using. With a 300mm lens, use either 1/350 sec. if your camera has half-speeds, or use 1/500 sec. When hand-holding a camera, support the lens in one hand and the camera in the other. Brace your elbows against your waist and breathe shallowly as you focus and fire. If you're swaying, try to fire at the peak of your upswing when the camera is momentarily stationary.

Shoulderstocks provide an added measure of stability. A good one enables you to hold the stock to your shoulder and trip the shutter with one hand while using the other hand to focus. If you set your camera on autofocus mode, use your free hand to hold the stock for additional support. A stock made of wood or metal is less likely to break under stress than one made of plastic.

Some stocks come with a camera strap that can be wrapped around your shoulders or waist for additional support. Don't encumber yourself in this way in a boat if there is any danger that the boat will capsize. Camera equipment sinks, and you will, too, if you're attached.

THE WINDY UPLAND GOOSE

A female upland goose incubates her nest on a sparsely covered hillside as a fierce wind blows across the Patagonian plains in Argentina. The nesting goose is tolerant of people, and you know that a slow approach should bring you within range for your 500mm F4 telephoto lens. Although it is midmorning and clear, you're concerned about the 40 mph wind that is buffeting your lens. You're using ISO 64 speed film.

Challenges:
- What is your base exposure if the sun is over your shoulder?
- At what height is it advisable to use your tripod?

- Are there any ways to increase the stability of your camera and lens?

In one of the windiest places on earth, in the foothills of the Andes Mountains in Patagonia, I was faced with just such a dilemma. On the only day I had a chance to film an upland goose, near-gale-force winds reaching gusts of 60 mph blasted my telephoto lens and coated the windward side of my face with gritty particles of sand. The middle-gray tones of the female goose were sunny f/16, but the wildlife equivalent, 1/500 sec. at f/5.6, was still too slow to stop the vibration I saw through my viewfinder. I sacrificed the

minimal depth of field of f/5.6 and used 1/1,000 sec. at f/4 instead.

The 500mm telephoto lens has a 6-inch-long lens hood. By removing the hood, I hoped to reduce the surface area exposed to the wind. Lens flare wasn't a problem because the sun was behind me, although I was concerned about the fine sand that filled the air.

By keeping my tripod at its minimum height, I was able to use the maximum-stability shooting stance. I rested both elbows on my knees, leaned into the camera, and pressed down hard on the focusing collar. It was difficult to move closer with the tripod legs shortened, but this kept me low to the ground, which presented a less threatening outline to the goose than if I was standing upright.

Because I had to cover a number of yards, it was impractical to lay a heavy bag over my lens for additional weight. In any case, the extra weight might not have helped; the wind was so strong that any added surface area might have caused more shake. I could only brace myself and fire at the fastest possible speed, 1/1,000 sec., whenever there seemed to be even a momentary gap in the heavy wind. The technique worked, and I obtained sharp images.

500mm F4 lens, 1/1,000 sec. at f/4, Kodachrome 64.

LENSES FOR PHOTOGRAPHING WILDLIFE

The beauty of an SLR camera lies in its ability to accept a variety of different-size lenses offering a whole spectrum of magnifications and potential effects. The terms standard, telephoto, mirror, zoom, macro, and wide-angle describe particular lenses that might be of use to you. If you're interested in all facets of nature, you could need a number of lenses or a few zooms covering a broad range of focal lengths. If you are a specialist, perhaps interested solely in birds, one or two long lenses offering high magnification might suffice.

The *standard*, "normal," SLR-camera lens is 50mm in length and produces an image similar to what you see with your unaided eye. This lens is the standard to which all other lenses are compared. *Wide-angle* lenses are smaller than 50mm in length and provide a greater angle of view and less magnification. *Telephoto* lenses are longer than 50mm and offer a more restricted angle of view along with greater magnification. You can determine the power of magnification of a lens by dividing 50 into the focal length of any

lens. A 500mm telephoto provides 10X magnification (500mm/50mm = 10X), making objects appear closer than they really are. Conversely, a 24mm wide-angle lens yields half the magnification; objects viewed through a wide-angle lens appear smaller or farther away. Zoom lenses incorporate a variety of focal lengths in just one lens, saving photographers money, space, and weight, as one lens replaces several. Photographs made with a high-quality zoom lens are excellent and rival those taken with an equivalent-length fixed lens.

Although lens choice is personal, wildlife photographers might think about following "the doubling rule" when purchasing new lenses, by adding lenses that either halve or double the focal length of your present lenses. You can cover everything from scenics to elusive wildlife with a set of five lenses—24mm, 50mm, 100mm, 200mm, and 400mm in focal length—without duplicating an effect or a magnification. However, you could reduce the weight and

COMMON ZEBRA, Nairobi
National Park, Kenya.
400mm F2.8, 1/250 sec. at ƒ/8.

Although I was using a fast F2.8 lens, I needed depth of field, not a fast shutter speed, for this picture. Don't use your lens at its fastest aperture if you don't need to; instead, use your aperture to its best advantage.

*Working distance
was no problem with
a group of handout-
seeking pelicans that
followed our tour
boat across a lake. By
leaning far over the
side with my wide-
angle lens, I had an
unusual water-level
perspective that
incorporated a wide
angle of view.*

trouble of carrying these five lenses by using zoom lenses instead. A 35-70mm or 28-80mm zoom lens, an 80-200mm zoom lens, and a 400mm telephoto lens provide even broader coverage with less gear. Regardless, these three or five lenses make a great "starting set." If you add either a macro lens or an extension tube, a teleconverter, and perhaps a smaller wide-angle lens, you'll be able to cover almost everything nature has to offer. Of course, you might not need all of these lenses, or you might need even more. Exactly which ones you'll need depends upon what you plan to photograph and how much you're willing to spend.

I've adapted the doubling rule to my selection of telephoto lenses. Instead of using a single lens for wildlife, I use a 300mm F2.8 lens for those situations where image size isn't a problem but obtaining sufficient light is difficult. I always carry a matched 1.4X converter to use in situations when I need a stronger magnification. This requires just one *f*-stop, making my 300mm F2.8 lens a 420mm F4 lens. When there is sufficient light, I use a 500mm F4 lens for the greater magnification it offers. If I need extreme magnification and conditions permit, I add the 1.4X converter to the 500mm F4 lens to make a 700mm F5.6 lens. With these telephoto lenses, my 1.4X teleconverter, and my 80-200mm zoom lens, I can cover most of my wildlife subjects.

CHOOSING THE RIGHT LENS

Choosing a lens involves focal length, lens speed, minimum focus, weight, and ultimately price as the latter generally reflects these other considerations. You'll save money using zoom lenses. Although a "good" zoom is expensive, it is still cheaper than buying two or more lenses of equivalent quality that lie within the range of the zoom lens. An 80-200mm zoom lens, for example, incorporates three "standard" lenses: the 80 or 90mm lens that is often used for human portraiture, the 100 or 135mm medium telephoto lens, and the 200mm telephoto lens, as well as every focal length in between. However, don't expect that just one or two "super-zoom" lenses will satisfy all your needs,

especially in terms of optical quality. If sharpness and lens resolution are important to you, you may want to use modest zoom ranges, such as 20-35mm, 35-70mm, and 80-200mm. Telephoto-zoom lenses cover the focal lengths between 100 and 500 or 600mm, but most of these are heavier, slower, and not as sharp as are fixed-length telephoto lenses.

Both zoom lenses and fixed-length lenses are available over a very broad price range. You can expect to pay anywhere from less than one dollar per millimeter to over 10 dollars per millimeter of

WHICH FOCAL LENGTH IS BEST FOR WILDLIFE?

Telephoto lenses between 300 and 800mm are most frequently used for bird and mammal photography. Lenses of 600 and 800mm are so heavy and long that many people find them difficult to use. A 300mm lens might be too small for photographing birds but is suitable for many types of mammals. Although a 500mm lens is great for birds, using this lens can cause the same handling problems that longer lenses present. Because of its convenient size, adequate magnification, and broad affordability, a 400mm lens is the ideal choice when selecting a single telephoto lens for wildlife photography.

ANDEAN CONDOR,
Southern Andes,
Argentina.
500mm F4.5 lens,
1/250 sec. at ƒ/5.6,
Kodachrome 64.

Although I decided to use a manual-focusing lens, I could've easily kept the focusing brackets of an autofocus lens centered on the bird's head or body as it passed at a constant speed and height within 100 feet of a nesting colony.

lens. For example, the price of a 400mm telephoto lens ranges from under 200 dollars to well over 5,000 dollars. This significant price discrepancy in lenses of the same length reflects major differences in lens quality, brand name, and speed.

Brand-name lenses offered by the major camera manufacturers usually cost more than generic lenses produced by independent lens makers. Although you may be paying something for the brand name, the lenses offered by camera manufacturers are usually better built and are less likely to need repair if subjected to minor abuse. Field photographers should take this into account because working outdoors can be very hard on equipment. I use my gear hard; over time, I save money on repairs by using my camera manufacturer's lenses.

There are also price differences within one manufacturer's line, depending on the optical quality of the lens. The distortion created as light passes through glass is corrected in the best lenses. These lenses are often referred to as *apochromatic* (APO) and concentrate the various wavelengths of visible light at the same focal point. Lens and camera manufacturers may identify these color-corrected, more expensive lenses by the letters APO, LD (low dispersion), L (luxury), ED (extra-low dispersion), or AT (advanced technology). (These descriptive terms are not industry standards; they simply identify "good" glass.) Optically, many generic lenses and manufacturer's lenses are similar; you can be safe buying the generic lens if you treat your equipment with care.

The *speed* of a lens, or its maximum aperture, also affects the cost. Faster lenses have wider maximum apertures and are more expensive than slow lenses with smaller maximum apertures. Speed is relative to lens length; while an ƒ/2.8 maximum aperture on a 50mm lens is very slow, it is very fast for a 300mm or larger lens. Most manufacturers offer several different lens speeds for a particular focal length. Speeds of ƒ/2.8, ƒ/4, ƒ/4.5, and ƒ/5.6 are common maximum apertures on 300mm telephoto lenses. A color-corrected fast lens is

BLACKTAILED DEER,
Yosemite National
Park, California.
300mm F2.8 lens,
1/60 sec. at *f*/2.8,
Kodachrome 64.

*I found this buck on
a dreary, rainy day
in Yosemite Valley.
Without the speed of
a fast telephoto
lens, the low light
level would've
made photography
impossible with my
slow-speed film. Even
so, I had to wait for
the deer to pause to
make a sharp image
with the slow shutter
speed I used.*

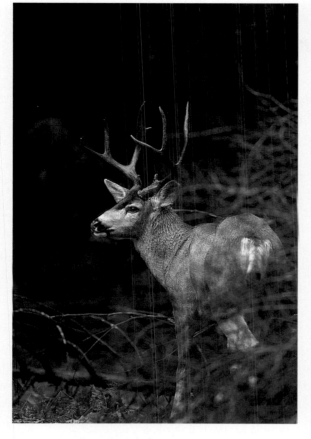

often 4 to 6 times more expensive than a slow, uncorrected lens.

In wildlife photography, a fast lens offers many advantages. Because a camera focuses with the lens wide open—that is, at its maximum aperture—a fast lens is brighter and easier to focus. Since depth of field is shallowest at the maximum aperture, images "pop" into focus. Additionally, you can use faster shutter speeds in any given light, which is critical to obtain sharp images. Unfortunately, fast telephoto lenses are heavy. The average 300mm F2.8 lens is almost three times the weight of a standard 300mm F5.6. A slower, lighter lens may be better for a backpacking photographer or someone lacking the strength needed to carry a heavy lens.

SHUTTER SPEED, APERTURE, AND LENS CHOICE

On page 41 I discussed some shooting options with various modes, using the example of a deer walking through a forest. The ambient exposure was 1/60 sec. at *f*/4 with ISO 64 film. Now I want to talk about this lighting situation in terms of available shutter speeds with different speed lenses.

With a 300mm F2.8 lens, a shutter speed of 1/125 sec. can "stop" the deer's motion, but this speed would be too slow if the deer is walking quickly or if the image size is large and fills the frame. A 300mm F4 lens requires a 1/60 sec. exposure. A moving deer would be blurred, but you could obtain a clear image if the deer pauses.

A 300mm F5.6 lens needs a slow shutter speed of 1/30 sec. Although it is difficult to clearly capture a walking deer at this speed, you might obtain a razor-sharp image if the deer is motionless, providing you use good camera-handling techniques.

Besides speed, other factors can influence cost. Autofocus lenses are usually less expensive than manual-focus lenses, with the exception of the largest autofocus-telephoto lenses. Another way to save money is to purchase a floating-aperture zoom lens instead of a zoom lens with a fixed maximum aperture. These lenses are identified by the two stops listed for their widest aperture. In a floating-aperture zoom lens, the aperture varies with the focal length in use. For example, on a 35-70mm F3.5-4.5 zoom lens, *f*/11 at the 35mm setting becomes *f*/16 at the 70mm setting. On an automatic-exposure mode, a floating aperture isn't a problem because the camera adjusts for the change. If the camera is set on manual mode, you must either know at what point you've lost some light or continually check your exposure by metering through the lens. This will be inconvenient for photographers who use incident-light meters, estimate their exposures off the sunny rules, or use manual electronic flash and set the aperture accordingly.

Some lenses offer *internal focus* (IF), which means all focusing movements occur within a fixed-length lens. Lenses without internal focus increase in length as they focus closer. This increase can affect exposure because some of the light that passes through the lens is lost.

EVERGLADES RAT SNAKE, South Florida. 100mm F4 lens, 1/125 sec. at *f*/11 with TTL flash, Kodachrome 64.

This nonpoisonous rat snake looks threatening, reared into a defensive S-shape on the forest floor of this jungle-like hammock. I used a hotshoe flash, but the working distance of the 100mm macro lens was sufficient to provide flash coverage of the snake at the required small aperture.

An IF lens can be useful when you're photographing from a blind: Shy subjects are less likely to be frightened by a stationary lens projecting through a porthole. There is also an advantage when using *polarizing filters*. These filters polarize light and are very useful when shooting scenics. Polarizing filters "pop out" clouds as they darken blue skies; they eliminate reflections off glass and water, and help saturate color as well. The amount of polarization you achieve depends on the rotation of the filter, and since the front of many IF lenses are stationary even as you focus, you won't have to adjust a polarizing filter after focusing.

The minimum focusing distance of a lens may be important to you. An IF lens usually focuses closer than a non-IF lens, so a larger image size is possible. However, the IF feature shouldn't be a decisive factor in lens selection because minimum focus can be extended by adding an inexpensive extension tube to most lenses.

Because of their weight, telephoto and zoom lenses of 200mm and longer frequently have a *tripod collar* at their centers of gravity. This collar provides more stability to the system and less stress on a lens mount than is possible if the camera is mounted to a tripod. An additional advantage is that your perspective remains the same when flipping from horizontal to vertical, since the camera position remains stationary as

the lens rotates within the collar. This is extremely convenient when photographing active wildlife.

True *macro* lenses focus closely enough to offer at least 1:2, or one-half life-size, magnification. Some macro lenses focus to 1:1 or to life-size. The numbers representing magnification can be confusing; think of these as fractions. The ratio 1:2 could be written as 1/2, or half life-size. It is easy to see why 1:2 and 2:1 are not interchangeable and represent different ratios. The ratio 2:1, or 2/1, represents an image twice life-size.

Fixed macro lenses are available in 50mm, 90mm, 100mm, and 200mm focal lengths. Although I own a 50mm macro lens, I rarely use it for photomacrography, although it does see use as a scenic lens. I use the 100mm macro lens for insects when I'm using a Kirk macro-flash bracket. The working distance of a 100mm macro lens is useful for studio setups of reptiles and small mammals when space is limited. A 200mm macro lens is ideal for wildflowers, reptiles, and amphibians in the field, and for some studio work. Most 200mm macro lenses have tripod collars, which makes changing from horizontal to vertical easy.

Although some zoom lenses offer a macro mode, many of these focus only to a 1:4 magnification and are really only close-focusing zoom lenses. A few will focus into a true macro range of 1:2 or more. Avoid zoom lenses that offer a macro mode at their smallest focal length. The working distances within the 24mm, 35mm, and 50mm range are often too short for practical use.

APPLYING CRITICAL DATA ON LOCATION

Too many photographers take into account only the size and magnification of their lens when composing images. Lens length also determines the working distance, the angle of view, the amount of compression, and the depth of field. Understanding these factors and their interrelationships is critical to producing good compositions. One of the most important factors

is magnification. As you double the lens length, magnification also doubles, enabling you to have the same image size from twice the distance. Increasing a lens by any given factor increases its magnification by the same amount.

Although images get larger as you increase the magnification, the *coverage area*, or *angle of view*, becomes smaller. A 50mm lens has a 48-degree angle of view. At 2X magnification, a 100mm lens has a 24-degree angle of view, a 200mm lens has a 12-degree angle of view, a 400mm lens has a 6-degree angle of view, and at 16X magnification, an 800mm lens has an angle of view of approximately 3 degrees. Reducing the angle of view by using a longer lens can

simplify or clean up a messy composition as this will reduce the amount of area present in the background.

Many photographers don't think about lens length when photographing approachable macro subjects, that is, those requiring magnification that approaches life-size on film. Let's use, as an example, a portrait of a dew-covered dragonfly at dawn, made with a tripod-mounted camera positioned about 30 inches above the ground. At dawn, it is easy to approach dragonflies, and working distance is not a problem. A dragonfly can be photographed with either a 50mm macro lens or a longer 100mm or 200mm macro lens. Each of these macro lenses is capable of producing an image that is one-half life-size, and depending on the manufacturer, they can also reach a life-size reproduction ratio.

A photograph of the dragonfly made with the 50mm lens may include a distant horizon line and bright sky, as well as any vegetation visible within the 48-degree angle of view. However, if you switch to a 200mm lens, you can still maintain the same image size you had with the 50mm lens simply by increasing the working distance between the lens and subject. Or, you can magnify the dragonfly four times if you maintain the same working distance for both lenses. Either way, with the 200mm lens, you'll have less background clutter.

Remember, doubling the magnification also doubles the distance required to produce images of identical size. You create the same image size

MACRO LENSES AND WORKING DISTANCE

What length macro lens do you need? I rarely use my 50mm macro lens because I find it inconvenient to be as close to most subjects as this lens requires. I use it in macro portraiture when I want to include some background habitat. Usually, I simply use the 50mm macro lens as my "standard" 50mm lens.

I use the longer macro lenses far more frequently. Along with the ease of magnification, I find the increased working distance has many benefits. For example, my tripod legs won't bang into the vegetation that supports a dewy spider web; I can film a plant or frog from the edge of a swamp, rather than within it; and I can keep a safe distance when photographing potentially dangerous subjects. Photographing a copperhead with 30 inches between us is far safer than approaching it from a mere 7 inches!

BLACK-FACED SKIMMER DRAGONFLY, Poconos, Pennsylvania.

It is very important to check the depth of field when doing photomacrography. Too shallow a depth may result in parts of your subject being out of focus (left), while too much can create an image that is too busy (right).

200mm F4 lens, 1/30 sec. at ƒ/8, Kodachrome 64.

200mm F4 lens, 1/8 sec. at ƒ/16, Kodachrome 64.

of the dragonfly by using a 50mm lens at 10 inches, a 100mm lens at 20 inches, or a 200mm lens at 40 inches. However, the amount of background included is progressively reduced, and the composition will be simpler with the longer lenses because of their smaller angles of view. You may not think a greater working distance is important when you're photographing easily approached, sleepy, chilled dragonflies, but it is when you photograph a dragonfly at high noon when they are active and far more elusive.

DETERMINING DEPTH OF FIELD

Beginners often falsely assume that they can obtain greater depth of field by using a shorter lens, but this is not entirely true. Depth of field is dependent on two factors: aperture size and image size. Depth of field increases as aperture size decreases, that is, as the numbers grow larger. Conversely, if you're using the same f-stop, depth of field decreases as image size increases, whether you accomplish this by using a longer lens or by shortening the working distance. The same depth of field is obtained with lenses of different focal lengths when the image size and the aperture of the lenses are identical. This is advantageous in macro work, when it may be helpful to use the working distance of a longer lens.

Let's go back to the example of the dew-covered dragonfly. A portrait shot at a working distance of 40 inches with a 200mm lens at $f/11$ has the same depth of field as one taken with a 50mm lens at $f/11$ when you're 10 inches from the subject. The depth of field, less than one-half inch, is quite shallow with either lens. The depth of field changes if the focal length changes, but only if the working distance remains the same. For example, if you switch from a 200mm lens to a 50mm lens without repositioning your tripod, you will have greater depth of field, but your image size will be only one-fourth the original size. If you move closer with your 50mm lens to obtain the image size that you obtained with the 200mm lens, the

depth of field with the 50mm lens will equal that of the 200mm lens.

I often incorporate these ideas of working distance, depth of field, and angle of view when I photograph wildlife in crowded parks, or when background clutter detracts from my subject. For example, although I'm able to obtain an adequate image size of a ground squirrel on a campground with a 100mm lens, I often back off and use a 300mm lens instead. The longer lens eliminates the background clutter of tents, picnic tables, and people.

Lens choice can also exaggerate or compress the distance between objects within your frame. The standard 50mm lens records distance relationships much as the human eye perceives them. Lenses smaller than 50mm exaggerate distances, while telephoto lenses compress or shorten distances. This is why photographers use short telephoto lenses for human portraiture. Because these lenses compress subjects, facial features are flattened, rather than pronounced. Portraits made with wide-angle lenses distort and produce huge noses on pinheads. Most people find this unappealing.

In nature photography, using a longer lens can "stack up" an animal against a distant geologic feature because the lens shortens the apparent distance between the background and the subject. You can also use this compression to shorten the distance between scattered animals, thereby creating a tight flock or herd, or it can be used to simply frame a subject against a simpler or more pleasing background.

For example, let's say you are photographing Dall sheep 100 feet away as they graze on a steep slope in Denali National Park in Alaska. Directly behind the sheep, but 20 miles away, the 20,320-foot-high Denali (Mount McKinley) juts skyward. With a 100mm lens, both the Dall sheep and the huge mountain towering over the Dall sheep are magnified 2X. You can exaggerate their relative size by increasing the working distance to the sheep. By backing off to 400 feet, you can obtain the same image size of the sheep with your 400mm lens that you had with a

GRASSHOPPER, McClure, Pennsylvania. 80-200mm F4 zoom lens with 50mm extension tube. Kodachrome 64.

A zoom lens combined with an extension tube makes a versatile macro lens. From a single tripod position, you can obtain a variety of different image sizes and compositions if you are within the focusing distance for the tube. Be careful about choosing your aperture! In the first image (left), made with an 80mm lens, I shot the grasshopper at sunrise at f/4, which produced a natural-looking round sun. I got closer and closed down, which increased my depth of field (middle), but not enough to render the sun sharp 93-million miles away. Instead, the sun took on the shape of an out-of-focus highlight that mirrored the shape of my stopped-down aperture. This created a very unnatural-looking octagon shape. For the third image (right), I opened up to f/4 again, so the sun, reflecting the round shape of the wide-open lens, appears round.

100mm lens at 100 feet. However, that additional 300 feet from Denali is insignificant when compared to the 20 miles separating you from the mountain. Denali at 8X will tower over the Dall sheep. Also, at 400 feet, a 400mm lens is close to infinity focus. Both the sheep and the mountain will be detailed, especially if the lens is stopped down to f/8 or smaller. Although depth of field might not seem especially significant in this example, at the close distances typical of most wildlife photography, depth of field is important.

You can determine depth of field three ways: by depressing the depth-of-field button on your camera or lens, by reading the depth scale inscribed on some lenses, or by consulting a depth-of-field comparison chart available in books and lens manuals. The first method works best because you can see what is in focus and what is not. You can also see the degree of sharpness present in the areas that are

"technically" outside the depth of field. Depth scales found on some lenses or in books only define the distance that is truly sharp. They provide no information on the degree of sharpness or fuzziness, which I call the *zone of apparent sharpness*, which is present both in front of and behind that area. In fact, the depth scales on lenses longer than 100mm are so small they're almost useless, but closing down and making a visual inspection to determine the zones of apparent sharpness is quite worthwhile.

Surrounding areas can be very important to your composition. Imagine a portrait of one flower among many in a field. Without a visual check, it is impossible to determine what amount of sharpness you need in the other flowers that frame your subject. Should they be fuzzy blurs of color or sharp enough to be nearly in focus? Which effect best complements your subject? You won't know unless you can check by using a depth-of-field preview button.

HYPERFOCAL DISTANCES AND LENSES

Understanding the relationship between aperture and lens length is more than an exercise in photo trivia. The knowledge can be very useful when you're photographing scenics or wildlife in landscapes where maximum depth of field is required. A 24mm lens at *f*/16, focused at the hyperfocal distance of 4 feet, will have a depth of field extending from 2 feet to infinity. At *f*/8, the depth of field narrows, extending from 4 feet to infinity, with the hyperfocal distance at 8 feet.

When you use longer lenses, the hyperfocal distance is farther from the camera and closer to infinity. A 50mm lens at *f*/22 is sharp from 6 feet to infinity with the hyperfocal distance at 12 feet. Nothing closer than 6 feet will be sharply in focus, but those areas outside the true depth of field may appear sharp by being within the zone of apparent sharpness.

Depth of field increases as your lens aperture grows smaller. At f/16 with this 24mm wide-angle lens, depth of field extends from the 2-foot mark to infinity. As such, the hyperfocal distance is 4 feet. With the lens on the right, the depth of field is considerably reduced at the f/4 aperture. Depth ranges from approximately 10 feet to infinity. Although there isn't a mark on the lens to indicate the hyperfocal distance, you know that it is 20 feet if you understand the definition.

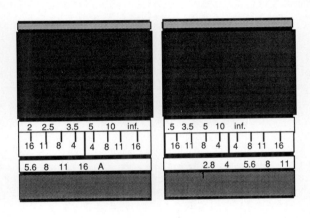

Depth scales are useful in accurately determining a lens' *hyperfocal distance.* This is the point of focus where everything from half that distance to infinity is sharp and within the depth of field. The hyperfocal distance approaches infinity as apertures widen or as lens length increases, because the depth of field decreases. Hyperfocal distance can be invaluable when you want to maximize depth of field. To find your lens' hyperfocal distance, set the infinity mark on the focusing collar over the *f*-stop on the depth scale for the aperture you're using. You'll find that the minimum point of sharpness will be directly above the *f*-stop mark at the other end of the depth scale. This determines the hyperfocal distance, the point of actual focus. If you understand this, you won't

be surprised to see that your focusing mark will be at twice the minimum focus distance.

For example, suppose that the depth of field ranges from 2 feet to infinity. The focusing mark will be at 4 feet. If you wish to have a foreground object as close to you as possible and still be in sharp focus, position it at 2 feet. Here, that object may look soft and out of focus when the lens is wide open. Beginners see this, panic, and reposition that object so that it's in focus, which is back at 4 feet. They forget that the depth of field will extend to the 2-foot mark, which they would see if they used a depth-of-field preview button.

SPECIAL LENSES AND ACCESSORIES FOR CLOSEUP WORK

Too frequently, animals are either shy or are small and require special macro or telephoto lenses to make an interesting photograph. Although both macro and telephoto lenses provide large images, macros do this by focusing closer, while telephotos do this by magnifying or decreasing the angle of view. There are other ways to reach macro, or near-macro, capability without using a macro lens. Special lenses and accessories for shooting wildlife closeups include mirror lenses, teleconverters, telescope converters, closeup diopters, extension tubes, and bellows.

Mirror lenses are squat, barrel-like telephoto lenses that rely on a *catadioptric,* or *reflex,* mirror to achieve their focal length within a very short length. A series of mirrors within the catadioptric lens bounces the light back and forth to produce the same degree of magnification found in a traditionally shaped lens, but at a cost. Mirror lenses are slow, with a fixed aperture that is usually one or two *f*-stops slower than a normal telephoto lens. Because a mirror is located in the center of the front element, an optical aberration occurs: Out-of-focus highlights appear as doughnuts, instead of blurry dots as produced by straight lenses. These doughnuts can severely detract from an image. However,

some mirror lenses are very sharp. Most are far less expensive, and significantly lighter and easier to carry, than traditional telephoto lenses. I have seen excellent work done with mirror lenses, although the slow speed of the lens and the doughnut highlights deter me from regularly using them. If price and weight factors are more important to you than speed and natural highlights, by all means, purchase a mirror lens.

Many telephoto lenses and some zoom lenses couple with special *teleconverters* to increase a focal length by a factor of 1.4X, 1.6X, or 2X. There is little loss of image quality if the teleconverter is optically matched to your telephoto lens. However, you lose light by the same factor as you gain magnification. A 300mm F2.8 lens becomes a 420mm F4 lens with a 1.4X teleconverter, or a 600mm F5.6 when a 2X teleconverter is added. Most photographers agree that a high-quality 1.4X teleconverter produces sharp images, but that most 2X teleconverters do not. I recommend having a 1.4X teleconverter. If you must have a 2X teleconverter, I suggest that you carefully test one to determine if its degree of sharpness is sufficient to meet your requirements.

Determining exposures with a teleconverter is simple. Remember, the converter reduces the light that reaches your film by the same factor

as it magnifies. With a 1.4X teleconverter, the reduction is one *f*-stop, and with a 2X teleconverter, it is two *f*-stops. Your in-camera meter, or your camera's TTL flash-metering system, will automatically compensate for the loss of light. You really don't have to worry that your 300mm F2.8 lens is now a 420mm F4 lens.

If you estimate exposures using one of the sunny rules, or if you use an incident-light meter, you must factor in the light that is lost with the teleconverter. For example, with a 1.4X teleconverter, you'll lose one stop of light, which can be corrected by either widening the lens aperture by one—that is, going to a larger *f*-number on the aperture scale—or by using one stop slower shutter speed.

As an example, if your base exposure taken from an incident light reading was 1/250 sec. at *f*/4 with a 300mm lens, adding a 1.4X teleconverter changes the base exposure to either 1/125 sec. at *f*/4 or 1/250 sec. at *f*/2.8. If you're using a 300mm F2.8 lens, the 1.4X teleconverter makes it a 420mm F4 lens, although you can still use the *f*/2.8 setting on the lens barrel. With the 1.4X teleconverter added, the *f*/2.8 aperture functions as an *f*/4 aperture, which the two exposure combinations listed above reflect. Confusion often arises when a photographer adds a teleconverter and, knowing that the smallest aperture on the lens is lost, mistakenly

GREAT BLUE HERON (flying with stick), southwest Florida. 300mm F2.8 lens with 1.4X teleconverter (420mm F4), 1/250 sec. at *f*/5.6, Kodachrome 64.

I added a 1.4X teleconverter to my 300mm lens to obtain a larger image size. At 420mm (8X magnification), it was difficult to obtain sharp focus and compose simultaneously. My shooting ratio, or percentage of successful shots, was terrible with my manually focused lens, and most of the sharp images were centered. Autofocus might have helped here.

stops down to the next *f*-stop. In doing so, he or she is underexposing by two stops.

Again, if you use your in-camera meter, don't worry about the effect the teleconverter will have. Your camera will adjust automatically. If you don't use that meter, remember to increase your exposure by one stop of light, just as you'd have to do if a cloud suddenly obscured your scene. You'd open up then, either by changing the aperture or the shutter speed, and you need to do the same when you add a teleconverter.

Some telescopes and spotting scopes offer camera adapters for wildlife photography. Although the optical quality of a few of these is excellent, most *telescope converters* lack optics comparable to the least expensive, smaller telephoto lenses. All telescopes are incredibly slow, with maximum apertures of *f*/11 or smaller that require fast, grainy films.

Almost any lens will focus beyond its minimum focus if auxiliary closeup diopters, extension tubes, or bellows are added. In each case, infinity focus is lost as the lens' focusing range shortens. Of the three, the simplest to use are the *closeup diopters* (also called closeup lenses) that screw onto the front of your lens like a filter. There is no reduction in light, and the optical quality of those incorporating two lens elements is quite high. These closeup diopters are especially convenient when you're traveling, if space is limited, or when a macro lens may not be necessary. Buy one large enough to fit the largest lenses it can be used with. For example, Nikon's 5T and 6T dual-element filters have 62mm filter threads. But with step-up filter rings, they can be used on lenses with filter threads of 58mm or 55mm lenses as well.

Extension tubes, as the name implies, are hollow cylinders that you mount between the lens and the camera to shorten the focusing distance of the original lens. Tubes are available in various lengths, depending on the manufacturer. For example, my Nikon set includes lengths of 8mm, 27.5mm, and 52.5mm. They can be used alone or in combination, depending on the amount of magnification you require. This procedure is objectionable to some photographers because you must modify the combination of extension tubes as you move closer or farther away from your subject. I don't mind the inconvenience because tubes have advantages: They're easy to pack on trips, as a

BLACK VULTURE (with fish), Everglades National Park, Florida. 500mm F4.5 lens with 1.4X teleconverter (700mm), 1/250 sec. at *f*/4.5 with TTL flash, Kodachrome 64.

Image sharpness is difficult to obtain with very long lenses. I used my maximum-stability sitting position (see photograph on page 56) and a TTL teleflash system to maintain sharpness. Determining exposure was difficult. The black subject required opening up the aperture by one f-stop, which overexposed the gray-white fish head. Therefore, to crop most of the fish head out of the picture, I used the longest lens combination I had.

set of tubes is no longer than a 100mm lens, and perhaps most important, they are less likely to be damaged than a bellows.

In contrast, the larger, bulkier *bellows* offer a continuous range of extension throughout their length. Bellows resemble an accordion bellows, with pleated folds that expand and contract as the bellow unit is focused or as a degree of magnification is determined. Because the bellows are soft and pliable, a focusing rail is required to support the lens and camera. This rail adds to their weight and bulk, which you don't need when you're in the field, and you'll find that the leather or plastic bellows material can rip on thorns or sharp branches if you're not careful.

Both tubes and bellows merely conduct light; they don't have lenses. The prime lens, the lens that is attached to your camera body, is the lens that determines the image quality. The tubes or bellows enable you to focus more closely with that lens, and thus increase magnification. You can determine the amount of magnification by using the formula:

$$\text{Magnification} = \frac{\text{length of extension}}{\text{length of prime lens}}$$

For example, a 25mm tube added to a 50mm prime lens yields 1:2 magnification. This is frequently called the *reproduction ratio*. Most macro lenses have some extension built in. Most 50mm macro lenses have 25mm of built-in extension, most 100mm lenses have 50mm, and some 200mm lenses have 100mm of built-in extension, providing 1:2 magnification in each case. This built-in extension must be considered when determining magnification. Adding a 25mm tube to the 25mm of built-in extension for a 50mm macro lens at minimum focus provides 50mm of total extension. Thus, 50/50 = 1:1, or life-size.

Reproduction ratios are inscribed on the lens barrel of macro lenses and some other lenses. Most begin at 1:10, or one-tenth life-size, and continue down to 1:4, 1:2, or 1:1, and you can assume that the required amount of extension is built in. If a 100mm macro lens focuses down to

1:2, assume it has 50mm of built-in extension. Adding an extra 50mm of tube will yield 1:1.

Adding extension reduces the amount of light reaching your film. The greater the amount of extension, the more light is lost. If you're using your camera's meter, no exposure compensation is required when taking a reading because the meter adjusts for the reduced light. However, if you're estimating your exposure or using an incident meter, you'll have to take the light reduction into account. A 50mm tube requires an increase in exposure of about one *f*-stop as the light reaching the lens is reduced. You must take this into account when you're estimating exposures or when you're using an incident-light meter or manual flash. With in-camera metering or TTL flash, this is done automatically.

It is wise to add only the minimum amount of extension necessary to obtain your required image size. Don't use a 50mm tube on a 100mm lens if you only need to extend the minimum focus by a very small amount. Adding too much extension can bring you closer than you need to be, and it will always cost more light.

Adding extension tubes to an 80-200mm zoom lens is an inexpensive and practical way to achieve macro capabilities at a broad range of working distances. By adding a 50mm tube, you'll have 1:2 magnification when the lens is

EXTENDING A TELEPHOTO LENS' FOCUSING RANGE

I regularly use a 300mm lens for small bird and reptile photography. By adding 25mm of extension, I change the focusing range of my lens from its original 9.5 feet–infinity to only 6.33–13.5 feet, which overlaps slightly with the lens' original minimum focusing range. Adding a 50mm tube limits the focusing range still further, from 5–8 feet, but with an exposure loss of almost two *f*-stops of light. However, at this final minimum focus, an object only 3.5 inches wide fills the frame.

METAPHID JUMPING SPIDER, Pine Barrens, New Jersey. 80-200mm F4 lens with reversed 100mm F3.5, 1/60 sec. at ƒ/11 with manual flash, Kodachrome 64.

High-magnification photography opens up a whole new world of subjects. When I mount a reversed short-barrel 100mm lens onto my zoom lens, the 100mm lens acts like a high-quality closeup lens, offering approximately 2X magnification. You'll need a male-to-male filter adapter to attach the two lenses, and a great deal of patience to frame a tiny moving subject within sharp focus.

set on 100mm at infinity focus, and nearly 1:1.5 at 80mm. However, with the lens set on 200mm, you'll have either 1:1.5 when the lens is focused at its minimum distance setting or approximately 1:4 magnification when the lens is set at infinity. With a 1:1.5 reproduction ratio, my 200mm lens has a working distance to the subject of approximately 17 inches. At 1:4, that distance increases to 34 inches.

Closeup diopters can be used in conjunction with extension tubes for even greater magnification. I find the 80-200mm zoom particularly convenient for this. With my 80-200mm zoom, a Nikon 6T, and a 50mm tube, I obtain just slightly less than 1:1 when the lens is zoomed to 80mm, and about 1:1 at 200mm when the lens is focused at infinity. If I focus down to the minimum focusing distance, the reproduction ratio changes significantly. At this closer distance, the magnification is about 1.4:1, or greater than life-size, when the lens is zoomed to the 200mm setting. Thus, with this combination, by zooming from 80 to 200mm while maintaining the same distance setting

on the focusing barrel (let's use ten feet as an example), the image size increases, while the angle of view and the working distance decreases.

This zoom/tube/closeup lens setup provides a great deal of flexibility when composing without having to move the tripod's legs. If I need less magnification, I can either remove the closeup lens for a modest reduction or turn the focusing barrel toward the infinity mark. If I need a significant decrease in magnification, I'll remove the extension tube from the zoom. Try this for yourself. Get a ruler, a zoom, and the various closeup accessories you normally use. I think you'll agree that the setup provides a great deal of compositional freedom and flexibility.

In fact, using closeup diopters and extension tubes is so convenient, you might question whether a macro lens is necessary. Perhaps not, if you rarely pursue macro subjects. But if you need the added sharpness and the convenience of continuous focus from infinity to closeup, using true macro lenses is a good idea. They're certainly required for my work.

THE COOPERATIVE CALIFORNIA QUAIL

On a rare, clear day at Point Reyes National Seashore, California, the territorial whistle of a male California quail rings sharply. You quickly spot the bird perched atop a weathered fenceline and watch with amazement as the bird ignores the birders and photographers who walk within yards of its perch. Although a portrait of the bird would be effective, you hope to incorporate the flowers that surround it into your photograph.

Challenges:
- What lens will be most useful in obtaining a sufficiently large image of the quail without frightening the bird from its perch?
- What is the base exposure for the scene?
- Will it be possible to incorporate the flowers and the bird within the image and retain sharpness in both?
- What aperture will prove most effective?

Although the bird was fairly tame, we maintained a minimum distance of twelve feet to avoid flushing it from the perch. At that distance, a larger telephoto lens was required for a large image size. Most of the group used telephoto lenses of 300mm, 400mm, or 500mm, but even with the 6X magnification of a 300mm lens, a working distance of less than 20 feet is required for a frame-filling image.

At short working distances, the depth of field will be quite shallow with a telephoto lens, and critical focusing and selective composition is important. I always focus on the eyes of my subject to ensure that the face is sharp. Because it was sunny, I used the wildlife equivalent of sunny $f/16$ for ISO 100 as the base exposure. At $f/8$ at 1/500 sec., I had enough depth of field to render all parts of the quail sharp, but not enough depth to include sharply

focused flowers, too. For that, I would have needed to switch to a smaller lens or to back off, resulting in a smaller image size both ways. Of course, I could have used a smaller aperture for greater depth of field, but the image still could have gone soft due to camera or subject movement. An active bird like this quail should be filmed at a shutter speed of 1/250 sec. or faster.

I composed the image in a way that incorporated the out-of-focus flowers as a frame of colored blurs around the quail. This technique, called *selective focus*, actually draws the viewer's eye into the scene and to the center of interest.

300mm F2.8 lens, 1/250 sec. at $f/8$, Fujichrome 100.

80-200mm F4 lens, 1/250 sec. at $f/11$, Fujichrome 100.

UNDERSTANDING ELECTRONIC FLASH

Many photographers don't understand flash techniques, and although they might own flash equipment, they rarely use it. Fortunately, this doesn't have to be the case. When compared to the flash units of old—a mere decade ago—a modern electronic flash is simple to use. In fact, many camera systems incorporate dedicated flashes in which the exposure is determined in-camera and *through-the-lens* (TTL), just as ambient-light readings are. Choosing a flash is as important as any decision you'll make when selecting gear.

CHOOSING A FLASH SYSTEM

Electronic-flash units can be divided into four types, based on how the exposure is determined. Two of these, *automatic* and *dedicated automatic*, are of little use to wildlife and nature photographers. Exposures made with either one can be inaccurate. The exposure sensors are located on the flash or in a special off-flash unit and might not correctly read the same quantity of light that actually reaches the film. In contrast, a flash unit incorporating TTL-flash metering has a sensor located within the camera body. This sensor reads the light that reaches the film. Depending on the camera make or model, these flash-exposure systems are referred to as either TTL or *off-the-film* (OTF). Both read light through the lens, but OTF does so after the flash reflects off the film. For the purpose of this text, they are sufficiently similar that both can be referred to as TTL. This metering system is extremely convenient, especially when you use telephoto or macro equipment. It does, however, have some limitations (see page 82).

There is also *manual* flash, where charts, dials, exposure formulas, or special flash meters enable you to determine the exposure. Despite the advantages of using TTL, you still have to use manual flash in certain situations where TTL flash can't be used. For example, if your subject is small, not centered, and against a non-middle-tone background, an incorrect exposure will result with TTL flash. Also, if there is a large reflective area, such as wet skin, water, or glass, the TTL sensor will prematurely shut off the flash.

I've already recommended that any new camera you consider buying should incorporate a TTL flash system. Fortunately, most TTL flashes can be used in a manual mode, too, so you really have the option to use either one as the conditions require.

In the field, I find a TTL flash very convenient. When using my old Canon T90, I use a Canon 300TL flash, and with my Nikon 8008 and F4, I use a Nikon SB24. Both flashes can be used either from a hotshoe or off-camera, and both can be switched to manual when necessary. In the studio, or when multiple flash setups are required for broader coverage, I use the manual modes of Sunpak's 611 and 522 flashes. These flash units have large guide numbers and variable power ratios for short flash durations.

MEASURING FLASH POWER IN TERMS OF GUIDE NUMBERS

Flash units vary in the intensity of their light output, which determines the aperture that can be used at a given distance. The intensity, or power, of a flash is indicated by a *guide number* (GN). The larger the GN, the more powerful the flash and, usually, the more heavy and bulky the flash unit.

SOUTHERN
COPPERHEAD,
Great Smoky
Mountains National
Park, Tennessee.
100mm F4 lens,
1/60 sec. at f/16
with three manual
flash units,
Kodachrome 64.

*Closeup and macro
photography often
requires flash in order
for photographers
to use the small
apertures necessary
for enough depth
of field. I positioned
three flash units
around this snake
and hid behind
a black screen while
the snake searched
for, and swallowed,
the mouse it had
struck.*

FILM SPEED IN RELATION TO GUIDE NUMBERS

Doubling an ISO doesn't double the GN, but it does double the power of the flash unit, and a smaller aperture can be used. If your flash is rated at GN 80 for ISO 100, the GN for other film speeds will be:

ISO	GN	f-stop at 5 feet	at 10 feet
400	160	32	16
200	110	22	11
100	80	16	8
50	56	11	5.6
25	40	8	4

When comparing flashes, keep in mind that guide numbers based on ISO 100 film are given. Although the GN changes as the ISO rating changes, it doesn't change by the same factor. Doubling the film speed doesn't double the GN, although it does increase it. A flash with a GN of 110 for ISO 100 has a GN of 160 at ISO 200 and a GN of 80 at ISO 50. Although this may seem confusing, there is an explanation. The guide number is based on a simple equation:

$$GN = f\text{-stop} \times \text{flash-to-subject distance.}$$

In flash-exposure tests, film is exposed at a fixed distance, usually 10 feet, at various apertures. Multiplying the aperture chosen for the best exposure by the flash-to-subject distance gives the GN. Thus, if the ideal exposure is $f/11$ and the flash-to-subject distance is 10 feet, then the guide number is 110. Now, recall that you gain one stop of light when the ISO doubles. If you have $f/11$ at ISO 100, you'll need $f/16$ for ISO 200, because the aperture closes one f-stop with a film that is twice as sensitive to light. This aperture, $f/16$, multiplied by the flash-to-subject distance, 10 feet, yields the new guide number, 160. Following this reasoning, for ISO 50, the GN is 80 because $f/8$ is one stop less than the $f/11$ of ISO 100.

The GN changes if you use zoom flash heads. These special flash heads contain built-in Fresnel lenses that change the angle of light coverage emitted by the flash. Most zoom flash heads have an illumination range between 24mm and 85mm, and many adjust automatically to provide the proper coverage for the lens in use. Guide numbers are smaller at wide-angle settings because the light disperses to cover a larger area. With Nikon's SB24 flash unit, for example, the GN ranges from 98 at the 24mm angle of coverage to 165 at 85mm. Similarly, the guide numbers for a Canon 430EZ range from 83 at 24mm to 145 at 85mm. Don't worry if you're using a lens longer than 85mm, because the longer lens' angle of view will fall within the coverage area produced by the 85mm zoom setting on your flash. If, however, you're using a lens smaller than the minimum zoom setting—for example a 20mm wide-angle lens—some vignetting will appear around the edges because the light dispersed by the flash can't cover this larger angle of view.

The factory-set GN is determined in a controlled, indoor setting where a room's walls confine, and thus intensify, the flash's illumination. If a flash were to be tested for the GN outdoors, where you'll be using it, that number would be lower, often by a full f/stop. Additionally, the listed GN usually refers to the full-power setting. For flashes on manual mode, the GN changes as the power ratio is dialed down to a lower power. With a Sunpak 611 flash unit having a GN of 160 at full power for ISO 100, the GN drops to only 14 when the flash is dialed down to its minimum 1/128 sec. power setting. This low GN requires the extremely short flash-to-subject distance of less than one foot for use with an $f/16$ aperture. However, the benefit is in the flash duration. This also changes, from a slow 1/400 sec. at full power to 1/50,000 sec. at minimum power. The latter is fast enough to stop the motion of almost any living thing.

If you're using TTL, it doesn't really matter whether or not you know the GN because exposures are automatically determined in-camera. But if you use your flash on manual mode and your GN seems inaccurate (as often

happens outdoors), knowing how to determine the correct GN is critical. Here's how to find it: Do an exposure test outdoors using a middle-tone subject that is 10 feet from your flash. Bracket exposures both above and below the suggested aperture and record the frame number for each exposure. Use slide film, because a poorly exposed negative can't always be detected from a print. Process the roll, pick the best exposure, and multiply the f-stop for that slide by 10. If $f/5.6$ is the best exposure, your new GN is 56 ($f/5.6 \times 10$ feet).

How powerful a flash do you require? You'll need a flash with a high GN if you plan to use your flash outdoors for bird or mammal photography. Most high GN flashes mount off-camera on a special bracket. These powerful flashes are usually bigger and heavier than hotshoe flashes; this may be a consideration when traveling or hiking. Low GN flashes usually mount via a camera hotshoe. These units are smaller, more convenient to use, and easier to pack. A low GN unit is all you'll need for macro flash techniques.

If you're planning to do high-speed flash work, don't assume that all low GN flash units have a very short flash duration. They might not. If you need an extremely fast flash, use a unit that has a power-ratio setting on its manual mode. These flash units have large capacitors and flash tubes. They also have low guide numbers due to the short flash durations, not because of small flash tubes that are incapable of producing large quantities of light.

APERTURES AND FLASH

The flash unit's GN and the flash-to-subject distance determine exposure. The closer you are to a subject, the smaller the aperture you can use. Determine exposure by the following formula:

$$f/\text{stop} = (GN)/(\text{flash-to-subject distance}).$$

You can change the apertures by varying the flash-to-subject distance. If the flash is too far away, the required aperture may be larger than your lens' maximum stop. If the flash is too close, the required f-stop may be smaller than the minimum aperture. Your flash must be within a specific distance range for the TTL metering system to emit the proper amount of light. If a TTL flash is mounted on the hotshoe, an over- or underexposure warning is usually given if you're too close to or too far from your subject. Unfortunately, when an off-camera cable is used, this check may not function.

For example, let's look at Nikon's SB24 flash unit set for an 85mm coverage. With TTL, the usable working distances change as the aperture changes, shortening as the f-stop becomes smaller. At ISO 64 and $f/2.8$, TTL works within

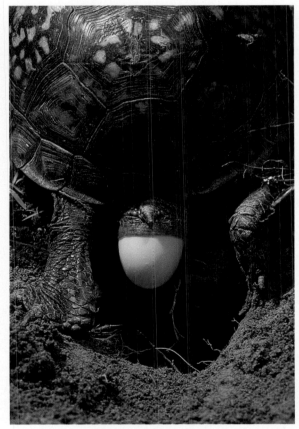

BOX TURTLE (laying eggs), McClure, Pennsylvania. 200mm F4 lens, 1/60 sec. at $f/16$ with two manual flash units, Kodachrome 64.

A fast flash-recycling time is occasionally necessary to expose a series of photographs made within a few seconds. A flash firing at full power requires the longest recycling time, while a flash emitting less light recycles progressively faster. Three ways to shorten your flash-recycling time: use a variable-power flash at less than full power; use a TTL flash held at its minimum TTL distance; or use special batteries, such as Quantum gel batteries.

Flash A's position will shorten the flash recycling time and allow a smaller aperture in both TTL and manual mode. Positioned as shown, a harsh shadow may form beneath the frog's chin. Flash B's position will require more energy, a longer recycling time, and a larger aperture. The light will be less harsh, however, since the frog's shadow will be cast behind, and not below, the frog. The best position for a flash would be at B's angle but closer, approximately at A's position. This would provide the smallest f-stop and shortest recycling time.

Use an incident flash meter to determine a manual flash exposure and to double-check your TTL system. Unlike an incident ambient-light reading, where the meter needs only to be in the same light, I had to hold my flash meter at this banana slug's position, or at an exact distance from my flash, for a correct exposure reading.

a range of 4.5 to 50 feet. At ISO 64 and f/16, TTL works only between 1.5 and 9 feet. At a distance of 50 feet at f/2.8 and at 9 feet at f/16, the TTL flash fires at full power because these are the maximum usable distances for the aperture chosen. At these distances, the flash uses most of the energy that is available, and a few seconds must elapse while the flash *recharges*, or *recycles*. When a flash fires, it discharges, to some degree, the energy stored in its capacitors. The flash then requires time to recycle before it can fire again. With TTL flashes, larger apertures or shorter flash-to-subject distances lessen the recycling time.

At the minimum working distances presented in our example of 4.5 feet for f/2.8 and 1.5 feet for f/16, very little energy is consumed. The flash recycles quickly, perhaps even fast enough to be used with a motordrive. With a manual

flash, the recycling time is based on the power setting. Some flashes offer a high and low setting; others dial down to a fraction of their full power. A flash recycles faster at less than full power. At 1/32 power, recycling may be nearly instantaneous. Also, recycling times can be reduced by your choice of batteries and are shortest with gel batteries, such as the Quantum Turbos, or with dry cells.

In contrast to the TTL system, where an f-stop can be used within a fairly broad distance range, the manual mode requires a given aperture for a specific distance. A manual flash emits a fixed quantity of light that isn't based upon distance or subject reflectivity. With the SB24 flash unit set for full power at an 85mm setting with ISO 64, the flash-to-subject distance is approximately 5 feet for f/16 and 20 feet for an f/4 aperture. In manual mode, an f/4 aperture can't be used at 5 feet, just as an f/16 aperture can't be used at 20 feet. Using these combinations would result in improperly exposed photographs.

SHUTTER SPEEDS AND FLASH
In flash photography, the aperture determines the flash exposure. The shutter speed doesn't affect the flash exposure, although the choice of shutter speed could affect the ambient-light exposure. Proper flash exposure requires only that the shutter is open long enough for the flash to fire. This synchronization, or sync speed, varies with the camera, ranging from as fast as 1/250 sec. to as slow as 1/60 sec. in older cameras. Most cameras have sync speeds of 1/90 or 1/125 sec., although any speed slower than this can be used, including the "B" or *Bulb* setting on most cameras. Although your camera is limited by its fastest sync speed, you aren't restricted to that setting. You may find a slower sync speed quite useful in certain situations.

Choosing the proper sync speed can be important in wildlife and nature photography. If you use a sync speed that is too slow for the ambient light, you could overexpose the background, the subject, or both. A sync speed

that is too fast will underexpose the background, although the flash exposure of the subject may be perfect. (Many flash photographs have this nighttime appearance where the background is black.)

You might, however, want to have both the subject and the background properly exposed or within one stop of each other. There are a couple of ways to do this. With many electronic cameras employing TTL, built-in flash programs sense brightness levels. The sensor automatically reduces the flash exposure to be less than or equal to the ambient-light exposure. Still, be sure to choose an aperture within the TTL range of your flash unit and a sync speed that can also properly expose for the ambient light.

Remember that the combination of shutter speed and aperture determines the ambient exposure, while the aperture alone determines the flash exposure. Let's say you choose a flash exposure of ƒ/16 for a subject in deep shade, where the ambient exposure is 1/60 sec. at ƒ/4. Normal sync speeds between 1/60 sec. and 1/250 sec. are too fast for the ambient exposure and will underexpose the background. However, since a flash can sync below its maximum speed, even to "B," a slower shutter speed can be used. In this example, choosing 1/4 sec. balances the flash and the ambient exposures at an ƒ/16 aperture.

Use faster sync speeds when you need to balance flash light with bright, ambient light, especially if you are photographing moving subjects. Slow shutter speeds allow bright ambient light to record images on film, just as brief bursts of flash light can "freeze" most motion. If you use a slow shutter speed and the subject moves, the ambient light image will blur or streak. Two images will be recorded: a sharp image that was made by flash, as well as a fuzzy image that was recorded by the ambient light. In these situations, the background frequently appears through the subject. Appropriately enough, this is called a *ghost image*, and the effect is known as *ghosting*. Ghosting can be minimized by combining a fast sync speed with a small aperture. The brighter the ambient light, the faster the shutter speed and/or the smaller the aperture you'll need. For example, if the background exposure is ƒ/11 at 1/60 sec., a flash exposure of ƒ/11 would balance with the ambient-light background. Remember, the flash exposure is constant, and any shutter speed within the sync range can be used. If, however, your camera syncs at 1/250 sec., you would underexpose the background by two stops if you use that sync speed. However, if you wish to avoid underexposing the background, you have to use a sync speed of 1/60 sec.

BLACK-THROATED HUMMINGBIRD, Danville, California. 200mm F4 lens, 1/60 sec. at ƒ/16 with one TTL flash unit, Kodachrome 64.

RUBY-THROATED HUMMINGBIRD, McClure, Pennsylvania 300mm F4 lens, 1/30 sec. at ƒ/16 with three manual flash units, Kodachrome 64

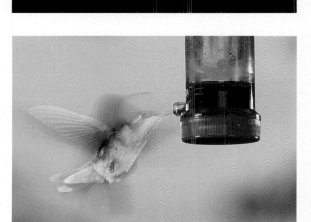

Two common errors: An unnatural black background is a common error produced by many flash exposures. In the top photograph, the background was in shade and required an aperture of ƒ/6.3 at 1/60 sec. I could've reduced the flash exposure to ƒ/6.3 or ƒ/8, or used a shutter speed of 1/15 sec., to balance the contrast between the flash and the ambient background exposures.

To produce the bright background in the bottom picture, I used a slow shutter speed to balance with the flash exposure of this ruby-throat. Ghost images, like this one, can result when photographing fast-moving subjects in bright, ambient light at slow shutter speeds with electronic flash.

A cooperative brown falcon perched along a trail provided a perfect photographic opportunity, except for the harsh backlighting. The natural-light exposure (top) produced high contrast, eliminated when I used a TTL teleflash to fill in the harsh light (bottom).

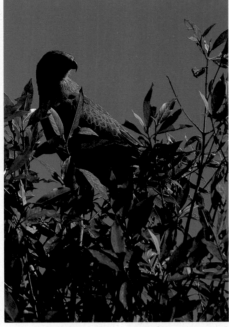

500mm F4.5 lens, 1/250 sec. at ƒ/8, Fujichrome 50.

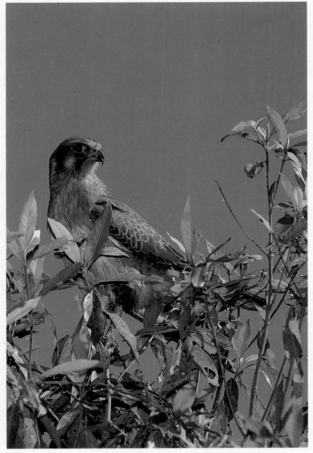

500mm F4.5 lens, 1/250 sec. at ƒ/8 with TTL teleflash, Fujichrome 50.

Ghosting is particularly troublesome with day-active, fast-moving subjects. Photographing hummingbirds illustrates this perfectly. These birds move so quickly that a fast sync speed of even 1/250 sec. won't stop their movement in ambient light, thus causing a ghost of the bird to appear on film. How do you eliminate this ghost image and still maintain a bright, natural-looking background? Photograph the hummingbird when it is in shade, rather than in full sunlight, while keeping the bright, ambient background visible. Although it is normally difficult or impossible to control the ambient light that strikes a bird, this isn't true with hummingbirds. If a hummingbird is visiting a sugar feeder, you could move the feeder into the shade. Balancing the flash exposure with the bright background exposure while using a fast sync speed minimizes, and perhaps even eliminates, ghosting. The ambient light within the shaded area may not be sufficient to register an image on your film, and, if it does, it will be so faint as to be barely noticeable.

Sometimes ghosting occurs despite your every effort. This might not be unattractive if the blur leads toward the subject, as if the moving object were streaking across the frame. You can achieve this effect if your flash has *rear*, or *second-curtain*, sync to trigger the flash just before the shutter closes. Unfortunately, most flashes fire just after the shutter opens, which results in streaks that lead from, rather than to, the "frozen" flash image. However, this can also be minimized if you pan with your moving subject.

FLASH, FILL, OR SYNC DAYLIGHT?

The effect you achieve with flash depends on the amount of ambient light. If the ambient light is low, you'll probably base your exposure on the flash exposure. However, if the ambient light is bright, you have a few options, depending on whether you're using TTL or manual flash. First, let's consider TTL flash. You can base your exposure solely on the flash exposure; a very short flash-to-subject distance might be necessary

GREEN CLEARWING
DRAGONFLY,
Everglades National
Park, Florida.
200mm F4 lens,
1/90 sec. at ƒ/16
with manual flash,
Kodachrome 64.

*Both the birds and
the bugs are tame in
the Everglades. I
approached this
dragonfly at my
minimum focusing
distance, determined
the ambient-light
exposure, and
balanced my manual
flash to provide a
half-stop more light.
The exposure was
based on the flash
illumination.*

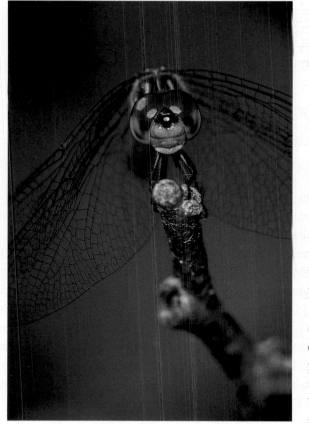

to employ a small enough aperture to overcome the brightness of the ambient light. Alternatively, you can balance the flash and the ambient light so that both require the same exposure. Using this approach, you would have to determine the ambient exposure first. This effect is frequently called *sync daylight*, and although it provides "snap" to images, it doesn't always look natural.

You could also base your exposure on the ambient light and use the flash's illumination only to fill in shadows or contrast created by the natural light. This fill-flash technique often produces very natural-looking images because it reduces the contrast recorded by film to a lighting ratio that more closely resembles how the human eye perceives contrast. How much fill you use is subjective, although most photographers prefer using one or two stops less light than is needed for an ambient exposure.

Imagine a barred owl sitting in the shade of a tree, where the surrounding foliage and the background are in sun and the exposure is 1/60

sec. at ƒ/16. The owl, in shade, is darker and requires a longer exposure. If you want your TTL flash exposure to be greater than the ambient exposure, you must position the flash close enough to the bird so that an ƒ/22 quantity of flash illumination strikes the owl. By setting your lens at ƒ/22 and maintaining the same 1/60 sec. shutter speed, the owl would be exposed correctly and be one stop brighter than the background. Getting the correct exposure is just as easy if you want the owl and the background to have the same exposure. Simply set the aperture to ƒ/16; the TTL flash will automatically produce the required quantity of light if the flash is within the distance range for the aperture you're using.

If you want to keep the background's ambient exposure brighter than the flash exposure of the owl, as you might if using a fill-flash technique, you would have to set your exposure based on the ambient-light reading. Then, either trick the TTL sensor by raising the camera's film-speed indicator to a higher setting or set the flash's exposure-compensation dial to minus one or two. By raising the camera's film-speed indicator to a higher setting, the camera's flash-exposure sensor would read for a faster film than the one actually loaded in the camera. The flash would emit less illumination than required for the ƒ-stop you're using. If you double the ISO from 100 to 200, the flash would emit only half the original amount of light. This procedure must be used with TTL flash systems that don't have built-in exposure-compensation dials, such as the Canon 300TL flash for the Canon T-90. Although you could also do this with flash units that have a compensation dial, it is easier to just set the dial to minus one or two.

With manual units, the ratio of flash to daylight depends on the flash-to-subject distance and the flash's GN. The results are the same as they were for TTL, but you have to be exact about where you place the flash, in contrast to working with TTL, where you only need to be within the flash range for a particular aperture. Use a variation of the GN formula to

AMERICAN COPPER
BUTTERFLIES,
Delaware Water Gap,
Pennsylvania.
100mm F4 lens, 1/15
sec. at ƒ/16 with one
manual flash,
Kodachrome 64.

*I had to position
the camera carefully
to capture both
butterflies sharply in
focus. My manual
flash provided an
ƒ/16 aperture at this
working distance. I
avoided a black
background by
taking an ambient-
light reading with the
aperture set at ƒ/16,
and set my shutter
speed based on that
setting. Had I used the
normal sync speed of
1/60 sec., I would
have underexposed
the background by
two ƒ-stops.*

When over- or underexposing the flash reading, keep in mind that you must do this with the aperture. Changing the shutter speed may affect the background exposure, but it won't influence the flash exposure of the subject.

For example, a subject that is properly exposed at ƒ/8 for 1/125 sec. with flash is properly exposed at ƒ/8 for 1/250 sec., as well. In daylight, changing the shutter speed affects only the degree of brightness in the background. A slower shutter speed would lighten the background and increase the possibility of ghosting. In contrast, too fast a shutter speed on a mechanical camera can force the shutter curtain to cut off part, or even most, of the flash's image. Fortunately, most electronic cameras have an automatic override that prevents this from happening. When a flash is turned on and is ready to fire, the camera's shutter speed is automatically set to the fastest sync speed.

MANUAL OR TTL FLASH?

For all its advantages, there are times when using TTL flash doesn't work very well. Admittedly, those times are few, but as you already know, a TTL flash sensor can be fooled. Manual exposures are based on flash-to-subject distances and aren't affected by composition or background. I use manual flash with highly reflective subjects, such as frogs, salamanders, and wet vegetation. TTL may underexpose these subjects if too much light bounces directly back to the meter and shuts off the flash prematurely.

Although you can use TTL or manual flash in multiple-flash setups, manual flash is less expensive to use. Multiple-flash units are useful in many types of nature photography. In the field, plants, fungi, bird nests, bird feeders, mammal dens, and reptiles look best when illuminated by two or more flashes. In studio wildlife setups, multiple flash is necessary to produce natural-looking lighting ratios. With manual flash, changing the flash-to-subject distance or the power ratio changes the usable ƒ-stop for each flash.

CALCULATING EXPOSURES WITH TTL AND MANUAL FLASH

Procedures differ when dealing with black, white, and middle-tone subjects. Consider the following recommendations for flash exposures with TTL or manual flash.

	TTL	*Manual*
Middle Tones	Trust your camera.	Use the guide number formula, flash meter, or flash exposure chart.
White Tones	Two Methods: 1. Decrease the ISO by two-thirds. 2. Set +1 or +2/3 on exposure-compensation dial on most flash units or cameras.	After using any of the above methods, close down by 1 or 1.5 ƒ-stops.
Black Tones	Two Methods: 1. Increase the ISO by one-half. 2. Set -1 or -3/4 to either the flash or the camera's compensation dial.	Same as above, but open up by one ƒ-stop.

THE BASKING MARINE IGUANA

It is high noon on James Island in the Galapagos Islands, and a blackish-gray marine iguana basks a mere four feet away from you. The equatorial sunlight is very contrasty, and sharp shadows divide the iguana's body in half. Fortunately, on your long overland hike to this spot, you're carrying all the gear you brought on the trip.

Challenges:

• What lens will work most effectively here?

• What accessories can you use to fill the shadows and reduce the contrast?

• What is the probable ambient light exposure for the iguana with ISO 64 film?

• You choose to use fill flash, but your old camera only has a 1/90 shutter sync speed. How do you base your exposure?

Animals in the Galapagos Islands are tame and permit a very close approach, but even such a placid creature as an iguana has a flight zone of three or four feet. At that distance, you can use a 50mm lens for a "habitat" shot, but a dramatic portrait requires a longer lens. I chose an 80-200mm zoom lens and tried a couple of different compositions.

Contrast is a problem with high-noon light anywhere in the world, but it is particularly evident at the equator. I had to reduce this contrast by using a flash. If I had used a natural-light reflector, I might have frightened the lizard because the reflector has to be held close; flash is less intrusive. At noon, the base exposure for a subject at eye level is between one-half and one full stop off the basic sunny $f/16$. Because the iguana wasn't middle tone, I had to base the exposure adjustment on sunny $f/11$. I estimated the exposure for the iguana for 1/60 sec. at $f/8$-11, having lost the extra half stop due to high-noon lighting. To confirm, I took a reflected-light reading off an area on the lizard I determined to be my "middle tone."

I based the flash exposure on the ambient light at a shutter speed of 1/90 sec. At 1/90 sec., the ambient exposure was $f/8$. Compensation was required with the TTL flash because the animal was darker than middle tone. An uncorrected TTL reading would have overexposed the dark lizard. I reduced the flash by 1.5 stops to just fill in, not cancel out, the shadows.

In a similar situation, you could also adjust the film speed to slightly more than twice the true ISO setting if your TTL flash lacks an exposure-compensation dial. If you use a manual flash, hold the flash back just far enough so that the flash exposure is less than $f/8$. An aperture of $f/5.6$ is ideal. (With some flashes, such as Nikon's SB24, when you set the power ratio and the distance scale on the flash, it gives the required flash-to-subject distance as long as it is mounted on the hotshoe.)

You might have to use the GN formula or an incident-flash meter. If you use the GN formula, divide the GN by $f/5.6$ to obtain the required flash-to-subject distance. If you use a flash meter, position the meter at the same distance as the lizard. You don't have to be exact, and the flash meter doesn't have to be next to the lizard. Just hold it about the same distance away. Any amount of fill-flash will work if the flash isn't too close and doesn't overpower the natural light.

80-200mm F4 lens, 1/60 sec. at $f/11$ with one manual flash, Kodachrome 64.

VERREAUX EAGLE OWL, Samburu Game Reserve, Kenya.

A teleflash system combined with my GN 140 flash, tripled the GN, extending my flash's reach from 31 to 93 feet. However, at this greater flash-to-subject distance, I was more likely to capture red eye. I produced red eye (left) by mounting the teleflash unit above the camera. To eliminate the red eye (right), a friend held the teleflash system 3 feet off-camera.

500mm F4.5 lens, 1/60 sec. at *f*/4.5 with one TTL teleflash, Kodachrome 64.

You can use a TTL teleflash system with any large lens. It will increase the flash's GN by three or four f-stops, depending on the size of the Fresnel lens used. (photo: Mary Ann McDonald)

to the contrary, daylight fill flash doesn't upset most animals. Most completely ignore the brief burst of light.

I use TTL mode when using a teleflash because a manual flash requires measuring the flash-to-subject distance and dividing that distance into the GN. This process is too time-consuming to be practical in the field, especially when a subject is active and is constantly changing positions.

To figure out a TTL fill-flash exposure with telephoto lenses, remember to take an ambient reading off the brightest area of your subject. You'll probably want to use your fastest sync speed if you are photographing wildlife. Set your flash exposure based on the ambient-light reading for this shutter speed.

With advanced flash systems, such as the Canon EOS 430EZ or Nikon SB24, flash fill should occur automatically as long as the ambient light is bright enough. Both flash units also have a compensation setting for additional control of the light ratio in situations where your flash could overpower the natural light and create an artificial effect. For example, this flash compensation is useful when the ambient light is very dim, as it may be under a thick forest canopy. With other flash units, you may have to trick the flash into emitting less light by raising the ISO. Remember, change the film speed only after you set the ambient exposure. Either double the ISO or raise it by two-thirds to achieve a natural fill-flash effect.

By basing your flash exposures solely on the ambient light, you can fire as rapidly as necessary

during peaks of activity. Although the flash might not fire every time, your ambient exposures will be correct. Some of the pictures could be contrasty, but you won't miss something important while waiting for a flash to recharge. And when the flash does fire, you'll have the additional benefit of the TTL fill.

It is wise to know your teleflash GN for situations where TTL may not work. This can happen when vegetation frames or partially obscures an animal, as leaves and branches can prematurely cut off the flash exposure. Since incorrect exposures can also occur if your subject is small or isn't center-framed, be sure to determine the correct *f*-stop by dividing the flash-to-subject distance into the enhanced GN.

CLOSEUP PHOTOGRAPHY WITH FLASH

Macro-flash exposures are simple to do with TTL metering. Although off-camera flash permits more accurate flash positioning and more diffused light, you can use a hotshoe flash with some lenses. At 1:2 magnification with a 200mm lens or at 1:3 with a 100mm lens, camera-to-subject distance is sufficient for both the flash and the lens to be aimed at the subject. At higher magnifications, *parallax*, where the lens and the flash are aimed at different areas, may occur. Tape an index card to the flash head, and then bend the card downward so that the flash strikes your subject. When you fire the flash test button, you'll see if the light strikes your subject.

Manual flash is also easy with macro equipment if you take advantage of the *Inverse Square Law*. This states that as light radiates from a point, the intensity is quartered as the distance from the light source doubles. In other words, you lose two stops, or end up with one quarter the light, every time you double the flash distance. Conversely, you gain two *f*-stops when you halve the flash-to-subject distance.

Macro work usually requires adding extension, which reduces the light reaching the film as it decreases the working distance. If you can mount the flash above the lens, the light lost to extension and the light gained by shortening the flash-to-subject distance will balance each

200mm F4 lens, 1/30 sec. at *f*/8 ambient-light exposure, Fujichrome 50.

200mm F4 lens, 1/60 sec. at *f*/16 manual flash, Fujichrome 50.

EASTERN GARTER SNAKE IN DUCKWEED, McClure, Pennsylvania.

The ambient-light exposure (left) has a pleasant lighting quality but is slightly "softer" because of the slow shutter speed I needed.

The flash exposure (right) is sharper because the short flash froze any movement. I don't like the shadow cast by the flash. I could have eliminated this with a reflector placed behind the snake, but I doubt if it would have tolerated that.

DETERMINING APERTURES FOR CLOSEUP MANUAL-FLASH EXPOSURES

You have to determine a basic exposure when you work with the Inverse Square Law and a manual flash. In order to do this, bracket a series of flash exposures on a middle-tone subject with the macro equipment you normally use. Hold your flash unit above the lens at a fixed position; you can do this by hand or with a flash bracket. You may be able to base your bracketing on an exposure suggested by your flash unit's instruction manual or by the flash exposure-compensation dial. If this isn't possible, then just bracket from the lens' smallest aperture at half-stop intervals until you reach $f/8$ or $f/11$. Record each aperture and the corresponding frame number. After your film is developed, match the best exposure with the correct f-stop. If you do your photomacrography by adding extension, this aperture should be usable from about a 1:1 to a 1:3.5 magnification ratio.

Shadows are always a problem with a single flash. In an aquarium, shadows can be cast upon the back of the tank, creating an unnatural-looking effect. This can be minimized at close flash-to-subject distances by utilizing the Inverse Square Law. At a flash-to-subject distance of 6 inches, a background 12 inches away will receive 2 stops less light, making a shadow barely noticeable.

VERMILION ROCKFISH, Point Defiance Park Zoo, Tacoma, Washington. 100mm F4 lens, 1/125 sec. at $f/8$ with TTL flash, Fujichrome 50.

other out. It is easy to maintain a constant flash position above your lens if you use a macro-flash bracket. As the lens length changes, just slide the flash to a new position on the bracket. With this approach, the basic exposure remains the same.

Low GN flash units are useful at short flash-to-subject distances. A GN of 32 is ideal for photomacrography if you use the Inverse Square Law to determine exposures. For example, at 2 feet with a 32 GN flash, the aperture setting is $f/16$. As you add extension and move the flash, camera, and lens closer, you maintain the $f/16$ aperture. Conversely, high GN flashes may be too powerful for closeup work. A flash unit with a GN of 100 requires an aperture of $f/32$ at 3 feet, a working distance that is too far away for many macro images. If you use a powerful flash, you must dial down to a low power ratio or reduce the light output via diffusion.

Macro-flash photographs taken in daylight can look as if they were done at night. If the subject is set apart from the background, there is likely to be at least a one f-stop difference between the subject and the background. In photomacrography, a few inches can be significant. Remember, according to the Inverse Square Law, the background exposure will be two stops less if the distance from the flash to the background is 2X that of the flash to the subject. For example, a honeybee photographed at a flash-to-subject distance of eight inches is two f-stops brighter than the background just 16 inches away. If $f/16$ were used on the insect, the background exposure would be $f/8$. That difference is even greater if the background is more than 16 inches away.

There are a couple of ways to decrease the contrast between subject and background. In studio macro setups, you can easily move the background closer to the subject. In the field, you can seek compositions where your subject is close to a natural background, although that is not always very practical. You can, instead, balance the small aperture of the flash with the

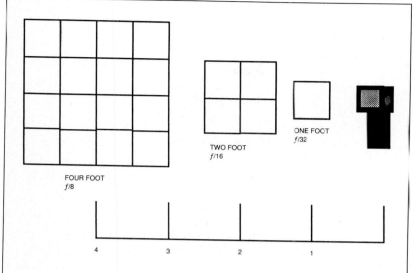

FOUR FOOT
f/8

TWO FOOT
f/16

ONE FOOT
f/32

4 3 2 1

According to the inverse square law, as you double your distance from a source of light, you quarter that light's intensity. Increasing the distance by only 1.5X will halve the quantity of light.

This principle can be used in macro photography, as well as when arranging lighting for studio and field setups.

ambient exposure by changing the shutter speed. You must be careful that ghosting doesn't occur if a slow shutter speed is required. Finally, you can illuminate the background with a second flash to decrease contrast.

WORKING WITH MULTIPLE FLASH UNITS

Even with the best techniques, a single flash source may produce unavoidable contrast or flat, uninteresting lighting. Understanding the relationship between flash-to-subject distances and aperture simplifies using two or more flash units together. Multiple flash can reduce the contrast between subject and background and cancel out or reduce the shadows each flash produces. I find multiple-flash setups especially useful at bird feeders, nests, or dens; in some camera "traps"; and in studio setups. You can position two or more flash units to create a very natural-looking lighting effect where and when the ambient light levels are too low for slow-speed films. By using a couple of flash units, I can recreate the effects of natural light; for example, by producing rim-lighting or by filling in the sharp shadows a single flash can cast. Multiple-flash TTL exposures are easy, although expensive off-camera connecting cables are

required to connect each flash unit. (These cables cost as much as 50 dollars apiece.) You can have different lighting ratios for the subject and background if you use bounce or diffuse the background flash to lessen its output.

Manual flash exposures are the most practical to use for multiple-flash techniques. If you use a manual unit, you can easily adjust the flash distances to provide different lighting ratios for your subject and background. The *key light*, or *key flash*, is the principle light source and is usually the light used to determine your f-stop. Fill flashes either fill the shadows created by the key light or illuminate the background.

When you work with manual-flash units sharing the same GN, your subject will always be brighter than the background if you make sure that the flash that illuminates the background is at a greater distance from it than the flash unit that illuminates the subject. For example, if the flash-to-subject distance is 3 feet, you must position the flash that illuminates the background at a distance greater than 3 feet. You can determine the exact lighting ratio by using the GN formula or a flash meter.

You can also use the Inverse Square Law to determine flash exposures and ratios. Since the intensity of light becomes one quarter as strong as the distance doubles, it follows that the light is reduced by half if the distance is increased 1.5 times. For example, if a flash at 8 feet requires an f/16 aperture, a flash at 16 feet needs an aperture of f/8. A flash-to-subject distance of 12 feet reduces the aperture by just one f-stop, to f/11. In the field, you can estimate or use your focusing ring to get these required distances.

There is no limit to the number of flash units that you can use in a multiple-flash setup. I've used as many as five flash units to cover a large area in the studio, and to fill in shadows and create specific lighting effects for some high-speed flash work. My usual setup involves three units. Regardless of the number of flash units used, all must fire simultaneously. You can easily

PORCHSIDE HUMMINGBIRDS

Hummingbirds are masters of flight, able to hover virtually motionless in midair as they feed on nectar. They are beautiful and challenging subjects for any photographer who wants to capture and stop the motion of their wings as they hover at a sugar feeder. Photographing them requires flash, since they are most active during the last two hours before sunset, when the light is low.

Challenges:

- How will you achieve sharp focus?
- What aperture will maximize depth of field?
- What flash duration and synchronization speed are needed to stop the hummingbird's wings?
- How can ghosting be eliminated?
- How can you avoid an unnatural, black background?

Like most bird photographers, I am fascinated by hummingbirds. At our country home, our front porch feeders are visited by half a dozen or so hummingbirds in late summer, and the activity is frenetic. Using affordable equipment available to anyone, I hoped to capture the frozen-in-flight wings of one of the ruby-throated birds feeding.

Hummingbirds beat their wings so rapidly—between 20 and 80 times per second—that they are nearly invisible to the unaided eye. To stop the motion of these wings required using a flash unit with a fairly fast

flash duration. A TTL flash placed close to the subject or a manual flash with an adjustable power ratio is capable of such short flash bursts.

At first I photographed a hummingbird rather late in the day when the ambient light was low. I used three Sunpak 611 flash units dialed down to 1/16 power providing a flash duration of 1/6,400 sec. At 1/16 power, the Sunpak has a GN of 32 for ISO 64 film, and since I needed an f/16 aperture to insure sharp focus, I positioned the three flash units about 18 inches from the feeder. (Although 2 feet is the actual flash-to-subject distance for a GN of 32 and an aperture of f/16, I placed the flash units closer due to the light lost using extension tubes on my 300mm lens.) This setup worked, capturing the "frozen" wing of a feeding bird and rendering a sharp image. Unfortunately, the low ambient light and my fast shutter speed underexposed the background, and the flash photograph appears as if it were made at night.

On my next attempt, I manned my camera earlier in the day and composed so that a patch of blue sky was visible behind the feeder. This eliminated the black background, but the wings are not completely sharp because ghosting is visible due to the bright, ambient light.

My final try included some drastic changes. Hummingbirds are aggressive, fearless feeders that

300mm F4 lens, 1/60 sec. at f/16 with three manual flash units.

quickly adapt to changes around the feeding station, making such elaborate setups possible. I erected a buff-colored sheet of posterboard behind the hummingbird feeder and transplanted some backyard jewelweed flowers as a natural prop. I positioned the flash unit for the birds in the usual way but added two additional units to strike the background. Set at the same manual power ratio as the main lights, they were placed far enough back to require an f-stop 1.5 times larger. Thus, at my working aperture of f/16 the background would be underexposed. The neutral-colored background allowed me to photograph in the last hours of daylight when the hummingbirds

were most active and still avoid a night-like effect. This meant I could use a fast flash duration and a small aperture without risking black backgrounds or ghosting. Jewelweed is a natural food source for hummingbirds, and my backyard provided plenty of props.

For accurate compositions and sharp focus, I had to remain behind the camera. Two Dalebeams wired together would have provided the same accuracy, but they would have required as much setup time as I spent filming. I attempted a remote shot with the trap-focus feature of my Nikon 8008 and databack, but this meant centering each shot, and I wanted greater latitude in my compositions.

I used a 300mm lens and two sets of extension tubes to provide the close focusing this small bird requires. A smaller macro lens could have given me the same image size but only at the cost of being closer to the feeder and probably disturbing the birds as they fed. At my 7-foot working distance, the birds fed unconcernedly while flashes popped off, stopping the birds' magical flight against a light-colored, ghostless backdrop.

300mm F4 lens, 1/125 sec. at ƒ/16 with three manual flash units.

Flash, jewelweed, and background setup for the hummingbird.

300mm F4 lens, 1/250 sec. at ƒ/16 with five manual flash units.

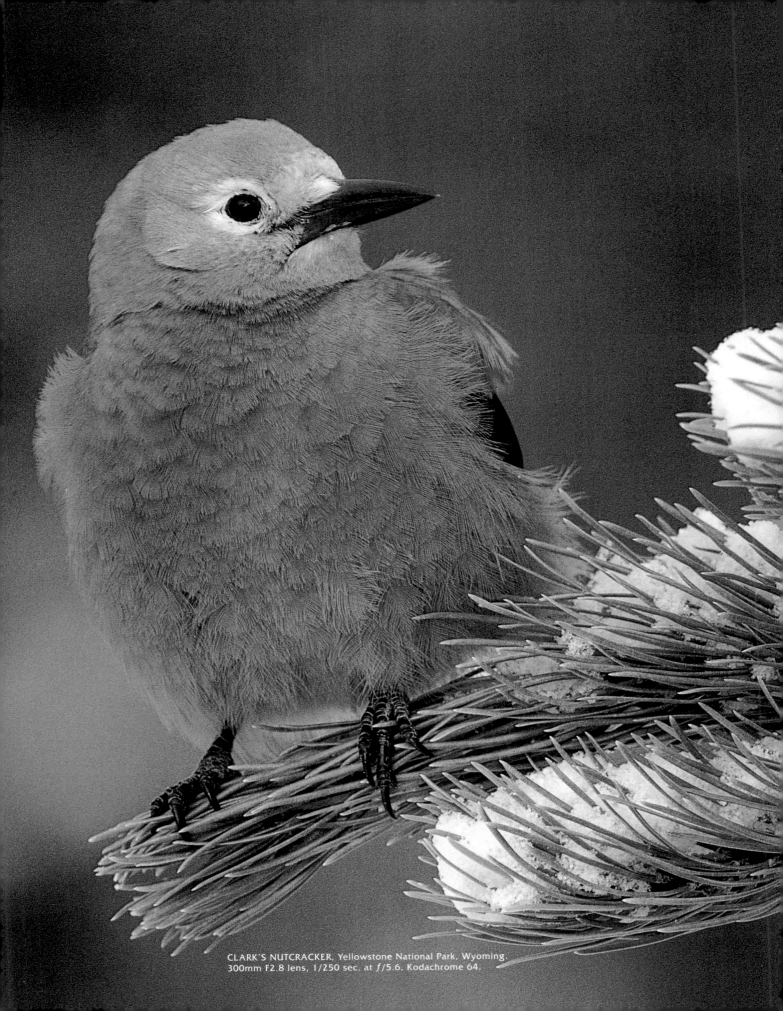

CLARK'S NUTCRACKER, Yellowstone National Park, Wyoming.
300mm F2.8 lens, 1/250 sec. at ƒ/5.6. Kodachrome 64.

PART 3:
COMPOSITION

DESIGNING THE PHOTOGRAPH

Ultimately, composition makes, or breaks, a picture. An image can be razor sharp and an exposure can be perfect, but if the picture isn't visually interesting, it fails. Composing an interesting image is sometimes difficult, but if you think your images lack something, take heart. Composition can be learned. Occasionally it comes naturally, as some people have a natural sense of what works—of what looks attractive, interesting, or intriguing. In fact, your best compositions have probably happened when you had a preconceived idea of the way you wanted to depict a subject. Perhaps this simply meant knowing you wanted to photograph at

NORTHERN LEOPARD FROG, Erie, Pennsylvania. 200mm F4 lens, 1/60 sec. at *f*/16 with manual flash, Kodachrome 64.

In wildlife photography, a subject-level view is very effective. It offers an intimate sense of "being there" that more traditional perspectives lack.

your subject's level or that you wanted to use a shallow depth of field to isolate an animal against a blurred background. Sometimes an image exists in your mind's eye, which, if circumstances permit, you'll recognize as you produce a photograph that interprets this image.

Then again, you may have a familiarity with a subject and an empathy toward it that you're able to convey on film. Sometimes an image simply evolves as you draw conclusions from studying your less satisfactory photographs and attempt to refine your efforts.

By studying photographs, you can learn to recognize what works in terms of the lighting, the framing, or the perspective. Although you'll learn from your mistakes, you're also more likely to repeat them unless you begin the recognition process of seeing. Begin by looking at the leading nature and wildlife magazines that publish outstanding images each month. Great photos are not only inspiring; they also share similar qualities that you'll identify and want to emulate. There are also excellent books dealing with composition. Some general guidelines follow that you can apply to your nature and wildlife photography.

PERSPECTIVE

Composition is a matter of *perspective*: how to convey the real three-dimensional world into the flat two dimensions of a photograph. In wildlife photography, one of the most effective perspectives is photographing at your subject's level. A toad's-eye look at another toad is a view foreign to most people but visually interesting to many. Subject-level photographs often provide an intimacy, a sense of being close, that other views lack.

MUDSKIPPER, Kakadu National Park, Australia. 100mm F4 lens, 1/125 sec. at ƒ/11 with TTL flash, Fujichrome 50.

Mudskippers are amphibious fish that spend a portion of the day sunning themselves on rocks, tree limbs, and mudflats. I stretched out flat on a dry section of mudflat for this mudskipper's portrait. The image was centered to insure that the TTL-flash sensor would read the subject and not the background that would have overexposed the fish. Mudskippers share their habitat with salt-water crocodiles, and I was very nervous about working alone next to this crocodile-infested, murky river.

I photograph from my subject's level whenever possible. Since many animals and flowers are low to the ground, this frequently involves spreading the legs of my tripod flat, or taking the ballhead off my tripod and resting it on the ground. Quite often, achieving this perspective involves my getting wet and muddy, but it is worth the trouble in the drama and sense of closeness that this angle provides.

Obviously, it is difficult to film birds or arboreal animals at their level. You might need a scaffold or tree stand to position yourself above ground level. This requires work and physical strength beyond some people's abilities. Of course, in studio or in field setups, an arboreal animal's perch can simply be positioned at a comfortable working distance to suggest height. I often do this at bird feeders.

When it is impossible to photograph a tree-dwelling animal at its level, locate your subject in the upper part of the picture frame. This makes sense visually, especially if branches or a tree trunk leads toward the subject. Your eyes naturally follow a tree upward until you spot

something, and frequently our eyes travel no further. I've often discovered another animal higher up that I first missed because my attention was arrested at the lower point. Including branches or a tree trunk that interferes with the center of interest only fills the frame with unnecessary clutter. Use the tree to lead your viewer's eye upward to your subject. This more closely duplicates how we view the world and creates images that are balanced and appear natural. The same idea applies to animals living on steep or hilly terrain. Let the lines of the cliff or hill lead your eye upward to the subject so that you place your subject in a natural viewing position.

Moving up or down can dramatically shift your perspective. Sometimes you can frame a subject against a pleasing background by raising it above or by dropping it below a horizon line. I frequently find myself doing this on mountain slopes where, by dropping to a lower position, I'm able to frame my subject against blue sky. Conversely, in low wetlands, a higher angle may frame my subject against open water, and I can

avoid bisecting a subject with a distant shoreline. This can make a simpler image, especially if it frames the subject with a more pleasing and uniform tonality.

Be careful not to cut your subjects in half with a distant horizon. This can happen if you don't look beyond your subjects. This is especially noticeable when photographing birds and animals near water. If the dark line of a distant shoreline frames a great blue heron at midbody, try changing your perspective. By dropping lower, you might be able to raise the bird clear of the horizon line and frame it against the sky. Conversely, by extending your tripod's legs to their full height, you could frame the bird with water. Either way, you create a simpler and more attractive image than one in which the subject is split in two.

Left-right movements also shift perspectives. The old visual cliché of a pole sticking out of a person's head can be corrected by a simple lateral shift. This is quite easy to do when you're shooting in prairie country or similar open country, where distant telephone poles or fences can visually skewer an otherwise wonderful-looking image of a pronghorn antelope or elk.

Remember, it is important to not only look at your subject but also to study the area in front of and behind it for distractions or competing elements.

When changing your perspective isn't possible, minimize the depth of field to eliminate troublesome or distracting backgrounds. How much depth of field you'll need, of course, depends upon the lens, the aperture, and the working distance you're using.

NATURAL LIGHT

The quality, direction, and intensity of the light dictates how you'll record your subjects. Beginners often overlook this, considering light only in its role in exposure. Light should also dictate how an image is composed, which is perhaps best illustrated when we shoot scenics. Every photographer has been motivated to visit a scenic location because of the beautiful photographs taken of that special area. Like me, you've probably felt frustrated when the vista before you differs from the photograph that brought you there. Except for the light, all the elements could be identical—but if the light

TAWNY EAGLES, Masai Mara, Kenya. 500mm F4.5 lens, 1/250 sec. at ƒ/5.6, Kodachrome 64.

When the top of the tree is included (left), our attention, leaving the bird, has nowhere to go. How we see is better reflected when our eyes sweep up to the subject and stop upon reaching it (right). I based my exposure on a reading of a middle-tone outside the picture area because including the sky would have produced an underexposure.

300mm F2.8 lens, 1/125 sec. at ƒ/8, Kodachrome 64.

300mm F2.8 lens, 1/500 sec. at ƒ/11, Kodachrome 64.

I shot this heron perched on a bridge (far left) before kids scared it off. Luckily, the bird flew to another perch nearby. Backlit by the setting sun, the bird looked better than it had initially, and I took another frame (left). Then I noticed that the silhouetted legs of the bird merged with the horizon line. By moving in a little closer and dropping down, I raised the bird higher in the final shot (bottom).

300mm F2.8 lens, 1/500 sec. at ƒ/11, Kodachrome 64.

differs, everything about the scene changes and the photograph you seek simply isn't there.

Too often, amateurs see only the subject and not the light. Their attempts at making calendar-quality scenic images are disappointing because the essential ingredient, the correct light, is missing. Even the best compositions can be dependent on the nuances of light. Professional photographers recognize this and may wait days for just the "right" light.

The best light for scenics often is not a brilliant sunny ƒ/16. The shadows cast by direct sunlight can be very contrasty and harsh. If you are photographing landscapes in bright sunlight, use the lighting creatively. If the sun is behind you, use the foreground or a natural frame to convey a sense of depth. Change perspectives, so that the sun is no longer over your shoulder but instead strikes your subject at an angle that casts an interesting shadow. This also helps when you are using a polarizing filter (see page 125), since these filters work best when the sun is perpendicular to your subject. By changing perspective and rotating the polarizer, you'll notice dramatic changes in the contrast between

STELLAR'S JAY,
Yosemite National
Park, California.
300mm F2.8 lens,
1/125 sec. at ƒ/2.8,
Kodachrome 64.

*Animals and birds
can be photographed
in very low light with
slow ISO films if they
are still. A bit of luck
and a sense of timing
and anticipation can
help you catch a
normally active bird
during a brief second
of stillness.*

in direct sunlight. Remember, keeping a cloudy bright sky out of your picture is a good idea because of the differences in exposure between the sky and subject. If that is not possible, you may be able to use a graduated or *split neutral-density (ND) filter* to reduce the contrast in your scenic images (see page 124).

Inside jungles or woodlands, patches of bright sunlight and deep shade can ruin your images because of the great range in light values. In these areas, cloudy bright light is ideal because the extreme contrast between sunlight and shade is reduced under this diffused light. Conversely, with seascapes, contrast isn't usually a problem because water often mirrors the bright sky and requires a similar exposure.

Heavily overcast skies can lend a brooding drama to landscapes. In this light, both sky and earth can have a similar tonality, which you can check by taking a spot-meter reading of each area with your camera. If there is more than a one-stop difference between the sky and land, you may choose to reduce the contrast. You can use a split ND filter for this or simply compose to eliminate the brighter, distracting sky. Very overcast light can also create a bluish cast to film when it filters through a canopy of leaves inside a forest. An 81A or 81B *warming* filter adds a light yellow cast to this blue-green, filtered light (see page 126).

Perhaps the most striking photographs are made under what I often refer to as "magic light": the golden light of sunrise, the orangish hue of sunset, and the peculiar quality of filtered sunlight following an afternoon thunderstorm. The quality of this light is both different and beautiful, and produces images not possible in any other type of light. You can visualize this magic light if you think of the formation of a rainbow, a magical combination of sunlight and moisture. When sunlight and mist or rain meet, a rainbow may form, although you may not see it. However, you can anticipate the location of a rainbow and position yourself to include one in your photograph. A rainbow forms in mist or water droplets at a point approximately 45 degrees

any clouds and the sky you place within your frame. Of course, brilliant sunlight is often necessary when photographing wildlife when a fast shutter speed is required. However, even then, sidelighting or backlighting can make a more interesting image.

Learn to recognize the possibilities other light offers. Cloudy bright light is ideal for mammal portraiture, wild flowers, or any other subject where distracting shadows can pose problems. Landscape photographs, especially fall-foliage scenes, enjoy a saturation and lack of contrast under cloudy bright light not usually obtainable

opposite the position of the sun. If the sun is to your back, the rainbow will be at a 45-degree angle from your cast shadow, depending of course upon where the moisture is in the sky.

A rainbow doesn't last very long, so exposing for one is often a cause of high anxiety. It is really not difficult. Simply pick a middle-tone area nearby, and take a reflected-light reading.

You can make a rainbow bolder, too, by adding a polarizer. Rotate the polarizer until the rainbow is most distinct, and then take your exposure reading. Because there can be a difference in tonality between your middle-tone area and the sky, bracket by 1/2 or one ƒ-stop on either side of your base exposure to be sure you get it right and that you have a well-defined rainbow.

PRONGHORN, Yellowstone National Park, Wyoming. 300mm F2.8 lens, 1/125 sec. at ƒ/8, Fujichrome 50.

After an afternoon thunderstorm passed, a brilliant rainbow formed in the east. Although the rainbow was beautiful alone, the image needed a center of interest to complement the rainbow. On a distant hill, I spotted a pronghorn doe that I hoped to position in front of the rainbow. I ran uphill and arrived before the rainbow disappeared. (If you're out of breath, like I was, you're more likely to shake your camera while either focusing or when depressing the shutter. Use a cable release!) Exposure was based upon a middle-tone area to the right of the rainbow.

GNU, Masai Mara
Game Reserve, Kenya.
80-200mm F4 zoom
lens, 1/30 sec. at
ƒ/16, Kodachrome 64.

*Motion can be
depicted many
different ways. I used
a relatively slow
shutter speed and
panned with the gnu
as they ran. Panning,
especially at slow
shutter speeds, is
challenging. Don't be
disappointed if
your shooting ratio
is very low.*

FINDING A CENTER OF INTEREST

Most photographs have a subject or a center of interest, although this doesn't mean that your subject must be centered or stand alone. An entire field of flowers or a detail of fallen autumn leaves can be the subject, not just one single flower or one leaf. Although including a center of interest in your photographs seems obvious, they are frequently lacking in many compositions. This is especially true with beginners who are trying to imitate a calendar or greeting-card-style photograph of a forest floor or a macro landscape of leaves or pebbles. To avoid this, step back from your viewfinder and ask yourself what you find appealing in your image. Decide if there is a center of interest that is either obvious or hidden, and if it truly holds some interest.

Finding a center of interest when photographing wildlife is no problem, although the photographs you make may be boring because of the animal's behavior or the way you placed it in the frame. Still, most of the time wildlife photographers at least know what they are supposed to be seeing. However, centered animals, regardless of their activity, often appear static. This is especially true of animals that are stationary, but also applies, to some extent, to animals that are running or flying.

I've found that manually focusing on flying birds or running animals is so difficult that most of my sharp images end up being centered, though I consciously try to avoid it. To correct this, prefocus on an area and let your subject fly or step into focus. Fire at the instant before the subject moves into the zone of sharpness because there is a minimal lag time as the mirror flips up and the shutter opens. With practice, you'll find that you can anticipate the time to fire fairly accurately.

If this doesn't work for you, consider using autofocus. This could increase your chances of obtaining sharp images, though the compositions might not be exactly what you originally hoped for, since the focusing brackets operate only when your subject is centered in the frame.

To imply motion, try panning with your subject. Place the subject so that it flies or runs into the frame, instead of locating it in the center. You can further imply motion by using a shutter speed slow enough so that the background blurs as you pan. You must pan smoothly. Slow shutter speeds often produce jerky images because the camera has time to wobble as you pan. Limit most pans to no less than 1/30 sec. Because of their greater speed, shutter speeds of 1/125 sec. may be sufficient for flying birds.

When panning, both you and your subject must be in motion. The subject will blur if the camera is still when the film is exposed. For sharp images and smooth pans, start tracking your subject long before you expect to shoot. As you snap off one or several frames, continue your swing as you follow its progress. You may find this difficult to do when the camera's return mirror is constantly flipping up and blacking out the viewfinder. Practice helps. Try panning with bicyclists at a park or with a cooperative dog you can coax into repeatedly running past you.

Panning is most effective when your subject is traveling perpendicular to you. Anticipate the position where you expect to fire, and plant both feet facing that direction. Twist in the direction the subject is coming from, so that you'll "unwind" into a more comfortable shooting stance that faces your subject at the moment of firing. Although I use a tripod when I pan with my 500mm lens, I frequently hand-hold the 300mm lens and all smaller lenses. Hand-holding the camera provides a smoother pan.

Another way to make a "boring" animal interesting is to shoot a closeup. Frame-filling detail is always intriguing. Tight closeups have other advantages, too; they eliminate contrast, distracting backgrounds, and such unattractive aspects of the subject as partially molted fur, bands on bird legs, or withered flower heads.

If you can't fill the frame with your subject, consider positioning it at a point of power. These power points are easy to determine within a 35mm frame. First, divide the frame into three equal sections by drawing two imaginary lines

When a rectangular format is divided into thirds, the points of intersection mark the points of power.

AUSTRALIAN WHITE PELICAN, Queensland, Australia. 300mm F2.8 lens, 1/30 sec. at ƒ/2.8, Kodachrome 64.

The pelican is positioned in an upper-left power point to simplify the composition. Had I placed the bird in the lower half of the picture, the distant shoreline would have been visible and distracting. I based the exposure on an incident-light meter reading and closed down one half-stop to compensate for the white bird.

THE LIMITATIONS OF DEPTH

How shallow can the depth of field be? With a Nikon 200mm macro lens focused at 2.3 feet, depth of field ranges from 1/16 inch at $f/4$ to about 1/2 inch at $f/32$. At 20 feet, depth ranges from 9 inches at $f/4$ to about 6 feet at $f/32$.

Based on the aperture for the wildlife equivalent for a mid-tone subject, at $f/5.6$, depth of field is only 13 inches when the lens is focused at 20 feet! With a longer lens, the depth of field is even less. For example, with a 300mm lens, depth of field is only 5 inches at $f/5.6$ when the lens is focused at 20 feet.

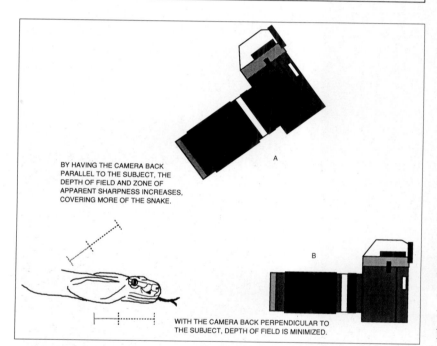

BY HAVING THE CAMERA BACK PARALLEL TO THE SUBJECT, THE DEPTH OF FIELD AND ZONE OF APPARENT SHARPNESS INCREASES, COVERING MORE OF THE SNAKE.

WITH THE CAMERA BACK PERPENDICULAR TO THE SUBJECT, DEPTH OF FIELD IS MINIMIZED.

Camera B's depth of field could extend from the snake's snout to its jaw if a small aperture was used. Any portion that extended beyond the jaw would be progressively more out of focus.

Camera A's depth of field extends beyond the jaw and would include more of the snake within the zone of apparent sharpness.

Study the area both in front of and behind your subject. *Hotspots*, or unattractive bright areas within your image, distracting colors, out-of-focus objects, and foreground blurs can draw your eye away from the subject. Sometimes these distractions are visible only when the lens is closed down. Always use your depth-of-field preview button to check for them unless you're sure that nothing is distracting within your frame. This is critical in photomacrography, where grass blades or similar obstructions in front of the lens are invisible when the lens is wide open.

Foreground distractions are usually more bothersome than those in the background.

Fortunately, these are fairly easy to notice; you tend to overlook the background ones. Think about it: You notice any pole that sticks up in front of the subject, but you often miss a pole that sticks out of the subject's head. Always make a special effort to look beyond your subject and to study the background, too.

USING SHAPE AND FORM

Repetitive shapes can be interesting and can offer a solution to the problem of where to cut off parts of a subject. In clusters of identical objects, none need be complete if there are enough parts of each to imply one whole object. For example, a closeup of a cluster of daisies might not include a single complete flower, but the partial, repeated shapes of several clearly convey the form of a single flower.

With animals, it is sometimes difficult to decide what parts of an individual can be cropped out of a picture. Don't arbitrarily cut off part of one animal just because another is completely within the frame. Instead, try to include significant portions of each. If a part of one is arbitrarily cut off and the others are whole, the image has a sense of incompleteness or imbalance to it. For example, you might be so intent on filling your frame with a wonderful portrait of a lioness that you ignore another one whose head and neck protrude into your frame. Your image will be stronger if you reframe to include both, which can require switching to a smaller lens or backing up, or by composing in such a way that both heads and necks are attractively included in a complementary, mirror-like manner.

Sometimes you can create diagonals, which are often more interesting than straight lines, if there is no true orientation visible, such as a horizon line or a tree. This won't work with subjects where you usually have a frame of reference, such as a group of trees, but it may work with closeups that are basically abstract. A detail of a moss or lichen bed or a closeup of a cluster of cattails can be more interesting when

angled off a straight up-down orientation. Additionally, you can use diagonals and lines to draw the viewer's eye toward a center of interest.

Focusing sharply on the closest of several similar objects naturally draws a viewer's eye because our attention is frequently drawn to the nearest object. If I'm photographing a flock of shorebirds on a beach, I often focus on those closest to me, as I let the birds farther back recede into soft, blurred shapes. This is also practical because subjects at various distances might not be sharp even when you're using a small aperture. Remember, depth of field is dependent upon both image size and working distance, and the distance between objects can be too great to bring everything within focus.

The most effective way to deal with multiple subjects or with one subject that requires a great depth of field is to change your perspective so that everything important falls within your depth of field or within the zone of apparent sharpness. With a flock of birds or herd of mammals that spans a large area in your viewfinder, this usually requires a shift to the left or right to align the majority of the group at the same focusing distance. If you're filming just two or three animals, you could have to wait until one of the animals moves out of the frame.

With plants, scenics, or macro subjects, maximizing the depth of field can involve making vertical changes to ensure that both your film plane and your subject are parallel. Although most cameras have a small mark on the top of the camera body that indicates the film plane, it is really easier to use the camera body to see if the two are parallel. Simply step to the side and note the position of the camera back or the front of the lens to the lines of your subject. If they are parallel, or nearly so, you'll be using your depth of field most effectively.

FRAMING THE IMAGE

Because film is two dimensional, composing silhouettes creates problems if one black form merges with another to form a featureless blob. Although your subjects are three dimensional, film can't record their different positions vis-à-vis

LIONESSES, Masai Mara Game Reserve, Kenya. 400mm F2.8 lens, 1/125 sec. at ƒ/8, Kodachrome 64.

Originally, a third lioness sat behind these two. With the narrow depth of field of my 400mm lens, the third lioness was soft and would have detracted from the composition. Luckily, she lost interest and moved off, leaving the two that had maintained a reasonably parallel plane with my camera. A reflected-light reading off the cats determined the exposure.

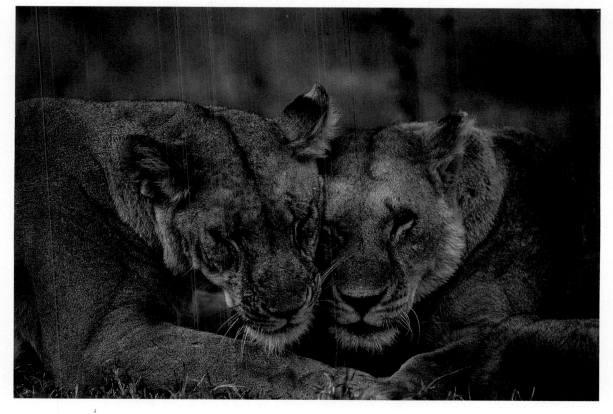

AFRICAN ELEPHANTS,
Masai Mara Game
Reserve, Kenya.
500mm F4.5 lens,
1/500 sec. at ƒ/16,
Kodachrome 64.

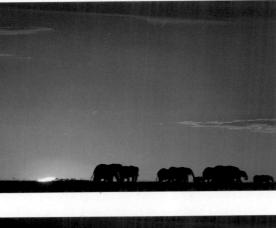

Instead of using the rule of thirds, this elephant landscape covers only the bottom 1/8 of the frame. Silhouettes must be separate in order to maintain their distinct outlines, otherwise they blend into a single blob (top). The elephants were walking along a small ridge, and we had to constantly reposition our van to keep the animals aligned with the sun and high enough on the ridge that their legs were visible (bottom). Without the low angle, the legs of all the elephants would have merged with the outline of the horizon and disappeared. For this exposure, I metered the bright sky, excluding the sun. I then overexposed by one stop to bring up the brightness.

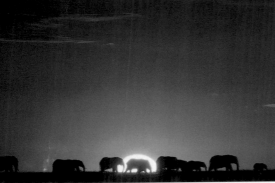

A CHECKLIST FOR COMPOSING EFFECTIVELY

1. Find a center of interest.
2. For easy compositions, fill the frame with your center of interest.
3. Follow the Rule of Thirds. Don't arbitrarily cut a scene in two.
4. Position your center of interest at a point of power on the Rule of Third's grid.
5. Include all important elements of your subject within your frame.
6. Remember that you can't make a silhouette against a silhouette.
7. Use your depth-of-field preview button when positioning the subject in relation to the film plane .
8. Eliminate foreground and background clutter. Sweep the edges for distractions.
9. Simplify compositions, but if you "garden," do so selectively and ethically.
10. Use natural frames or selective focus.

the camera, which is, however, apparent to stereoscopic human eyes. Try as you might, you can't make a silhouette against a silhouette!

With your attention riveted by your subject, you may overlook distractions or merging elements within the frame. To eliminate these, simplify your composition by doing closeups, using a shallow depth of field, or, if your subject is moving, by panning at slow shutter speeds to blur stationary objects.

Some photographers take this idea of simplicity too far, moving subjects to the studio and using neutral-gray or colored backgrounds to eliminate background distractions. Instead of removing your subject from its natural habitat, study your image to look for distracting elements you could remove. Dried grasses, leaves, or light-colored twigs often reflect more light than a middle-tone subject, and these hotspots can draw the viewer's eye from your center of interest. Removing this distracting clutter, often called "gardening," simplifies many macro and plant photographs. If you do garden, don't remove living leaves or flowers, or otherwise destroy plants or habitats just to clean up a picture! Common sense and ethics demand that you treat every living thing with as much value as the subjects you choose to photograph.

You can use potential distractions in the foreground creatively. With a shallow depth of field, you can selectively focus on the center of interest. Out-of-focus areas become amorphous spots of color when a long lens, a shallow depth of field, and, in most situations, a short working distance are combined. Photographers frequently use this *selective-focus* technique in flower photography, but it can also be used with animals or birds when conditions permit.

In contrast, foreground elements that are sharply in focus can be used as natural frames. Tree limbs, rocks, or other "strong" elements are candidates. Be careful, however, that the object you use as a frame is visually interesting. A straggly, thin branch jutting into the top of your picture may look like a frame to you, but to everyone else it may be a distraction.

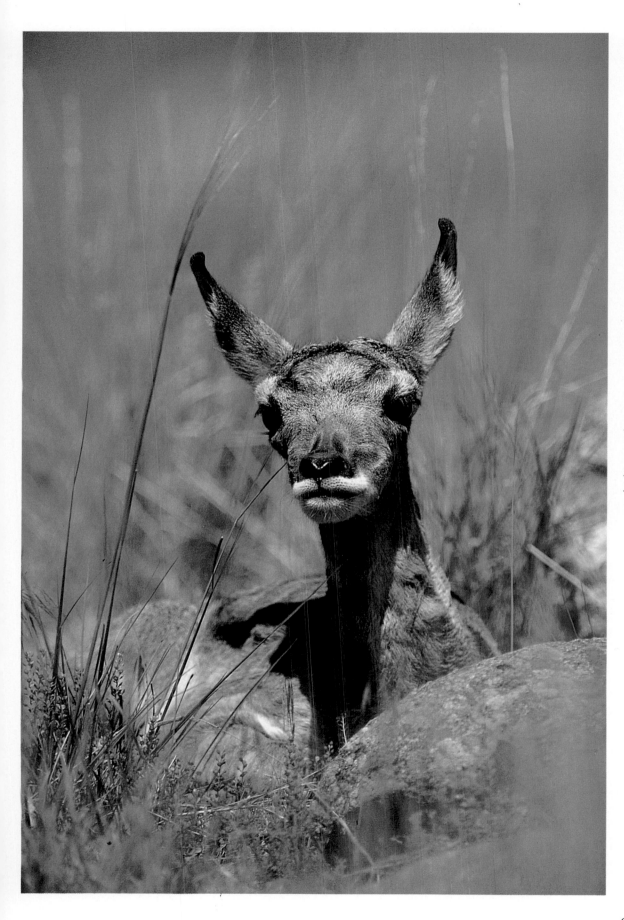

PRONGHORN FAWN, Yellowstone National Park, Wyoming. 500mm F4.5 with 1.4X teleconverter, 1/250 sec. at *f*/5.6.

I needed all the working distance I could get in order to not disturb this hidden pronghorn fawn. By keeping our distance, the fawn relaxed from its huddled protective crouch to look up and explore its world. I obtained a large image size by adding my 1.4X teleconverter to a 500mm lens for a 14X, 700mm image.

By staying low and keeping my distance, I avoided frightening the fawn and I was able to incorporate selective focus with the foreground grasses to softly frame the image.

VISUALIZING A SPARROW

In one of the salt marsh islands on Delaware Bay, you discover a friendly seaside sparrow that has accepted your presence near its nest. Although the female deserts the grasses when you approach, both mates quickly return to the area. You know that the nest is hidden somewhere within the matted tussocks close by. The male is obviously defining its territory, for every few minutes it flies to another clump of grasses to sing its insect-like song. Sometimes the bird is only a few yards away, but in the grasses it is very hard to see or photograph.

Challenges:

- What is the best method to capture the birds on film?
- Will working the nest present any dangers to them?
- In what way can you exploit the male's urge to sing from its various territorial perches?
- How can you create a strong composition with these visual elements?

During one of the many slow periods while one of my photo-tour groups waited for the tide to ebb and our migrating shorebirds to return, I stumbled onto the nesting area of this seaside sparrow. An inhabitant of deer fly and mosquito-filled salt marshes, this sparrow is rarely seen up close. I've seen only a few and had never photographed one.

It was tempting to set up a camera at the bird's nest, because it was fairly likely that one or both birds could be photographed there. Although I was within six feet of the nest a number of times, I couldn't see any sign of the nest in the thick, low grasses; I also knew that parting the grasses to search could destroy the nest. (If I have a choice, I prefer not to take the responsibility of photographing a bird at its nest. It has been done numerous times and if it is not done right, it can lead to the death of the eggs or young.)

While observing the male singing, I devised a simple solution. The male always sang from the tallest grasses along its territorial boundary. I suspected that if I placed a perch at or close to one of its usual singing locations, I could entice it to sing at

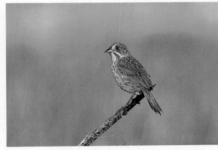

500mm F4.5 lens, 1/500 sec. at f/5.6, Kodachrome 64.

500mm F4.5 lens, 1/500 sec. at f/5.6, Kodachrome 64.

500mm F4.5 lens, 1/500 sec. at f/5.6, Kodachrome 64.

the new perch. It took only a few minutes to locate some sturdy reeds, and a half-hour wait to discover that my hypothesis was correct.

I decided to switch props after the sparrow visited a couple of times. I used different reeds, sticks, and pieces of driftwood, and the singing male accepted each as it was presented. After a time, inspiration struck: I had a visual image of the perfect photo, the "definitive" seaside sparrow image, one that said "this bird lives in the salt marshes of the seashore."

To shoot this, I placed the hollowed shell of a horseshoe crab's exoskeleton on the bird's latest perch, a weathered section of post. The spike of the crab's tail and the thorn-like projections of the shell would, I felt, be visually interesting for those who knew what they were seeing, and intriguing to those who didn't. As I expected, the bird quickly accepted the new perch.

In the top far left picture of this perch, the bird is small and centered. From my angle, the background was divided by a line of beach visible above the out-of-focus salt marsh. By moving the bird to a point of power and raising my tripod slightly, I eliminated the two-tone background in the top near left photo. This also added a bit more interest, although probably not enough to hold anyone but a birdwatcher's attention. In

500mm F4.5 with 1.4X extender (700mm), 1/250 sec. at f/5.6 with TTL teleflash, Fujichrome 100.

the bottom left shot, I centered the bird again, but by including the crab's shell, I added significantly to the image.

At the very end of my shooting session, the sparrow flew to a nearby stump, where I photographed it, above, using a 500mm lens with a 1.4X teleconverter. Luckily, a wind wasn't blowing off the nearby bay, otherwise the extreme magnification, 14X, would have resulted in a soft image, despite the use of flash. I based this exposure on an ambient-light reading and closed down one half-stop from that setting. The TTL flash, however, used the set aperture, which resulted in a bird that attractively stood out from the background.

HANDLING CONTRAST

What you see and what film records often differs. This is evident from the way contrast varies between human sight and what appears in a picture. Unlike your eyes, which can instantly adjust to changing light levels, the slow ISO color-slide films favored by most nature photographers can't expose accurately for these extremes in tonality. If you base an exposure on a bright area, the dark areas will be underexposed. If you base an exposure on a dark area, the bright areas will be overexposed. Averaging the two usually results in unsatisfactory compromises.

Of course, any "correct" exposure is subjective. Visualize a lioness perched on a hill against a sunset. The animal should appear dark because it is framed by a bright sky. However, the image

BLUE GROUSE, Olympic National Park, Washington. 500mm F4.5 lens, 1/250 sec. at ƒ/4.5, Kodachrome 64.

Dappled, diffused sunlight created a beautiful light on this cooperative grouse, while harsh, noonday sun bathed the high country only a few feet away. Occasionally, contrast is eliminated or reduced by natural factors, but when it isn't, there are a number of ways you can effectively control the situation.

can be exposed several ways. By taking a reading off the cat, you can achieve detail in its otherwise dark shape, but the sky will be overexposed. Conversely, exposing for the bright sky produces a silhouetted cat that more closely resembles what you actually see. Averaging the two contrasting tonalities won't work because the range in exposure is just too great for both to be rendered properly. Many photographers would choose the exposure that produces a silhouette because it most closely matches what their eyes see. Which exposure you prefer is a matter of taste.

Frequently, contrast in your subject is subtle and more difficult to recognize. Imagine, for example, a bird perched in partial shade. You "see" the bird without recognizing that only part of it is in sunny ƒ/16 light and is three ƒ-stops brighter than the part of the bird that is in the shade. Your film records this difference in light, resulting in a contrasty photograph where neither of the two tonalities is properly exposed. Once you learn to recognize contrast, you can use it to your advantage, reduce it, or even eliminate it. These choices involve one or a combination of simple techniques that can improve your photographs.

REDUCING CONTRAST WITH REFLECTORS AND DIFFUSERS

You can reduce or eliminate the contrast visible in your subjects in a variety of ways. Remember that electronic flash can fill in shadows and dark backgrounds. You can also use mirrors, crinkled aluminum foil reflectors, and the white side of a gray card to bounce light into shaded areas. And frosted plastic panels are good for diffusing and scattering direct sunlight that falls on a subject. Each method produces a slightly different effect in lighting, and each has its special applications.

LIONESS, Masai Mara Game Reserve, Kenya.

Eliminating contrast may require changing perspective. First, I based my exposure on the cat and overexposed the sky at sunset (far left). Then I metered the sky and underexposed the cat (left). This produced a better picture, but left the cat in silhouette. Finally (bottom), I simply moved the van to position her against a less contrasty background and based my exposure upon a reading off the cat.

300mm F2.8 lens, 1/30 sec. at ƒ/2.8, Kodachrome 64.

300mm F2.8 lens, 1/125 sec. at ƒ/5.6, Kodachrome 64.

300mm F2.8 lens, 1/60 sec. at ƒ/3.5, Kodachrome 64.

A mirror reflects light directly, creating a spotlight effect. In photomacrography, when only a small area is involved, a single small, concentrated square of reflected light can be used. Two or more mirrors, or mirrors and diffusers used together, may be necessary to produce even, natural-looking lighting over a larger area.

Mirrors are easier to use than flash because you can see the effect you're getting. If you don't like the effect, you can simply rearrange the mirrors. With flash, you must rely on your own experience to previsualize the desired effect. Another advantage is that mirrors have many applications. I've used mirrors to illuminate snakes hiding inside rock crevices, to bounce sunlight onto the underside of mushrooms, to fill in the shaded cups of drooping flower heads, and to catch the brilliant cobalt blue of a fence lizard's belly. You can work with smaller ƒ-stops if you use mirrors, even on an overcast day or in the dull light that immediately follows sunrise. I've used that extra light at dawn to add brightness to the color of dragonflies and spiders that were still torpid from the night's chill. This actually

increased the contrast between the subject and its background, but still improved the final image.

Here is an unusual example of using mirrors in the field that involved an eastern bluebird nest. I aimed five small mirrors toward the bluebird's nest hole, which raised the light level there to just one stop less than sunny *f*/16. This balanced well with the patch of sky visible

If you don't recognize contrast, you may produce an image like this underexposed kookaburra (right). Although a small sliver of sunlight reached the bird, it was not enough to balance with the bright, sunlit areas visible behind the bird. To create a less contrasty picture, I used a TTL flash mounted on a teleflash bracket (below).

**BLUE-WINGED
KOOKABURRA,**
Kakadu National Park,
Australia.
500mm F4.5 lens,
1/250 sec. at *f*/5.6,
Kodachrome 64.

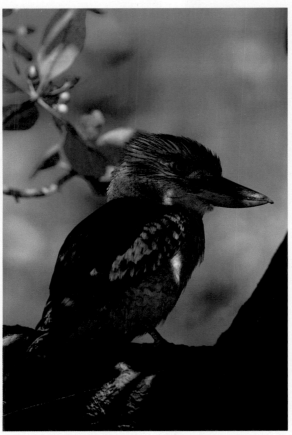

behind the nest. Additionally, this directed sunlight revealed the male's brilliant blue plumage that had appeared dull when it was in the shade. The bluebird was completely oblivious to the change in light around the nest, which wasn't surprising, because the nest hole was exposed to direct sunlight late each day. However, during the two hours I worked, I had to readjust the mirrors continually as the sun arched across the sky. The sunlight passed beyond the nest hole every ten minutes and changed the *angle of reflectance*, or the angle that the sun reflected off the mirrors.

Small Plexiglas locker-room mirrors, which are available at school supply and grocery stores, work well in most cases. For larger subjects, safety mirrors sold for cribs or playpens are a good idea. Don't use glass for obvious reasons. A workshop participant suggested using polished squares of stainless steel because they are unbreakable and are less likely to be scratched than a plastic mirror. A final precaution: Be careful when using mirrors to redirect sunlight at your subject. Keep in mind that you are aiming direct sunlight that can overheat or desiccate a subject in shade just as in direct sunlight. This can kill a flower, a reptile, or any heat-sensitive subject that is normally found in shade or that seeks shade when necessary. Reptiles may show their growing discomfort by opening their mouths and panting. Other animals and plants aren't so obvious.

Aluminum reflectors made of woven aluminum fabric or crinkled foil work in much the same way as mirrors, although the light cast is a bit "softer" and more scattered. If you make a reflector with aluminum foil, make sure that you crinkle it first, otherwise the smooth sheet acts like a mirror. I generally carry several homemade aluminum reflectors that I adhere to thin cardboard with rubber cement. These reflectors are flexible, so I can easily bend one to bounce light in a specific direction. A homemade reflector lasts about a year, but it is the cheapest piece of camera equipment I ever need to replace!

*By positioning two
aluminum reflectors
on the shaded side
of this box turtle
(below), I increased
the light until it
was equal to the
illumination on the
turtle's sunny side.
Aluminum reflectors
can cast specular
highlights, visible on
the turtle's beak and
face (right). I didn't
use a tripod because
I was able to rest my
camera directly
upon the ground.
The exposure was
based upon a sunny
ƒ/16 calculation.*

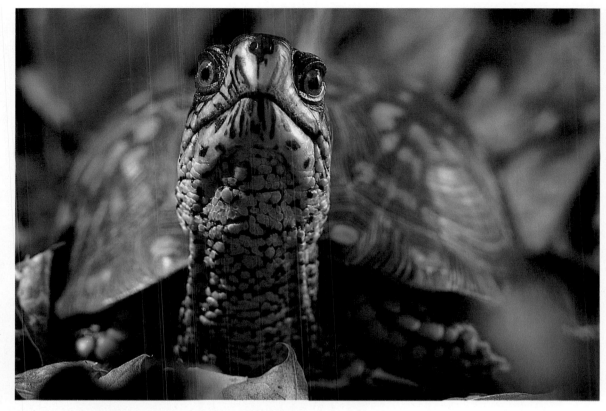

Several manufacturers offer collapsible reflectors in silver, white, black, and gold. The smaller sizes are most useful for nature work, the larger sizes for adding fill light for portraiture. Silver and white reflectors are excellent for general nature and wildlife work, functioning like white paper or aluminum foil. I use a gold reflector when I'm photographing people. The gold reflector fills in shadows and reduces contrast with a very "warm," pleasantly toned light. Black reflectors are also available. These absorb rather than reflect light and actually increase contrast. Photographers interested in portraiture find this useful for *Rembrandt lighting*, a contrasty light style where the shaded area lacks all detail.

White paper or white plastic can also be used as a reflector to create a softer illumination than an aluminum reflector casts. I often use the white side of a plastic gray card for this because it reflects almost the same quantity of light as a crinkled aluminum foil reflector. Where aluminum may cast *specular highlights*, or bright spots, on subjects such as turtles or frogs that have wet or otherwise highly reflective surfaces, white reflectors are less likely to do so.

You'll have less fill light the farther you hold a reflector from the subject. In contrast, a mirror reflects usable light a much greater distance. You can actually increase the ambient light to greater than sunny ƒ/16 (the brightest natural light that falls on a middle-tone subject) by using a couple of aluminum reflectors and mirrors together.

Diffusion screens also reduce subject contrast by scattering direct sunlight. I use lightweight plastic fluorescent panels, which are available at

DRAGONFLY
(emerging from
nymphal cast),
McClure,
Pennsylvania.
200mm F4 lens,
1/30 sec. at *f*/16,
Fujichrome 100.

*The metamorphosis
of a dragonfly
requires the insect to
climb out of the pond
and emerge from
its aquatic nymphal
exoskeleton. A
number of minutes
elapse before the
adult dragonfly's
wings harden and
the insect is capable
of flight. During this
time, a dragonfly is
an extremely
cooperative subject.
I used a plastic
diffusion screen over
the insect to soften
the harsh direct
sunlight, and two
mirrors braced on
chunks of wood that
I positioned nearby.
I based the exposure
upon the camera's
spot-meter reading
of the nymph's
exoskeleton.*

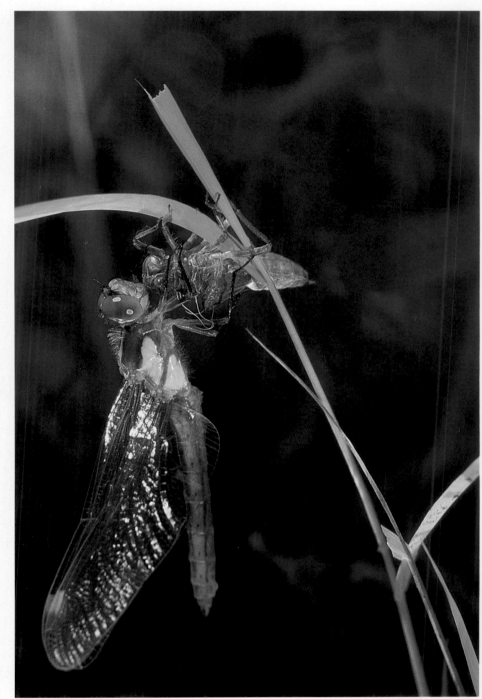

most hardware or home-supply stores. These diffusers have some flexibility, so by bending the plastic I can change both the direction and the intensity of the transmitted light. The exposure is reduced by one-third to one full *f*-stop, depending on how I hold the diffuser.

To determine your exposure when using these accessories, take a reflected-light reading off your subject when the diffusers, reflectors, or mirrors are in place. If you're using an incident-light meter, hold the meter close enough to the subject so that the bulb or metering face is in the same light. Don't use any of the sunny rules when you work with reflectors and diffusers. I find it too difficult to guess accurately how much light is being reflected or bounced onto a subject.

FOREGROUND AND BACKGROUND CONTRAST

You may wish to simplify a composition by reducing the contrast in the foreground or background too, because hotspots or multiple highlights in these areas can draw the viewer's attention away from the subject. By eliminating these hotspots, you simplify the composition and the subject stands out. You can do this a couple of ways. You can "garden out" the bright area, or you may be able to shade these bright, competing areas with a cloth, a tarp, or an article of clothing. If you shade the hotspots, your viewers' attention will be directed to the brighter subject.

Conversely, your choices of lens and perspective can also increase the contrast between a subject and its surroundings. It is possible to frame your subject against a dark background by using a long lens' narrow angle of view. When there is no natural dark background, substitute one by using an item of clothing, a camera pack, or a log or rock as a shaded background. Similarly, a longer lens and a sufficiently shallow depth of field can soften a busy, contrasty background as highlights and shadows merge into one pastel blur. The sharply focused subject stands out.

Some photographers take this one step further by framing macro subjects against artificial middle-tone backgrounds. Macro subjects, especially insects and spiders, are frequently shot with flash, and backgrounds often appear unnaturally black. Occasionally, green, blue, or gray cardboard is used to provide a light, "natural" background to eliminate this effect, but I think the results of using these colors often looks contrived. Use a natural prop, such as a flat piece of bark, a large leaf, a rock, or log, so that an artificial background isn't necessary.

For another effect, some photographers use enlargements of out-of-focus flowers or plants as backgrounds for macro subjects. If you try this, be careful that your subject's shadow isn't cast onto the background. The photograph will look artificial if it does. To avoid this, either aim the flash so that the shadow casts downward and misses the background, or use two flashes, one aimed at the subject and the second directed at the background, for natural, even lighting.

Black backgrounds do look natural with nocturnal, or night-active, animals, such as skunks, opossums, flying squirrels, and owls that are illuminated by flash. But in the field, a single flash unit can cast a visible, unattractive shadow against a nearby background. Although you might not be able to see this, you should assume that a shadow will be visible if your background is within a couple of feet of your subject. To reduce this shadow, position the flash so that any shadow is cast downward or away from the background, or use two flashes on opposite sides of the camera to fill in the shadows a single flash casts.

In a studio setup, use a black, nonreflective cloth for a natural-looking background for nocturnal animals. Hang the cloth back far enough so that it receives less light than the subject. Use the Inverse Square Law or a flash meter to be sure that the background receives at least two stops less light. If the subject's exposure is $f/11$, the black background should be $f/5.6$ or less. The background will appear a "natural" black and not gray. To convey a sense of depth and authenticity in the studio, include leaves, branches, or logs as props. Place them far enough back so that they're also underexposed by a stop or two less light.

USING DIFFUSION TENTS

Some photographers advocate using white parachute cloth, propping up the center to form a teepee-like hood in order to cover large areas of a forest floor. Special diffusion tents are made for this. A tent can also eliminate, or at least reduce, the detrimental effect a light wind has on obtaining sharp images. Be careful when you use any type of diffuser in a wind. A tent or plastic screen can blow over and onto your subject, and perhaps destroy it in the process.

CONTROLLING CONTRAST WITH FILTERS

Contrast is a particularly common problem with landscapes under overcast or cloudy skies. A cloudy bright sky sometimes reflects two or three stops more light than the land below, and even a heavily overcast, gray-looking sky can be a stop brighter than the earth. Photographing under blue skies can also create extreme contrast problems: for example, when photographing a stream bottom or canyon where one side is in the sun and the other is shaded. This type of contrast can be handled two ways. The easiest way is to simplify the composition by using a longer lens to exclude the bright sky or the bright side of the canyon or stream. By excluding the area of higher contrast, the image gains a more uniform tonality and a more pleasing exposure. You could end up with a more interesting, closer view of the scene, too.

How do you include the entire scene, both the earth and the sky, within the frame, even if there is a three f-stop difference between the two tonalities? A "normal" exposure will produce unsatisfactory results; however, there is a solution. For extreme contrast problems, use a split or graduated neutral-density (ND) filter to reduce this contrast. These filters are divided into two sections, one clear and one tinted. The tinted half of the filter cuts down on the light passing through it, and you position this over the brightest area of the scene. The clear half of the filter, which does not affect the exposure, is positioned over the darker area of the scene.

Split-density filters are usually round, and most are divided equally into two hemispheres of clear and tinted areas. Using one means you must compose a scene with either the horizon or the line between the light and dark areas centered in the frame, which could compromise your composition. Split-density filters screw onto a lens like any normal filter, and they are usually less expensive than graduated filters.

Graduated filters, as the name implies, provide a gradual transition from the clear to the tinted areas. They are available in two shapes, round or rectangular (or square). Both can be rotated on the lens for vertical compositions and subjects. To accommodate your composition, the square or rectangular filters slide up or down inside a special bracket that is attached to the lens. Ideally, lining up the gradation line at an obvious separation won't require splitting the image into two equal halves.

Both types of filters come in a variety of colors and tonalities. ND filters reduce contrast without affecting the true color of your scene. In most cases, a two f-stop graduated ND filter can lower the contrast between earth and sky so that it falls within the exposure latitude of your film. You can use two or more filters together to increase the amount of reduction needed.

Depending upon the filter or the combination of filters you use, the reduction of light is usually between one and four f-stops. To determine your exposure, read the darker area of the scene, the part that will be covered by the clear glass. Set the exposure based on that reading. Then position the filter so that the filtered half covers the brightest area of the image, and the bright area will be toned down accordingly.

ND filters are also useful when a slow shutter speed is needed for panning or for deliberate blurs. Additionally, you can use ND filters to produce *angel hair* on rapids or waterfalls when the ambient light is too bright for you to use a sufficiently slow shutter speed. This effect is the creamy white or cottony look that is created when you photograph moving water with a slow shutter speed.

The square, graduated filter slides inside the filter bracket mounted to the front of Mary Ann's zoom lens. To insure a sharp image, she will remove her left hand from the focusing barrel before she trips the shutter with her cable release.

AFRICAN ELEPHANTS, Masai Mara Game Reserve, Kenya. 35-70mm F2.8 zoom lens, 1/125 sec. at ƒ/5.6 with polarizing filter, Kodachrome 64.

Polarizing filters are very useful on sunny days for photographing animals in habitat, your "wildlife scenics." For the filter to be effective, the sun must be at an angle to your subject, not directly over your shoulder. If you don't base your exposure on an in-camera reading, remember to compensate by one to two f-stops for the light loss when you use a polarizer.

Polarizers can also be used as ND filters. You'll lose one or two stops, depending on the rotation of the filter, by mounting one on your lens. If your main interest is wildlife photography, don't keep a polarizer permanently attached as you might do with a *skylight* filter. The one or two stops of light you lose could have been used for obtaining better depth of field or for using a faster shutter speed.

Some photographers regularly shoot through UV and skylight filters, while others do not. These filters, which don't affect exposure, are designed to reduce haze and improve contrast. Although most of my lenses have a skylight filter attached, I don't shoot through them but use them as very reliable lens caps. My lens caps often pop off, and the front lens element could be scratched when bouncing around inside my pack. Filters stay on, and my lenses are safer with them. Of course, these filters become smudged and scratched, and you must remember to remove them before you shoot. Occasionally I forget, and the images that result reflect this.

Polarizers have several other applications besides that of an ND filter. Their most common usage is in scenics to emphasize clouds. However, to be effective, the sun should be in a perpendicular position to the subject. As a guide, point your index finger at the subject and your thumb toward the sun. The polarizer

works best if your thumb forms a right angle to the line of your finger, as if you were pointing an imaginary pistol. Skies will appear darker or bluer and clouds will "pop" out. (Be careful with Fuji slide films. Many photographers agree that Fuji's blue skies look better without polarization.)

Polarizers can remove reflections from water or glass. When photographing streams or lakes, I've used them to reveal fish by eliminating the glare of the reflected sky on the water. In swamps, this produces inky black water, which creates a striking contrast with the surrounding vegetation. Polarizers also eliminate the waxy, reflective sheen on leaves, thereby producing snappier colors and greater saturation in scenics, plants, and macro landscapes. They can also increase contrast in scenics where you want to emphasize the ruggedness of terrain by eliminating some of the fill light in shadows.

Polarizers also come in handy at zoos, aquariums, or in-home setups when you want to avoid reflections from glass. Photography in these locations usually involves flash, but the correct polarizer for your camera system won't affect a TTL flash system. Manual flash requires compensation, so bracket by a stop or two to be sure of a good exposure. Be careful how you position the flash when shooting through glass. The flash must be set at an angle—that is, taken off the hotshoe—or the flash illumination will reflect directly back from the glass. Polarization cannot remove this!

Polarizers can be your most useful filter, and I recommend every photographer having at least one. Because polarizers are expensive, buy a filter that fits your widest diameter lens, and then use step-up rings to fit this large filter to your smaller lenses. Two types of polarizers are available, *linear* and *circular*, and the metering and autofocus systems of many autofocus and electronic cameras require the more expensive circular filter. Most manual-focus cameras use linear filters. Either filter can be used on either camera, although this may require using manual focus and making exposure readings based on

When a lens hood
doesn't provide
enough shade,
improvise! Make
sure that the item
you use to cast a
shadow doesn't
appear in your
photograph. That
isn't likely to happen
unless you're using a
short focal-length
lens. (photo: Mary
Ann McDonald)

an incident-meter reading. A linear polarizer can confuse an autofocus sensor and the exposure system. Remember, an incident-meter reading won't reflect the one or two *f*-stops lost to polarization. You'll have to open up off the incident reading by one or two *f*-stops.

A variety of color filters is available, virtually covering the colors of the rainbow. Some photographers consider their use manipulative and artificial. Others enjoy the creativity that the added color provides. Whether you choose to do so will depend on your own style of photography.

Finally, I often use an 81A or 81B as a warming filter when I'm photographing in a deep forest. Light passing through a canopy of leaves may look bluish or greenish on your color film, and a warming filter helps to eliminate this. At times, I also use an 85A, a yellowish-orange filter, to add extra punch to a sunrise or sunset. When I film reflections of the sky or sun, I sometimes use a graduated orange or sunset filter to add extra color. The results are attractive, even if the color has been enhanced.

In addition to controlling contrast by using filters, you should also use a lens hood to shield the front of a lens from direct light, be that either sun or flash. Direct light scatters and causes flare when it strikes the front element of a lens, or it may concentrate into weird ghostly shapes that are light shadows of the aperture. Either one ruins a picture.

A lens hood is unnecessary if your light source is behind the camera. Even so, it is better to always keep a hood attached and extended because the hood offers some protection against dust or scratches and may act as a cushion if you should drop a lens. I remove my lens hood if I'm photographing in high winds, since a long lens hood increases the surface area exposed to the wind and increases the chances of having camera shake. However, if blowing salt spray, sand, dust, or direct sunlight might strike the front element lens, I keep the lens hood on and attempt to weigh down the camera and lens assembly to provide extra weight and stability.

Both metal and collapsible rubber hoods are available. Metal hoods provide more protection if you should drop a lens, but rubber hoods are easier to carry because they flip back over the lens when they're not in use. Different focal lengths require different lens hoods. You can use long telephoto lenses, with their narrow angles of view, with very deep hoods. Wide-angle lenses require shallow and very wide hoods, so that the hood doesn't show up as dark corners in your image. This problem, called *vignetting*, can also occur when you use thick filters, or a lens hood and a filter together. You can check by using your depth-of-field preview when the lens is stopped down to its smallest aperture. If vignetting results, remove either the filter, the hood, or both. If you don't have a lens hood with you, try shading the front element by holding your hand out of view above the lens. This works just as well as a lens hood in preventing lens flare. Just be sure that your hand doesn't appear in the picture!

THE BLACKTAIL RATTLESNAKE

In the foothills of Arizona's Chiricahua Mountains, you discover a large blacktail rattlesnake coiled in the shade of an alligator juniper tree. It is midafternoon; the sky is clear and the light, in open areas, is sunny ƒ/16. Wisely, you don't consider handling the snake, but you're concerned that the low light in the shaded areas will be too slow for a good exposure.

Challenges:
- What is your primary concern when working with this subject?
- What lens will you choose?
- What type of light will you use to brighten the dull, shaded snake?

On a warm June day, I discovered this blacktail rattlesnake lying in the shade of a tree. Although I was carrying a snake stick, moving the snake into the direct sunlight would have been counterproductive because the hot desert sun would have quickly stressed it. Although I had one flash unit with me, I didn't use it. The sight of the snake was so dramatic that I didn't want to risk the potentially flat lighting that one flash can produce. Instead, I used four reflectors that I positioned on either side of the snake to bounce sunlight into the shadowed areas. Unlike using flash, I was able to see my results and I had a good idea whether or not the light was balanced.

I was using a Canon F-1 without a mirror lockup, and at the slow shutter speeds required for maximum depth of field, I knew I'd have camera shake because of the mirror. To eliminate this vibration, I filled two small cotton bags with loose gravel and positioned both of these over the camera's pentaprism. The greater mass of this system absorbed the shock and vibration caused by the return mirror. It worked, but it also made looking through my viewfinder awkward. I misframed a couple of shots when one of the bags shifted and moved my camera a tiny fraction. A camera with a mirror lockup would have worked much more easily (shortly after this experience, I switched to a camera system that offers this essential accessory).

Because the snake was lying on the side of a small hill, I was able to create a dramatic perspective by positioning myself below the snake and resting my camera on the ground. As a result, I was able to shoot up at the snake. It tried to crawl off twice, but gentle nudging with my snake stick brought the snake back into its defensive pose. Patiently coiled and as still as death, the snake was safe and ready to strike if I moved in too close—which I probably did. I used a 200mm macro lens and was close to the minimum safe working distance for

this snake. A rattlesnake can probably strike no more than about one-half its body length, and I estimated that I was two feet away. For safety's sake, I urge you to keep at least a body's length away from any venomous snake and, even then, don't do this unless you're under the supervision of an expert.

200mm F4 lens, 1/8 sec. at ƒ/32 with reflectors, Kodachrome 64.

PART 4: WILDLIFE ON LOCATION

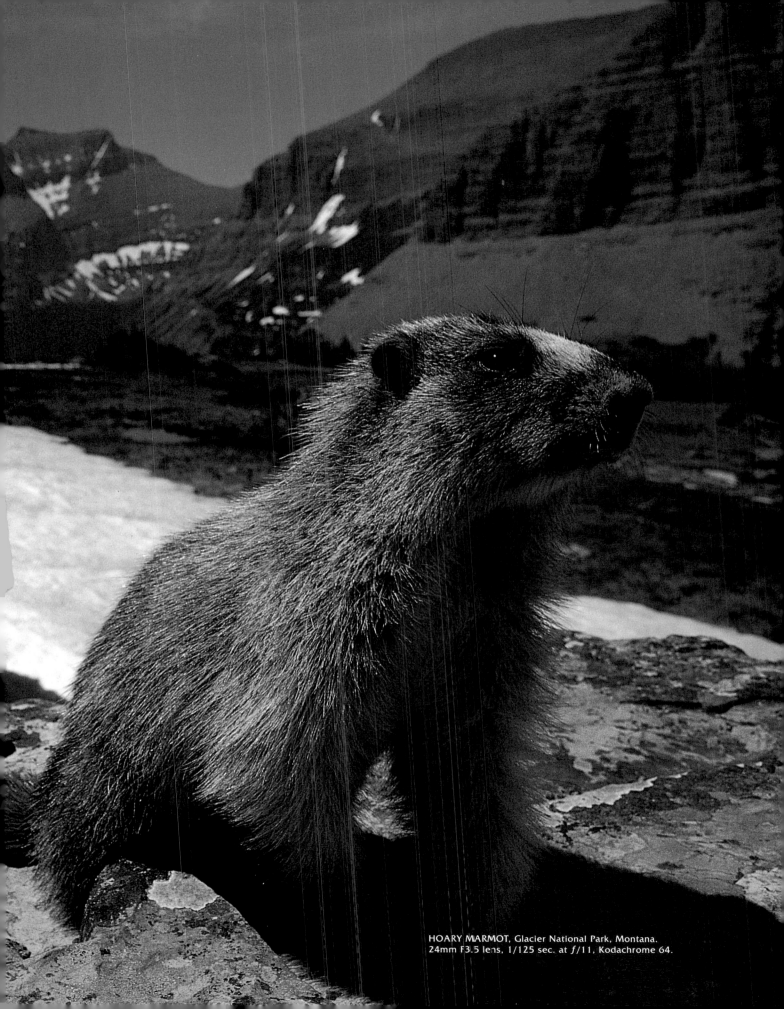

HOARY MARMOT, Glacier National Park, Montana.
24mm F3.5 lens, 1/125 sec. at ƒ/11, Kodachrome 64.

GETTING CLOSE TO YOUR SUBJECT

Technical information about how to make great pictures is as useless as good equipment if you can't get close enough to—or can't find—animals to photograph. Think about the area where you live—your best opportunities to photograph wildlife are probably nearby. Ideally, every photographer should live near a park or wildlife refuge where animals are protected and tame, but many aren't that fortunate. Whatever your personal circumstances, whether you're lucky enough to have a refuge or just a small woodlot or pond nearby, by photographing close to home you can visit an area repeatedly and during the best light. You'll get to know your subjects, when they're present, and what they'll do.

Even the smallest pond, meadow, or woodlot offers nearly unlimited picture opportunities once you become sensitive to its potential. When you visit an area frequently, animals grow accustomed, or *habituated*, to your presence. You can facilitate this process by building feeding stations or bird feeders that, as a bonus, set the stage for more photographic opportunities.

Anyone who regularly photographs wildlife agrees that habituation isn't always easy. In fact, it can be difficult, frustrating, and often completely unproductive, especially if your subject is elusive. For example, since the eastern United States boasts a huge population of whitetail deer, you might expect that photographing deer in forests, or other suitable habitats, would be simple. But the truth is quite the opposite, because to survive, the species of mammals and birds that are hunted in North America must be wary. It is very difficult to photograph these animals in unprotected areas, since their lives often depend upon eluding

humanity. I'm not trying to discourage photographers from attempting to photograph such game as deer or geese outside protected areas. This is just more difficult with animals that are unprotected and hunted. Fortunately, in parks or refuges, game animals are often approachable. The number of people visiting these areas ensures repeated and safe contacts. Not surprisingly, most great game-animal photographs are made here.

Whether you are seeking the most elusive animal or one that is common or tame, you can rely on a number of techniques to increase your chances of success. Which one you'll use depends on the type of animal you're trying to photograph, the amount of time you have, and the energy you're willing to expend. I've found that, in the course of a year, I usually use every technique I know. I suggest that you give all of the following techniques a try to see what works best for you.

Moving slowly while photographing is just as important as using a slow approach. Don't startle your subject with a sudden hand movement when grabbing for a piece of gear. Once you've finished, leave with as much care as you used in your approach so that the animal's final experience of you is positive. (photo: Mary Ann McDonald)

STALKING WILDLIFE

No matter where you find animals, it seems as if they're never as close as you'd like them to be. Although using a longer lens helps, you'll probably want to move or sneak in for a better shot. This requires some skill and some common sense.

It is extremely difficult to sneak up close to any animal or bird, because its senses of smell, sight, and hearing usually far exceed people's ability to stalk. To increase your chances, walk slowly and quietly, and pause frequently for at least 30 seconds. Move only when the animal or bird isn't looking. When stalking a deer or woodchuck, the best time to move is when the animal is feeding and its head is down. When an animal looks up, you must freeze, even if you're in the midst of taking a step. With sharp-eyed birds, use natural cover—a rock or tree—to keep yourself out of view. Birds are generally too alert to allow you to move in when you think they're not watching. Be careful where you step when stalking, because leaves or twigs can snap underfoot and frighten your subject.

Most mammals have excellent senses of smell and hearing. Stalk *downwind*, with the wind blowing from the animal to you. When you're

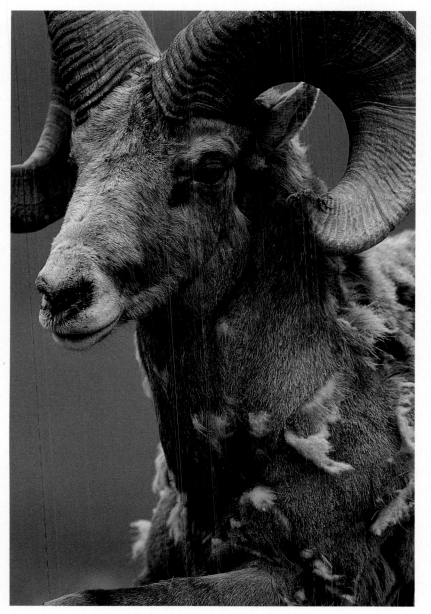

BIGHORN SHEEP RAM, Yellowstone National Park, Wyoming. 500mm F4.5 lens, 1/250 sec. at ƒ/5.6, Kodachrome 64.

Animals in parks or refuges are often habituated to being around people, but slow approaches and slow movements are still necessary to avoid frightening them. It took my wife and I over an hour to hike into the Bighorn high country, and another two hours to work into a shooting range where I could capture them with a 500mm lens. After that, it was easy, and after another half hour, animals walked within only a few yards of where we sat. I based my exposure upon a spot-meter reading of the nearest ram's face and shoulder, while Mary Ann photographed me (opposite page) in relation to the herd.

close enough, wait for the best pose since you may only get one chance. The first click of a shutter or a burst of a motordrive can frighten off a wary animal. However, you'll lessen the chances of this happening if you use a manual film advance or the single-shot mode of an electronic camera. These make less noise and might not alarm the animal.

Stalking can appear menacing. Sometimes, moving in at a slow amble is more successful with animals that aren't terrified of people. During this type of approach, I make no effort to conceal myself; instead I simply move slowly and quietly within full view of my subject. I stop frequently "to smell the flowers," which gives the animal time to accept my presence.

This slow ambling doesn't work very well with animals unaccustomed to people; they require a slightly different approach: I stay as low to the ground as I can, moving slowly forward a foot or so at a time. Although I make no effort to hide, by advancing in a belly-crawl or sliding forward in a sitting position, I present a very small profile that seems to be less threatening. I've had incredible success getting close to various skittish animals, especially along coastlines where I've been able to approach them within the minimum focusing distance of my 500mm lens. With this method I've photographed seals, shorebirds, and even sharp-eyed egrets, animals that always flee if stalked.

I've found that the most difficult aspect of "moving slow and staying low" is dealing with a tripod-mounted camera. Sliding a heavy Gitzo tripod across a mudflat is difficult when you're creeping forward on your belly. I don't even try. Instead, I carry along a small-angle iron bracket tripod that is sturdy enough for my Arca-Swiss ballhead and 500mm telephoto lens whenever I anticipate any beach crawling or low-to-the-ground work.

When approaching an animal, it is important to know how close you can get before you frighten it. All animals have a *fight-or-flight zone*, a minimum distance from humans beyond which an animal shows some type of stress. The distance varies with the animal, ranging from hundreds of yards for a hunted species, to perhaps only a few feet for one that has been fed by people and is tame. The reaction varies with the animal, too. Birds, reptiles, and most mammals simply flee if you're within the flight zone. Large mammals may run away, or they may attack out of fear. It is madness to step anywhere near this zone with a grizzly bear, especially if you have surprised it.

Furthermore, individuals within a species react differently, and a species's behavior can change with the seasons. A bull moose in velvet, when its antlers are still growing and covered with a sensitive layer of skin, might run off or only make a false charge if approached too closely. A moose in the fall rut, when its hormones are wired for fights with other males, is a different, very dangerous animal. Surprisingly, a placid cow moose becomes one of the most dangerous animals in the north woods when she is with a young calf.

It is imperative that you stop before you reach this fight-or-flight zone. Even if the animal is harmless, you should avoid frightening it. Once you've frightened an animal, it is almost impossible to regain its trust. If you pay attention to your subject, you can recognize when you are approaching too closely. Birds stop feeding or begin to bob their heads. Hoofed mammals may stare, paw, or snort. Although behavior varies, you can count on an animal's behavior to change when you enter its zone of fear.

Unfortunately, some overzealous photographers don't stop at the fight-or-flight zone. Although they risk personal injury by pushing an animal, they're also causing the animal stress by moving closer. Not only is this unfair to animals, but this behavior initiates changes in park and wildlife refuge policies that affect everyone. With the increasing popularity of wildlife photography, it is imperative that wildlife subjects be treated with respect. And, no matter how you get close, don't ruin the experience when you've finished photographing by frightening the animal as you leave. Use as much effort and caution when leaving as you use during your approach.

If you stay out of its fight-or-flight zone, your subject should relax, even if it originally showed some nervousness when you approached. As it accepts you, it will resume its normal behavior, perhaps even come closer to you, as it grows more confident and accustomed to your presence. Sometimes this takes only a few minutes. When an animal accepts you, photographing becomes magical, as you are given an intimate glimpse into your subject's natural world. You can talk quietly and even move about with a surprising amount of freedom—if you don't stand up. That almost always causes alarm.

Sometimes photographing habituated animals poses unique dilemmas. Shorebirds wintering at beach resorts are accustomed to people who walk by at very close distances and pay the birds no attention as they pass. Photographers deviate from this normal behavior when they stop to photograph the birds or inch toward them with their tripods. The birds recognize this and get nervous. It is frustrating to watch a plover or

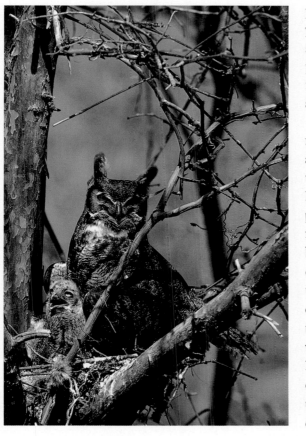

GREAT HORNED OWL ON NEST, McClure, Pennsylvania. 400mm F4.5 lens, 1/250 sec. at ƒ/6.3, Kodachrome 64.

I placed a blind 40 feet up an adjacent tree to photograph this mother and chick. Birds differ in their level of tolerance, but this one didn't flush when I climbed my tree and entered the blind. I used the blind to hide my movements behind the camera, which was less stressful for the bird than if I had remained in view.

godwit that is running away from you pay no attention to a beach stroller who walks right on by. To get close in such cases, I've tried crawling in slowly, inching forward on my belly. At other times, I've casually walked a certain distance, pretending I was just a stroller, before I began my final approach, slowly advancing in small increments. Occasionally, I've simply sat down in the sand and waited, letting the birds move toward me as they fed.

Animals often stray nearby as they feed or move about. In parks and refuges, many species come much closer to you of their own volition than they tolerate if you try approaching them. In fact, a bison or elk can walk into its fight-or-flight zone and require you to retreat. I enjoy this stationary method best because the animals are making the decision to approach as they continue with their natural behavior.

WORKING WITH BLINDS

Photographing from a blind, a hiding place for you and your camera, is another way to shorten your working distance to wary or elusive subjects. For a blind to be effective, you must place it where your subject is likely to be. Bird feeders, feeding stations, nests, watering holes, and game trails are all obvious sites.

Be careful that you don't disrupt an animal's normal activity as you set up a blind. If a blind abruptly appears at a nest or den, the animals using them may abandon their young. Photographers have an unfair advantage when photographing birds at the nest. The parents' instinct to care for the young is strong, forcing birds to return to an area that under normal circumstances they would avoid. Some birds tolerate little disruption at their nests, while others, such as house wrens or robins, are very tolerant. After carefully reading this section on working from a blind, stop and consider this: Nest photography has been done for ages. The chance that you'll obtain anything new or unique is slim. *Don't disrupt a nest, perhaps causing nest abandonment, if you must photograph*

one. Make every effort to ensure that your activity doesn't hinder nest success in any way. Watering holes or feeding areas are only slightly less critical. I urge you to use common sense to avoid any chance of disturbance here, too.

When you've decided where to put the blind, slowly move it into position. At a nest, den, or water hole, installing the blind without disrupting the animal's routine could take a few days to provide it with enough time to accept the new structure. A lightweight, portable blind works best because the entire blind can be moved at once. If you're building a stationary blind, set it up in sections to give the animal time to accept it. At feeding stations or bird feeders, conditioning might be unnecessary, so a blind could be erected immediately. Of course, the amount of tolerance varies according to the species.

The type of blind you need also depends on your subject. Some animals are very wary, requiring a blind that not only conceals you but also blends in with the environment. Ducks and eagles, for example, sometimes avoid unfamiliar structures that appear in their territories. Then you need a blind made of natural materials or one that is heavily camouflaged with brush or leaves. The camouflage-net material sold in many sporting-goods stores and catalogs is perfect for this, as it breaks up the outline of everything it covers. You can place sticks or branches into the net's loose weave to complete the cover.

Some wary animals don't accept any unfamiliar structure in their territory. To photograph such animals, I've worked with natural hollows in boulder fields or I've dug *pit blinds* for concealment. You can dig pit blinds almost anywhere there is soil; they permit a very low camera angle and a very inconspicuous profile. But you must be careful that people or animals don't fall into the pit when you're away, and that you're safe when you're inside the blind. Once while I was in a pit blind, some kids kicked my lens and almost jumped on the top of the blind I'd dug along an apparently well-traveled spot. (Although their antics wasted hours of time I'd spent waiting, I had my revenge. When I flipped

back the blind's canopy to see what was happening, my sudden appearance terrified them!) Because pit blinds are dirty and damp, you must give special attention to your gear. Wrap everything you bring inside the blind in plastic bags, removing items only as they're needed.

Float blinds are another way to get a low perspective on difficult-to-reach subjects. Some photographers use the float rings sold in fishing stores as foundations for their blinds; you can also construct your own using a square of plywood and a truck tire's inner tube. Cut a seat through the plywood platform, then attach a wire mesh canopy to the top to cover yourself, the platform, and the tube. Add a camouflage cover, a net, or a collection of natural materials to the wire mesh to camouflage the blind. When completed, your blind could resemble a muskrat lodge, a disheveled heap of cattail reeds and bulrushes floating in a pond, or just something that keeps you concealed. If you try this, wear hip boots or a wetsuit. The thermal-conducting properties of water quickly chill you in all but the warmest water. Unlike other photography blinds, float blinds are designed for movement so you can approach an animal closely by slowly creeping forward. Follow the same precautions used for stalking, and move smoothly; a duck, for example, would become alarmed if a muskrat den began jerking toward it. Finally, be sure to wear swim fins if any deep water is nearby. A wind might blow your blind into the middle of deep water and leave you stranded. Perhaps this sounds comical, but it won't be if your inner tube springs a leak once you're out there.

Some animals exhibit no reaction to blinds in their area and quickly accept new structures. For these animals, almost anything can be used as a blind. I frequently use L. L. Rue's "Ultimate Blind." It is lightweight, camouflaged, and easily erected. If I'm working a few areas simultaneously, I also use homemade cloth or canvas blinds.

If you must leave a blind standing for days someplace where it might be stolen or vandalized, use a washing-machine shipping carton instead of a real blind. These boxes are

large enough to fit most people, and most appliance stores will save a box for you if you ask. I cut a porthole for my lens with a utility knife and use a plastic bucket as a seat. If the blind is damaged or stolen, I'm not too devastated.

Some animals won't approach a blind if they've seen you go inside it. To fool them, bring along a decoy assistant, someone who goes to the blind with you and leaves after you've entered. Most animals can't count and will return to the blind after seeing one person leave. Some animals apparently *can* count, so you might need two or three people to confuse your subject. A friend of mine keeps a mannequin in his tree blind to fool nesting red-tailed hawks. After climbing up into the tree, he lowers the mannequin to a helper who walks out of the woods talking to the dummy.

If I'm using game calls to draw predators or attracting birds with an owl tape (see page 136), I need an easily transportable blind because, for these activities, mobility is as important as total concealment. I use camouflage clothing, a camouflaged face net, and a *camou-net cover*—a 4 x 8-foot sheet of camouflaged netted cloth that takes the shape of anything it is draped over—instead of an actual blind. By squatting down into a bush, I can then practically disappear within seconds. Action generally takes

A good photo blind should be lightweight and easy to erect. You'll rarely want to use a blind that requires a lot of work to set up. L.L. Rue's blind is probably the quickest to set up and works extremely well for any subject that can be photographed from a comfortable sitting height. (photo: Mary Ann McDonald)

place within half an hour of calling subjects, and unencumbered by a "real" blind, I'm free to move to another calling site whenever I'm ready.

Your car makes an ideal mobile blind, too. Many roadside animals are familiar with vehicles, although they are probably accustomed to moving, not stationary, cars. It is frustrating to watch vehicles pass within yards of hawks or eagles, roosting or feeding along a busy highway, only to have them fly off as soon as your car slows down. You'll have better luck using your car in areas where the wildlife is accustomed to cars that frequently stop. Drive up slowly and, as you get within range, turn off the engine and coast to a stop. Position your camera beforehand, as you may only have a few seconds to shoot before the animal runs or flies away.

The engine should be off when shooting from any motor vehicle, be it a car, truck, or boat. The vibration of the motor causes a tremor that your camera will record. Be sure that everyone inside the vehicle is absolutely motionless when you're shooting. I generally remind passengers several times to be still, which I reinforce by telling them when I'm about to shoot. Although it is common sense, be sure you're completely off the road and clear of traffic; otherwise, you may risk an accident.

When I shoot from a car, I use either a beanbag draped over a windowsill or a beanbag resting on top of L.L. Rue's Groofwin pod. I keep the Groofwin pod attached to the window frame if I'm driving through a refuge or a park where an opportunity can arise at any time.

GAME CALLING

Two types of natural or simulated animal calls are good for attracting some species of mammals or birds to you. A *mouth call* is a device that attracts predators by imitating the cries of an injured rabbit or similar prey animal. Using a mouth call properly requires practice. *Electronic calls* are easier to use because they are tape recordings of real animals calling or screaming. Electronic callers are used to attract predators,

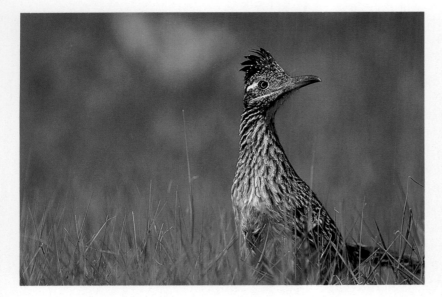

GREATER
ROADRUNNER, outside
of Bosque Del Apache
National Wildlife
Refuge, New Mexico.
500mm F4.5 lens,
1/500 sec. at ƒ/5.6,
Kodachrome 64.

*I played a tape of
a screaming
woodpecker to attract
this shy roadrunner
within camera range.
I wore complete
camouflage and a
headnet, and sat
alongside one of the
thick bushes
surrounding a
clearing. It took less
than five minutes
to bring in the bird.
I based the exposure
on sunny ƒ/16.*

owls, and certain species of birds. Johnny Stewart Wildlife Calls, of Waco, Texas, offers a large variety of animal sounds specifically designed to attract animals for photography.

Screech-owl tapes attract other screech owls, as well as many species of songbirds. Many songbirds have an almost human sense of hatred of owls and harass any that they discover. A variety of songbirds have been known to gather around a hidden speaker for as long as twenty minutes as they seek out the calling owl. Screech owls, of course, usually respond and investigate only at night. Game calling doesn't work with every species or every individual; however, it can be a useful way to attract active species that are wary, nocturnal, or difficult to find. Coyotes, bobcats, foxes, hawks, and owls often respond to the dying rabbit or squealing woodpecker tapes. In Africa, I've even attracted lionesses with the rabbit tape when I was calling jackals and caracals. This isn't surprising because many predators are opportunistic and will steal a meal from a smaller animal.

However, using any type of game call can be stressful or even harmful to your subjects. Predator calling is perhaps most effective in winter when food is scarce, but this ploy costs your subject valuable energy as it follows your false leads to food. Late summer or early autumn is a better time for game calling because food is abundant

then, and any animal that investigates is probably doing so out of curiosity, rather than because it is starving. For similar reasons, don't use an owl call to attract songbirds during the nesting season. Although most songbirds spend only a few minutes hunting for the owl, this is time the birds could be using to find food for their young or to search for real predators. Before the nesting season begins, and in late summer and autumn after nesting is completed, are better times because it is unlikely that you'll harm your subjects by calling.

Many birds also respond to tapes of their own species, especially before or during the nesting season. In fact, bird watchers often use tapes to lure rails or other elusive species into view, but they generally don't play a tape as long as a photographer might because they are trying only to see the bird. Many people have expressed concern that using bird tapes can stress animals and drive a bird from its nesting territory. This is a valid point. And using tapes or game calls is prohibited in most parks and refuges because it alters the normal routine of an animal or bird. If you must use bird songs to attract your subjects, don't use any recording of a songbird at high volume because this can drive the species you seek off its territory, and never play an owl or other bird tape during the nesting season for longer than five minutes.

Tree frogs, toads, and true frogs also call in the spring to attract mates. Although the expanded vocal sack of a singing frog or toad makes an attractive photograph, many amphibians stop calling when you approach them. Tapes can coax these shy amphibians to resume singing. Unlike the possible harm caused by tricking birds with recordings, amphibians aren't affected in the same way because they don't set up territories. You won't stress an amphibian by playing a tape. Instead, you might help them to draw in mates by coaxing them to resume calling.

When you are game calling for birds and mammals, wear camouflage clothing and remain absolutely motionless while waiting for game to approach. Remember, any animal you attract is

PHOTOGRAPHING AT BIRD FEEDERS

Many species of birds feed on or near the ground. If you find it difficult to get down to their level, you can bring the birds up to yours. Birds will accept a table or platform feeding tray that you can raise to a comfortable working height. For birds that feed in trees, you can simulate height by using the tops of branches or sawed-off sections of tree trunks as backgrounds or as locations to hide your bait.

Flash isn't necessary, although it can provide an attractive "snap" to your pictures, add an eye highlight, or stop the motion of a bird flying to a feeder. When using flash, be sure to balance the flash exposure with the ambient exposure. Otherwise, you'll have a "nighttime" bird shot. Use the fastest sync speed possible to reduce the chance of a ghost image.

RUPPELL'S VULTURE AND GNU CARCASS, Masai Mara Game Reserve, Kenya. 500mm F4.5 lens, 1/250 sec. at ƒ/4.5, Kodachrome 64.

It is not too difficult to drive fairly close to a group of hungry vultures on a fresh kill. I got this tight shot by creeping in slowly with my van and photographing the vulture from the window.

looking for the source of the call, and their senses are far superior to yours. A songbird's vision is so acute that it can see you blink from more than a dozen feet away, even when you're completely camouflaged. However, a face net and a camou-net covering that drapes over you and hangs a few inches out in front of your face helps disguise any facial movements you may make.

BAITING AND FEEDING

Many animals accept free meals and providing them can be an easy way to set up and capture

exciting closeups. Use natural foods as bait. Although once they're accustomed to handouts most mammals eat just about anything you provide, an unnatural food source makes a disappointing picture. Commercial bird seed is perfect bait for many small mammals and birds.

Feeders are good attractions for small birds and allow you to photograph them easily. Most species that regularly visit a feeder quickly grow accustomed to a blind, a camera and flash-remote setup, or even to an unconcealed photographer who sits quietly nearby. Although many photographers exclude the feeder to create a "natural" image, include the feeder in some of your pictures. These photographs might not be calendar quality but are useful for identification for use in field guides, textbooks, or slide programs. To make natural-looking shots at feeders, photograph birds or animals before they arrive at the bait. I frequently set up natural perches a short distance from the feeder. Most birds perch there briefly before flying on to the feeder. You can change the perches weekly for visual variety; for example, alternate teasel, corn stalks, cattail reeds, and assorted seed heads as perches in the areas around the bird feeders.

Animal-feeding stations are most active in the autumn and winter months, when natural food sources are scarce. If you start a feeder in the autumn, be sure to continue to supply it until spring. A well-stocked feeder can stop a bird during its migration. If the food supply suddenly stops, the birds will die. Fortunately, feeders provide the greatest amount of photographic opportunity when the weather is at its worst. This is added incentive for you to operate a feeder during the winter.

Keep in mind that water attracts birds and animals in dry areas, and often works better than any food source. I regularly set out pans of water and slices of grapefruit or orange when I'm set up in a desert campsite. Quail, woodpeckers, and a variety of songbirds are quick to find the water source, but you can hasten their search by suspending a can filled with water with a small pinhole in the bottom over the pan. Water

slowly drips from the can, creating a ripple and noise that quickly draws in birds.

Sometimes using carrion to bait such birds of prey as vultures, some hawk species, and bald and golden eagles is effective. These birds are extremely alert and frequently skittish. Along with the bait, perhaps a pit blind or a blind that blends in perfectly with the landscape will be necessary to photograph these wary birds.

Baiting and feeding stations work best on private land. In fact, this may be the only location where you can legally set them up, because feeding wild animals is illegal in most parks and refuges. Ironically, many animals in these locations are accustomed to receiving handouts from campers. Don't add to this problem—"tame" animals often become nuisances that are destroyed.

Along with songbirds, other animals can be brought to bait, including wild turkeys, deer, bears, ducks, raccoons, foxes, flying squirrels, opossums, and skunks. Many mammals visit stations only at night, so you'll need a flash. Use a multiple-flash setup with two or three units to provide a more aesthetic balance among the flashes.

If possible, photograph animals at baits or feeders from behind the camera, rather than by using a remote system. You have a greater chance of obtaining sharply focused, well-composed images when you're looking through the viewfinder. Remotes can free you for other things, but they offer little or no control over your composition. Use remote photography only as a last resort.

EASTERN SCREECH OWL, McClure, Pennsylvania. 80-200mm F4 lens, 1/60 sec. at ƒ/5.6, Kodachrome 64.

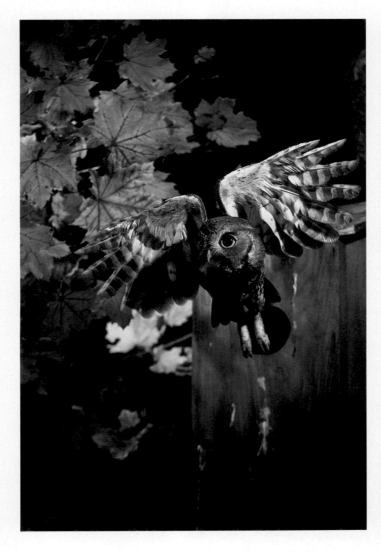

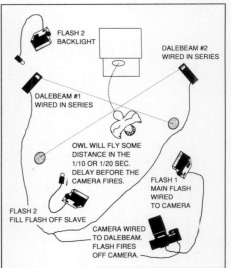

I positioned a remote camera and two flash units on an adjacent tree, and placed a third flash behind the owl's nestbox to provide backlighting. Three manual flashes were dialed down to 1/8 of their full power. I mounted two Dalebeam infrared units on Bogen Magic Arms and positioned them so that the beams crossed paths four feet in front of the nest hole (if I'd used only one Dalebeam, the bird could have crossed the infrared beam anywhere and still fired the camera). Because the camera was wired to the Dalebeams, I had to account for the 1/20 sec. time lag between the moment the beam was broken and when the camera fired. This involved estimating the owl's flight speed and direction. Fortunately, I did this correctly.

Having located a bat roost in the rafters of an old farm, my friend Ray Davis and I narrowed one window to match a 35mm format. Shortly, the bats accepted this exit. We positioned a single Dalebeam, wired to a flash, across the opening. We used the Bulb setting, since it was after sunset and our cameras were directed into the pitch-black attic. Whenever a bat broke the lightbeam, the flash fired, triggering three other flashes attached to a multiple PC socket. Before another bat could break the beam, we closed the shutter by releasing pressure either on an air-cable release for my Nikon F-3 or closing the switch for our electronic Canon T-90's. A motordrive advanced the film.

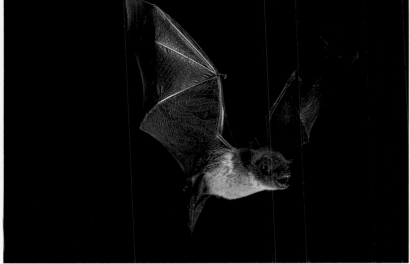

LITTLE BROWN BAT, Pine Barrens, New Jersey. 100mm F4 lens, Bulb at ƒ/11, Kodachrome 64.

REMOTE PHOTOGRAPHY

Sometimes unmanned or remote photography is required. I've found this technique useful when unusual perspectives, lengthy periods of time, or impossible reaction times are involved.

I often use a Dalebeam to fire a remote camera. For example, I wanted to photograph a screech owl as it left its nesting box. I used two Dalebeams wired in series so that the camera fired only when the owl crossed the intersecting point of the two infrared beams. One flash was activated by the camera, and two other flashes were connected to individual slave trippers. The most difficult problem in this type of setup was estimating the distance the owl would travel after it crossed the beams and tripped the camera. A little luck was needed to determine the proper focusing distance. I was lucky because I obtained a sharp image each time the owl broke both beams. This setup was completely automatic and operated throughout the night; a motordrive advanced the film after each shot.

A friend and I used a slightly different technique at a little brown-bat roosting colony. With the camera shutter set on "B," we tripped a single Dalebeam wired to a flash with a couple of electronic remote cords and *air-cable releases*, longer versions of the mechanical cable releases most photographers carry in their gadget bags. We used the "B" setting because we were filming at night when there was no danger of exposing the film through ambient light. We held four different cameras open with separate releases until a bat passed through the infrared beam and fired the one flash wired to the Dalebeam. Its light activated the other three flash units we had wired to a multiple PC socket. After each flash, we used the releases to close the camera shutters. The motordrives advanced the next frames.

Unfortunately, air-cable releases can only be used with cameras that have a threaded receptacle in the shutter button or camera body, which rules out most electronic cameras (unless they accept a special mechanical adapter). You can lengthen or shorten air-cable releases by connecting clamps. Time exposures, such as those used for the bats, are possible if the bulb remains depressed. This isn't as easy as it sounds, as I discovered while squeezing a bulb for one to four minutes for each of the 30 to 60 exposures I made at our bat house each night. When I was finished, my forearms were on fire.

Electronic releases can also be used for remote work. Ironically, many releases are inconveniently long when operated as camera trippers but are too short for remote photography. Some manufacturers make extension cables; you may be able to make your own by cutting the cable

midway and splicing in an extension wire. An electronics store can supply the wire. You can do this easily with older cameras, such as the Canon F-1, which use standard microphone-jack releases. Rewiring a cable for an electronic camera can result in loss of the data displayed in the viewfinder, even if the camera fires. The most difficult aspect of cutting an electronic release is coping with the fear that if the splice doesn't work, you've wasted a 30 to 50 dollar release!

You can also apply the trap-focus feature (see page 39) of some electronic cameras to remote photography. Several other "camera traps" are occasionally described in camera magazines or photography books. These range from mousetrap triggers to footpad electronic releases, but I've never used any of these. The methods described above have worked well enough for me that I haven't tried other techniques.

A final caution regarding remote or unmanned photography: Equipment left unattended is subject to destruction by animals, to theft, or to changes in weather. Although I haven't had the opportunity, photographers who have used camera traps to photograph bears have had equipment destroyed when curious bears played with camera or flash systems. There is little you can do to prevent a camera from being stolen, other than to camouflage it so well that it is difficult to see. Even then, any passerby can trip the camera and flash, which could prompt a search that concludes with your gear being stolen.

Weatherproof any camera that is out of sight for more than a few hours, especially one left out overnight. To weatherproof it, simply wrap the gear in plastic garbage bags and tightly bind the plastic around the gear with string or tape to prevent it from flapping and frightening your subjects. You can use clear, gallon-sized plastic bags over flash units that fire through the bag without any loss of light. The camera lenses, of course, must be kept clear. Cut a lens hole in the bag and use a rubber band to secure the edge of the plastic to the very edge of the lens. Protect the front of the lens with a filter instead of clear plastic because plastic can tear, peel back, and expose the lens glass to the elements.

STUDIO SETUPS

Sometimes photographing animals undisturbed and in the wild is nearly impossible. Occasionally, constructing a setup is the only practical way to film elusive wildlife. Ideally, even this can be

NORTHERN SPRING PEEPER IN CATTAILS, Poconos, Pennsylvania. 200mm F4 lens, 1/60 sec. at ƒ/16 with manual flash, Kodachrome 64.

For this studio portrait of an inch-long treefrog, I used two flash units and two reflector cards to fill in shadows. A white styrofoam base bounced light into the ventral region and an aluminum-foil reflector filled in the shadows on the left side.

done in the field. Some species, such as salamanders or frogs, can be collected and placed on a rock or log within feet of the capture site. After the picture is made, the animal can be released. Unfortunately, some animals can't be filmed in the field, at least not by most photographers. A few of my friends keep exotic venomous snakes from the jungles of Central Africa or the Amazon. Although I've been to some of these wild, remote areas, I've never seen any of the snakes my friends keep as pets. Nonetheless, they make fantastic nature subjects.

A studio setup can be as simple or as complex as your subject requires and your energies permit. For example, an animal rehabilitator's injured owl can be photographed in the studio with a black cloth background and one flash if you're only taking head shots. To capture an owl in a natural-looking habitat requires much more material, including branches, a sufficiently large background, and enough lights to provide even illumination. The goal of a studio setup is to recreate a habitat as simply and as realistically as possible. Study the habitat of the animal you're going to photograph, not only to get ideas about props, but to discern the key elements that comprise the habitat. Sometimes you need only a couple of very simple props.

Desperate for a "studio," I once filmed a northern spring peeper, a small treefrog common to the eastern United States, inside a shower stall, the only dust-free area in the mountain cabin that I was using as my base. Peepers frequently jump, and had my specimen landed on the cabin floor, its moist skin would have collected stray hairs and lint. This washed-down shower stall eliminated that hazard. I created the treefrog's habitat by inserting cattail stalks through a piece of white Styrofoam board I had taped onto a tripod head. If the peeper climbed to the opposite side of my set, I rotated the pan head and brought it back into view. Without touching my subject, I obtained many different perspectives.

On another occasion, I photographed a pet red fox inside a garage. I recreated a forest scene

by hanging lengths of tree trunks, borrowed from a neighbor's firewood cache, to 12D nails hammered into the open studs of the ceiling. A large log across the floor, some branches, and a garbage bag of fallen leaves completed the set. Because foxes are nocturnal, I used a black cloth stretched across a distant wall to provide the natural background. As this setup shows, I try to convey the sense of clutter and diversity of a typical habitat with only a few props. It is important, however, that the habitat you make is accurate for your subject. Don't photograph a desert species in a woodland habitat or a jungle animal in a temperate forest setting.

Natural-looking backgrounds can be difficult to make, especially with day-active, or diurnal, animals. I don't think an artificial blue sky looks natural, so I never use this as a background. Instead, I use rocks, logs, tree stumps, or leaves to frame my subject against the habitat, and a longer lens to minimize the background.

In most indoor studio setups, I use electronic flash. I almost always use at least two flashes, and I frequently use four. I try not to aim more than two flashes at the subject, in order to avoid multiple eye highlights. I use the other flashes for backlighting or for the background. In the studio, I use slave-coupled flashes to eliminate the number of wires I can trip over. I determine exposures with a Minolta Flash Meter III, although I used the GN formula before I bought the meter.

In a home studio, floor space is frequently limited. For this reason, I use one or two Bogen Magic Arms or studio lightstands to support the flashes, instead of one of my many old tripods. Lightstands can telescope to five or six feet from a small base and take up less floor space than a tripod. Although I seldom use a tripod's center column when in the field, I do use one in the studio, because it enables me to keep the tripod legs at their minimum length and allows me greater speed in adjusting for height when I'm ready to change my perspective. I can raise the camera by just one turn of the center-column's lock instead of adjusting three separate legs. The

short duration of the flash provides the necessary sharpness because the tripod is only a support.

I set up aquarium shots in a similar way. Instead of a black background, I use a greenish-colored square of posterboard, a piece large enough to cover the back of the tank. Because light reflects at the same angle that it strikes a surface, a flash unit mounted on the camera hotshoe would emit light that reflects straight from the aquarium glass back into the camera lens. You can eliminate these reflections by taking the flash off the hotshoe, holding it away from the camera, and aiming it at the tank at a 45-degree angle. In fact, for most setups, I use three flash units, two on either side of the tank and a third on top for overhead lighting.

Small aquarium tanks and most public aquariums are usually photographed with just one off-camera TTL flash. In public aquariums, you'll probably have to handhold the flash or have someone help you because there are too many people around to permit the use of a tripod and lightstand. Be sure to angle the flash so that the light doesn't reflect into the lens. You can minimize distortion and reflections in the background by placing the camera lens against the tank glass. You don't have to do this when photographing a tank at home because you can dim the lights in the room or hang a black cloth between the camera and the tank to eliminate the reflections ambient light causes.

Small subjects can be hard to find in the viewfinder when they are freely swimming inside an aquarium. You can reduce the amount of area you need to cover by restricting your subject's movements. I slip panes of glass into grooves I've cut into my tank's plastic frame. Typically, I'll cut grooves spaced one, two, and four inches from the front to accommodate specimens of different widths. You can safely confine a tadpole within a one-inch space inside a tank. But a small turtle that must surface to breathe requires the full four inches for freedom of movement.

A final point about studio shoots. If you're cooperating with a friend who keeps animals as pets or for exhibits, maintenance and care perhaps won't be your concern, but you must give proper care if you are responsible. Don't even consider collecting an animal for home studio if you don't know its life requirements: what it eats, the moisture it requires, and its tolerance to disturbance or to being handled. The activity of cold-blooded animals, such as amphibians, reptiles, fish, insects, and spiders, depends on temperature. These animals are active when warm and still when it is cold. Don't ever refrigerate and *absolutely never even consider* temporarily placing an animal in a freezer to chill it into a torpid, more manageable state; this can sicken or kill your subject. If that is not convincing enough, cold animals look droopy and unnatural when chilled. Cold-blooded animals are not heat tolerant, either. They can overheat and die if kept in the sun or under bright lights.

Fortunately, reptiles, amphibians, and fish don't have to eat daily, and food might be unnecessary if you keep a specimen for only one day. But some small mammals, like shrews or deer mice, eat surprisingly large quantities of food. Field guides, wild-pet care books, animal rehabilitators' guides, and other sources contain pertinent information on animal care should you decide to learn about certain animals. I urge you to do extensive research before you even think about shooting an animal in the studio!

Finally, collecting of many animals is illegal. In some areas, all backboned animals—including all fish, amphibians, reptiles, birds, and mammals—are protected by law. You may need to have a hunting or fishing license, or a special collector's permit, to have any of these animals in your possession. Almost all birds are protected by international laws and cannot be kept except by a licensed rehabilitator or exhibitor.

GAME RANCHES AND ZOOS
Ironically, photographers in the United States or Canada have a better chance of photographing predatory animals in undeveloped, third-world countries than in their own countries.

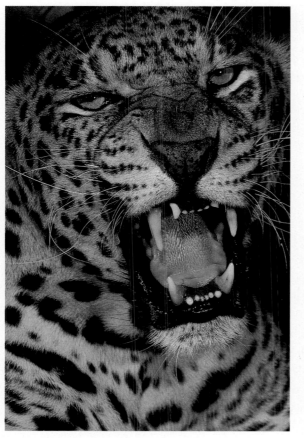

ASIATIC LEOPARD, Weed's Game Ranch, Florida. 80-200mm F4 lens, 1/60 sec. at *f*/11 with two flashes, Kodachrome 64.

Because I was using an F4 lens, I was able to fit its small diameter between gaps in the fencing of this leopard's cage, which eliminated any possible lens flare. I positioned a Sunpak 611 flash on either side of the enclosure, bolting each one into place with a Bogen Magic Arm. The exposure was based on a flash-meter reading taken outside the cage at the same flash-to-subject distance. Naturally, I had the owner's permission for all of this preparation.

Photographing cougar, bobcat, lynx, timber wolf, and a few other predators is so difficult that it is nearly impossible to do in the wild. A practical and very satisfying way to film these elusive predators is at game ranches specializing in captive animals. Although some consider this "nature cheating," there are few options for photographers who don't have enough time to wait at a waterhole, to bait, or to game call in hopes of getting a predator within camera range.

At game ranches, you or a small group can rent one or several species for photography. A trainer handles the animal in an open setting if the animal is sufficiently tame or in a large natural enclosure. This opportunity can cost 75-300 dollars per person, per day, depending on the number of photographers involved and your choice of subject. The experience is unique, and the images you can obtain are otherwise unavailable. There are a few game ranches specializing in this business throughout the United States. Photography magazines frequently carry their ads, and many workshops and tours (my own included) visit them regularly.

Although most wildlife photographers hope to visit exotic foreign countries to photograph animals, few are lucky enough to have the opportunity. Zoos are wonderful settings for encountering lions, leopards, rhinoceroses, and the like. Zoo photography can be fun and satisfying. By visiting several zoos and picking the best exhibits each has to offer, you can amass a wonderful portfolio of exotic species.

Many zoos now exhibit animals in open, moat-protected enclosures. Although there are no wires or bars to contend with, the area around the animal may be busy or unnatural. Bare ground, lawn grass, or background clutter can ruin the effect you wish to achieve. Use the longest lens possible to minimize this. Concentrate on doing closeup portraits, rather than capturing animals in their habitats. The latter framing won't be effective or look natural, anyway, unless you're filming in an aviary. Birds in aviaries can look very natural. Still, you must watch for and try to crop out the bird bands or multicolored rings with which keepers tag individual birds. Sometimes a bird perches in such a way that its legs or the rings are hidden. Use a shallow depth of field to eliminate background wire. You might also need a fill flash for illumination because screens and plastics cover many aviaries, making it too dark for slow-speed films.

Unfortunately, many animals and birds are displayed behind wires, bars, or glass. If you must shoot through these, place the lens as close to the cage as possible and shoot wide open. The limited depth of field should make reflections, fences, and bars disappear. Always pick a shaded section of fencing because bright, sunlit areas create a fuzzy, unattractive glare, just as a flash can. When using flash, position it so that its light doesn't strike the same wires or bars through which you're pointing the lens. I usually hold the flash up high and to the side of my camera's position, and if I have someone to help, I shade the cage area in front of the lens. Paying attention to these details pays off.

WAITING FOR THE BELTED KINGFISHER

Along the tall bank of a narrow, winding stream, you spot the nest hole of a belted kingfisher. About 100 yards away, a 30-foot-high dead snag hangs over the stream where, you suspect, the birds perch before returning to the nest. As if to confirm this, one of the pair flies in, rattling loudly as it lands on the top of the snag. Seeing you, it launches back upstream. Instead of working the nest, you hope to photograph the bird at the perch, holding a fish.

Challenges:

• Will the dead snag be useful for filming the perched kingfisher?

• Is there any other way you can get close to these wary birds?

• Would a remote device work for photographing the birds' fishing or perch site?

• What ethical concerns are there when filming at a nest?

Kingfishers are wary birds, and in all my field work I've never encountered one that allowed me to get close. Although I was pleased to find this nest, its location high on a bank made it too difficult to consider working.

I'm always reluctant to work a bird nest, because the bird's activities could be disrupted. This is especially true with birds nesting in shrubs or trees, since the nests are normally hidden; however, this usually isn't a problem with hole or cavity nesters.

Although the dead snag provided a perch for the birds, it was too high to be useful. Kingfishers aren't very big, and I couldn't obtain a satisfactory image size at a working distance of 40 or 50 feet. However, I knew kingfishers will perch anywhere if there is food below them. To test this, I placed a kiddie pool on one of the gravel bars near the nest and filled the pool with fish. I propped a

dead limb above the pool where I hoped the birds would land.

It took less than an hour for the birds to discover my fish-filled pool and to begin using the pool and perch as a fishing site. Once I was sure that their habits were established, I dug a pit blind at a suitable working distance from the perch. I used a pit blind because kingfishers are wary, and I suspected they might not accept a standing blind. Additionally, the area was frequented by fishermen, and I didn't want to call attention to the birds or to myself.

Digging this pit blind was easy, since the soil was thick with silt deposits. The pit was deep enough to allow me to sit inside with only the top of my head projecting above the ground. Over the pit I propped some willow branches to create a canopy where I draped cloth and

These pictures show the various stages in the construction of the kingfisher's pit blind. The blind was deep enough for me to sit comfortably inside on a shelf I carved out of the soil. The framework of saplings supported a cover of cloth and burlap. On top of this, I added a layer of camouflage

netting and a pile of grass clippings and willow leaves. When finished, the blind was barely noticeable from the birds' perch. Besides, they were focused on the kiddie pool I had filled with water and fish.

Inside the dark blind I couldn't see my mechanical camera's exposure settings, so I

counted the clicks made by my aperture ring to estimate the settings (with an electronic camera, the LCD's inside the viewfinder would have conveyed that information). I used the sunny f/16 rule to calculate my exposure, but I was off by one half-stop on many exposures because I counted incorrectly.

camouflage-netting. Finally, to complete the disguise I added leaves and grass cuttings.

Always obtain the permission of the landowner when digging a pit blind, and, for safety's sake, make sure the hole is securely covered when you're not inside.

I would have needed a Dalebeam to photograph the kingfisher diving into the pool, since my reaction time would have been too slow to capture the event. Working with a Dalebeam would have involved too many light stands and flash units to be placed at this location. As it was, I only used my blind once, but in the course of four hours I photographed the birds with five different fish on the perch above my pool.

500mm F4.5 lens, 1/500 sec. at f/6.3, Kodachrome 64.

PHOTO TOURS
AND SAFARIS

As you become more involved in wildlife photography, perhaps you'll seek new subjects in remote or exotic locations. Not only is this exciting, but photographing exotic animals and birds is also invigorating because it gives you the chance to apply all your skills within a concentrated period. However, travel can be both expensive and unproductive if you don't know where to go or how best to get there. I advise anyone visiting an area for the first time to do so with an organized photo tour or safari. It is usually less expensive than traveling alone because group discounts are available and the members of the group also share a number of other costs. Group travel is usually safer, although that doesn't mean foreign travel is dangerous, just that there is a certain amount of comfort in being with a group, especially if things aren't going very well.

In addition, you'll probably spend your time more productively with a group because most tours and safaris target specific areas that the organizers know. Most important, perhaps, group trips are usually more fun. Even the best shooting locations afford plenty of free time for conversation and information sharing, something that is not possible if you're traveling alone.

SELECTING A TRAVEL GROUP

Finding an outfitter is easy. Almost every nature and photography magazine runs ads that advertise tours, safaris, or photo safaris. Just be sure you pick the right one for you. Make a priority list before you begin reading brochures. Decide on your photographic goals and the amount of time you'd like to spend shooting. Consider the itinerary, the cultural aspects, the food, and the lodging. Then select the tour or safari that best meets your most important objectives.

You'll want to travel with a group of people who have similar expectations. Some people travel to take a vacation, photographing leisurely. Others travel as photographic workaholics and hope to spend every waking moment shooting. For example, some safaris to Kenya follow a relaxed schedule that perhaps includes an early-morning game drive, camp breakfast, followed perhaps by another short game drive, lunch, and a late-afternoon drive. In contrast, others offer a predawn game drive and breakfast in the field, a return for lunch, and an afternoon drive. A few safaris feature a full day in the field, although the midday hours are usually not very productive. Do you expect to be photographing all day? Do you want short game drives and enough time to lounge at a pool and read? You should decide this before you embark on your trip.

When comparing itineraries, always consider the time spent at each destination. I don't recommend any trip that covers a large number of parks or reserves to someone who hopes to do serious photography. Between destinations, most of your day can be spent on the road. This leaves little time to shoot, and you'll be too tired after driving to relax and enjoy the few hours you do have. I've found it more productive and rewarding to visit a few areas and to stay at each one for a longer time. You'll have more chances of encountering wildlife if you're spending your time afield, not driving to a new park every other day.

Most photo tours and safaris offer little if any photographic instruction; time is spent making pictures, not learning how to take them. A few trips do offer instruction, and if that is important

GNU MIGRATION, Masai Mara Game Reserve, Kenya. 400mm F2.8 lens, 1/250 sec. at ƒ/2.8, Kodachrome 200.

One of the highlights of an African safari is witnessing a river crossing of the migrating gnus. The animals can stack up along a river's edge for days, so you must be patient and have a great deal of luck to witness this event.

because of in-country travel costs. Food and lodging are major costs, so you'll have to decide whether you need to sleep in a four-poster bed or if you can make do with a modest mattress on a camp cot. Keep in mind that in tourist-oriented countries, such as Kenya, or in developed countries, such as Australia or Argentina, even the most affordable tourist camps offer pleasant conditions. In countries where tourism is only just developing, I suggest going first class, because conditions below that level are often distasteful.

PACKING GEAR

When you fly, carry your most important camera equipment, especially your film, on the plane with you. Luggage can be lost or misplaced, and you'll be out of luck for an entire trip if your luggage doesn't arrive. Most overseas trips involve a number of destinations, and it is often difficult, or impossible, to have luggage forwarded, especially after you've left the major cities. Don't expect to replace camera equipment unless you're prepared to spend a small fortune. Although lost luggage usually arrives within a day or so in the United States or Canada, even this delay could severely reduce your shooting time.

Airlines have weight and space limitations for carry-on luggage, and your gear may exceed these limitations. If this happens, you have a couple of options. You can try carrying the extra gear onto the plane. You may be allowed on, or you may be forced to check in some or all of the gear in order to comply with the company's weight restrictions. Find out the airline's restrictions before you pack so that you won't have the headache of dividing the gear when checking in or boarding the plane.

I carry a lot of gear, but I meet the stringent requirements of most airlines by wearing a Rue Photo Vest in which I pack many of my smaller pieces of equipment. It holds four camera bodies; four small lenses, tubes, or extenders; a hotshoe flash; an 80-200mm zoom lens; and assorted filters and cables. When I'm finished, the vest weighs about 25 pounds. I carry my larger lenses

to you, you should check this before you sign up. Many photo tours and safaris are led by professional photographers and, in theory, the leader should be available for help or for answering questions. The leader's expertise and personality can radically affect the success or failure of a trip. It is prudent to talk with or meet the leader of a trip before making a commitment.

People generally choose photography tours according to price, a determinant influenced by a number of factors, including the itinerary, the group size, the food, and the accommodations. A trip covering many areas can be expensive

and all my film in a luggage bag that complies with most airlines' overhead-compartment rules. I don't pad these lenses, although the film bags that surround them do offer some protection. Finally, I pack the tripod and tripod head separately inside one of my checked bags, usually wrapped in clothing or heavy coats.

Most domestic airlines handcheck film, especially if you arrive at the gate early. To facilitate this, I remove each roll of film from its box and plastic container and put 25-50 rolls inside a resealable plastic bag. All but the most uncooperative security clerks agree to inspect film if it is visible. In some countries, security personnel initially demand an X-ray inspection, but even some of these people can be swayed by sincere begging. If all else fails and you must have the film X-rayed, place your film inside a lead bag before you pass it through the machine.

Slow-speed films aren't harmed by one or two exposures to X-rays. In fact, I always pass my loaded cameras through the machine, since I'll probably have a new roll of film loaded in that camera by the time I go through security again. I've never had an adverse effect on film that has been passed through an X-ray machine. Although most X-ray machines claim to be film safe for speeds of ISO 1000, high-speed films can fog, so make your best effort to handcheck films faster than ISO 200.

PASSPORTS AND VALUABLES

Always carry your passport and important documentation with you. Luggage stores and catalog companies offer passport wallets that you hang around your neck and tuck into your shirt, a very safe place to store these valuables. Use traveler's checks; they can be replaced if lost or stolen. Carry your cash inside a money belt. Make a photocopy of your airline tickets and your passport. If you lose either one, a photocopy will expedite obtaining a replacement. Also, know the locations of your nearest consulate or embassy, in case you should lose your passport or money.

If you're planning to drive or rent a car, obtain an international driver's license from your local motor club. Try to make the rental arrangements before you leave the United States, instead of in the country you're visiting, in order to obtain a better rate and to have some protection against overbilling. If you're concerned about paying duty on camera gear you already own when you return home, carry a notarized list of your equipment and present it to the customs' agent. Many foreign destinations require inoculations and some hospitals have a travel clinic that can provide you with the required or the advised inoculations. Carry the yellow "International Certificates of Vaccination" booklet with you when you travel abroad. Your local hospital can refer you to the nearest travel clinic, and they should be able to provide you with the booklet free of charge so that you can keep a permanent record of your travel vaccinations.

WHAT TO BRING ON A TRIP

It is tempting to carry everything you'd possibly need for a major shoot, but space and weight limitations usually restrict this. Combine focal lengths by using zoom lenses, or eliminate macro lenses by using closeup lenses or extension tubes. Bring at least one extra camera body in case of loss or breakage. This is the equipment checklist I use for an average overseas trip:

- 3 camera bodies
- 24-35mm zoom lens
- 35-70mm zoom lens
- 80-200mm zoom lens
- 300mm lens
- 500mm lens
- 1.4X multiplier
- 1 hotshoe-mounted flash with off-camera cords
- Quantum Battery 1 for flash
- Photo reflectors
- Extension tube set
- Nikon 6T closeup lens

- Gitzo 320 tripod and ballhead
- Limited assortment of filters, including: 81, 85, ND, and polarizing
- Notebook
- 75-150 rolls 36-exposure film *
- Lead film bag for airport security check-in
- Swiss army knife
- Leatherman pocket knife and tool set

* Film is a personal choice, but expect to shoot at least 3 rolls of film each day. If you're an avid photographer or if you bracket most exposures, budget 10-20 rolls of film for each day. However, if you do bracket, reread the section on mastering exposure, and cut your film consumption in half!

MAGELLANIC
PENGUIN, Punta
Tombo, Argentina.
50mm F3.5 lens,
1/250 sec. at ƒ/5.6.

*A benefit of traveling
to exotic locations
is the opportunity
to photograph new
wildlife species.
At Punta Tombo,
penguins are
so accustomed to
people that many
nest right on the
trails, and obtaining
a ground-level,
penguin's-eye view
of a curious trio
is easy.*

GOING THROUGH CUSTOMS

Entering a foreign country at customs can be intimidating. Many customs officers look stern or bored, and after a long flight, many people find customs unnerving. Despite your first impression, customs checks are rarely difficult and most go smoothly. Have a positive attitude, and be friendly and cooperative. Answer all questions directly, but offer no more information than is necessary. Have your documentation handy; frequently, that is all you'll be asked to show. In some countries, corrupt officials attempt to levy "taxes" on your gear or on your profession if you state you're a professional, not an amateur photographer on vacation. If you have another line of work, such as insurance sales or teaching, give that as your occupation to avoid hassles.

THE WORLD'S GREATEST WILDLIFE DESTINATIONS

Worldwide tourism is expanding, thereby opening up new areas for easy, efficient travel. Ironically, habitat loss and poaching threaten some of the best locations. This shouldn't come as a surprise, as doomsayers have predicted the demise of Africa's wildlife for decades, and the results are hardly disputable. Therefore, I suggest visiting the most threatened areas first. For example, East Africa's exploding population

seriously endangers the grandest wildlife spectacle on earth. For that reason, I urge you to visit Kenya or, as a second choice, Tanzania, as soon as you can. Don't put off what literally may not be here tomorrow. Sadly enough, India's wild areas, portions of the Central and South American rain forest, and the rich jungles of northeastern Australia are also threatened, but these areas are currently accessible to tourism. As your time and budget permit, visit other locations that have a better chance of long-term survival. The following list, although incomplete, provides basic information about some of the best places I've found to photograph wildlife:

Kenya and East Africa. The trail to serious wildlife photography often leads to Africa, the site of the greatest wildlife spectacles remaining on earth. My childhood dreams of exploring Africa are shared by most photographers and tourists who have visited this continent. Kenya and Tanzania host the most tourists in Africa, and the majority go to Kenya. In the peak months of July and August, and December and January, you can see a dozen tourist vans and four-wheel-drive vehicles surrounding one animal in a Kenyan game park. This may disappoint those who were expecting the isolation of a 1930s safari film, but the crowd won't affect your photography. In fact, it actually might help because tour drivers frequently share sightings, which ensures that everyone sees game (and that grateful tourists leave tips). You can use a telephoto lens to crop out clusters of other tourist vans from your pictures. Kenya can be crowded, but the people are friendlier and the accommodations are nicer than those found in Tanzania. However, in Tanzania's Serengeti, you could have the area to yourself.

Most of the best viewing areas are found in semi-desert or grassland environments where using slow-speed films and slow lenses is possible. I rank the Masai Mara, Samburu, Ngorongoro Crater, and the Serengeti as the best locations. Nairobi, Amboseli, and Lake Nakuru are also popular and are open enough to be photographed with slow films.

Working distance is usually not a problem when photographing animals, such as the lion pride above, that are accustomed to safari vans. For the best photography opportunities, you must be out early. I recommend being in the field and at your shooting locale by sunrise when the best light and the most action occurs.

Tripods are rarely used inside a safari vehicle. Beanbags work better and can be used from either an open roof or a window position.

Kenya also offers a few tree lodges in the high forest country around Mount Kenya and the Aberdarres, but these are more productive for game viewing than for photography. Most people arrive at the mountain lodges late in the day and leave the following morning, having spent their time watching nocturnal animals that visit a waterhole or a salt lick located beneath spotlights. Serious photography is possible during the day, when you have the area to yourself, but this requires a two-night visit to a lodge. Fast lenses and fast films are useful because clouds and fog frequently shroud the jungle. I'd recommend staying at a forest lodge only to photographers who have done several lowland safaris and are looking for new subject matter.

Covering only three or four parks during a visit is best. This allows two to six days per park, which is sufficient time to obtain reasonable coverage. Smaller parks, such as Lake Nakuru, or reserves, such as Navasha or Baringo, can be covered in one full day. Others, such as Samburu, the Masai Mara, or the Serengeti, require longer stays of at least a few days. The world-famous Ngorongoro Crater demands a three-day visit. You should camp inside the crater rather than staying at a lodge on the rim. By camping, you'll have the prime shooting hours available and not waste these hours, as those commuting from the crater rim must do.

Most photo safaris last 18 to 21 days. The shorter trip provides about two weeks of field time, including the time spent driving to each game park. For the average tourist-photographer, two intense weeks of shooting is sufficient. Most people are tired at the end of the trip and are ready to return home. For the serious photographer, two years isn't enough time, with the wealth of mammal, bird, reptile, and insect life that is available. How long you'll stay should be governed by your interest level, vacation time, and budget.

Most safaris travel in either four-wheel-drive land rovers or in two-wheel-drive Nissan minibuses. Either vehicle can travel nearly impossible roads, but the land rovers provide access to areas impassable by bus. Vans can carry eight or nine passengers; however, any photo safari with more than five to a vehicle is very limiting. Three or four photographers per van is a better number, providing sufficient room for them to move around and lay out their gear. Land rovers are more limiting, and I suggest a maximum of only three photographers per vehicle. Although individuals can rent small land rovers or jeeps in Nairobi, the capital city of Kenya, and drive the parks unguided, for several reasons this is not a good idea for most first-time visitors. Some of these parks are vast and featureless, and it is easy to get lost. Safari drivers are excellent at sighting wildlife, and chances are you'll see and photograph more if you let a professional drive for you, instead of renting a

vehicle and doing everything yourself. Most important, traveling with someone who speaks the native language can be a lifesaver if your vehicle breaks down or if an emergency develops.

Minibuses are more comfortable and easier to shoot from than land rovers and other four-wheel-drive vehicles. Both minivans and land rovers have open tops, and most photographers shoot with their lenses on beanbag supports set on the roof. In fact, most African professionals forgo tripods and use *lens rests*, such as L. L. Rue's Groofwin, and beanbags they mount on open windows. You can obtain razor-sharp images with a driver and four photographers in a van if everyone cooperates and remains still when someone else is shooting.

Keep in mind that it is illegal to be outside a vehicle while on game drives inside most of Africa's national parks. That means setting up a tripod outside is impossible. Nonetheless, I recommend carrying a tripod for use in scenics outside the parks and for photographing birds

LIONESS, Masai Mara Game Reserve, Kenya. 500mm F4.5 lens, 1/250 sec. at ƒ/8, Kodachrome 64.

Although it is always a thrill to see a wild lion, most tourists see only sleeping cats. The time of day to witness activity on a game drive is early in the morning and late in the day. Midday, animals are asleep in the shade.

and small animals within the confines of the camps and lodges.

When photographing wildlife, longer lenses are best. Although you can be within a few feet of a sleeping lion, your best shots will be made at a greater distance. It is sometimes difficult to get close enough to use a 200mm or smaller lens with animals engaged in play or feeding behavior. If you try, you're likely to frighten them off. Carry a 300mm or longer lens for wildlife portraits and for capturing animal behavior. Shorter lenses, especially an 80-200mm zoom lens, are very useful for scenics and for animals in their native habitat.

Most photographers hope to photograph the "big five": a lion, a leopard, a black rhinoceros, an African elephant, and an African or Cape buffalo. But this has become difficult in recent years because increased poaching has nearly wiped out the rhinoceros. Elephants have also suffered a drastic reduction in numbers, but you're still likely to photograph one of these huge beasts. Leopards are not rare, but are well camouflaged and secretive, spending their time in thick cover or in trees. Most tourists fail to see leopards. East Africa has a huge variety of birds, too. Approximately 1,100 species inhabit Kenya, a country about the size of Texas. You need longer lenses of 400mm or 500mm for most bird species.

Wildlife is most active in the early morning when it is still cool. To increase your chances of photographing feeding or hunting behavior as well as to capture the best light, start your game drives before sunrise and eat breakfast in the field. By 11AM the light is harsh and hot and most animals become inactive. I recommend returning to the camp to give yourself and your drivers a rest.

India. Although India is noted for its large human population, this diverse country has an extensive park system. India is almost the size of the United States, and its parks are scattered. Travel by rail or air is necessary if you're visiting parks more than a few hundred kilometers apart. Indian

tours are usually longer in duration than African safaris because of the travel involved. Plan on spending 21-28 days on a comprehensive tour.

India has an exciting variety of wildlife. Chief among these is the Bengal tiger, probably the most majestic of the big cats. In contrast to East

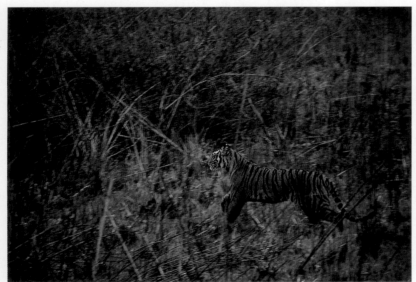

BENGAL TIGER,
Jim Corbett National
Park, India.
80-200mm F4 lens,
1/125 sec. at ƒ/4,
Fujichrome 100
pushed to ISO 200.

Wildlife photography in most of the big game parks of India takes place either from elephant back (top) or from a jeep. Although elephants can travel to places a wheeled vehicle cannot, filming from elephant back is difficult. Use the fastest lenses you're capable of hand-holding.

We tracked our first tiger by following monkey alarm cries. When we found the cat, it was too well concealed in the dried grasses to make a satisfactory image. Our mahout moved closer, the tiger charged, and our elephant side-stepped to meet it. The four of us riding on the elephant nearly fell off, and I shot a motordrive burst of the sky. At the next false charge I was ready, and in a burst of twelve frames I caught one reasonably sharp image when the cat broke its charge and ran past us. I used Fuji 100 film pushed to 200, exposed for the grasses, and panned.

Africa, much of India's best viewing areas are in forested areas where the lighting is poor. India is very hot, too, and the best shooting occurs when it is cool, either early in the morning or late in the day. Fast films and fast lenses are required.

In most Indian parks, game-viewing is done from open jeeps, open trucks, or from elephant back. Elephants can go anywhere, which makes for exciting rides and opportunities to photograph wildlife that is inaccessible by vehicle. Although photographing from an elephant sounds wonderful, it is extremely difficult to do. Elephants sway continually, kick the grass, scratch, and otherwise move about, which shakes both you and your camera when you're on one. Use the fastest lenses you can handhold, or use a shoulder-stock mount.

Photography is more productive from inside a vehicle, provided it is the right type. India's tourism and game-viewing facilities are not as sophisticated as East Africa's, so if you're not careful, you could find yourself inside a bus or large open truck on a game drive with a dozen other tourists. In parks open to vehicles, three or four passenger jeeps are available, so be sure that your tour uses one of these. Keep in mind that in India the traffic is unspeakable. I strongly recommend that you don't drive a vehicle. If you want to travel privately, hire a driver who is accustomed to the traffic conditions.

Although India's wildlife is diverse, the woods and forests make seeing game difficult. Animals are less accustomed to vehicles and are often quite shy, and your best photographic opportunities are at the most popular parks, where the game is habituated. Park's like Kazaranga, Ranthambore, Keoladeo, and Kanha offer the best opportunities. Tigers are most easily seen and photographed at Ranthambore, a beautiful national park where tigers roam old Mogul palaces and temples. Game-viewing is done by jeep, so sharper images with slower films are possible. In contrast, at Kanha National Park, game drives are from elephant back. There are tighter controls over tourism and game-viewing at Kanha, and contact with any tiger is generally briefer than at Ranthambore.

The best time to visit India is during the dry season between January and April. Ranthambore is best in April when the game is concentrated at the few remaining waterholes. Later, in the heat of summer, most animals move around only at night.

The Galapagos Islands. This famous archipelago lies 600 miles off the coast of Ecuador. Despite

COMMON LANGUR MONKEY AND BABY, Ranthambore National Park, India. 80-200mm F4 lens, 1/125 sec. at ƒ/11 with TTL fill-flash, Kodachrome 64.

Around temples and park entrances, monkeys are tame. This mother and baby were part of a troop that congregated outside one of India's best tiger reserves. Working distance was no problem. I based my exposure on a reflected-light reading of the langur's fur, opened up one half ƒ-stop, and used fill-flash to bring out an eye highlight and to accent the fur

the area's reputation as a naturalist's mecca, wildlife is not abundant. Mammals are few, limited to only a few marine species: the abundant Galapagos sea lion and the much less common fur seal. You may have a chance to see Pacific bottlenose dolphins and whales, but the possibility of photographing either is limited. The group of islands is perhaps best known for its tortoises, viewed by most visitors as captives at the Darwin Research Station. Wild tortoises can be found in the highlands of a few of the islands, notably Santa Cruz and the volcano calderas of Isabella, but few tourists make the effort. Both marine and land iguanas are common and easy to photograph. Several species of sea-dwelling birds nest on the islands, including three species of boobies (goose-sized birds related to the gannet), brown pelicans, ominous-looking frigatebirds, and two species of gulls. In the brush and forest, there are incredibly tame mockingbirds, short-eared owls, and the finches that were the final clue in Darwin's theory. However, it is not the diversity of the island's wildlife that attracts study, but rather the tameness of its species and their remarkable trust of man.

Access to the islands is strictly controlled, and all visitors must be accompanied by a licensed naturalist guide. The islands are a great destination at any time of year. Some interesting species, like the waved albatross, are absent between January and March, and only begin to nest in April. Most bird species nest throughout the year, although more activity is apparent from April onward. Tower Island, in the far northeast, and Hood, in the southeast, offer the most exciting photography, and both can be reached on a typical one-week cruise. Isabella Island's western visitation sites and remote Fernandina Island are available only to those on larger, faster boats or for people doing a ten-day or two-week cruise. Passenger jets service the islands daily, and most cruises, sleeping six to twenty passengers, originate in the islands. Large cruise ships also depart from Guayaquil, Ecuador, but these hold hundreds of people and visit only a few islands.

GREAT FRIGATEBIRD, Tower Island, Galapagos, Ecuador. 300mm F2.8 lens, 1/250 sec. at *f*/6.3, Kodachrome 64.

Although the bird and wildlife of the Galapagos are trusting, a long lens is useful for frame-filling portraits. I based my exposure upon the bird's red throat sack, then opened up one half f-stop to compensate for the dark plumage. Although the bird was dark, a sunny f/11 exposure would have overexposed the bird's middle-tone throat.

BLUE-FOOTED BOOBIES, South Plaza Island, Galapagos, Ecuador. 80-200mm F4 lens, 1/250 sec. at *f*/8, Kodachrome 64.

Instead of seeking a portrait, I used a zoom lens to include some of the sea cliffs that comprised this pair's habitat. An architectural grid screen insured that my distant horizon line was level. The exposure was based on sunny f/16.

Although hotels are available at a few small villages, most tourists sleep and take their meals aboard the boats that cruise to the various islands. Visits lasting between two and four hours are made after breakfast and before dinner. Most people return to their pangas, or tour boats, at midday when the sun is high and the temperature on these equatorial islands rises. These small rubber or wooden boats transport tourists between their cruise ships and the islands. There are no docks, and disembarking is either "wet," if it is into the water, or "dry," if it is onto the lava rocks. Both involve some risk to your gear. In rough seas, a dry landing may require stepping off the panga and into the grasp of your guide at the peak of a swell. In wet landings, an unexpected wave might jostle you just as you step into the surf. In either case, you can drop equipment into the water or fall overboard.

When you travel in a *panga*, hand-carry your equipment; don't wear a vest or backpack. If you fall overboard with your gear on, you could drown. Some outdoor companies sell waterproof plastic dufflebags that are perfect for storing gear. Once you're safely on the shore, you can transfer the gear from the dufflebag into a vest or backpack and store the dufflebag on shore above the high-tide mark. Everyone leaves their unused gear there, and property theft is rare, perhaps because each group is chaperoned by a licensed guide.

Once you're on the island, you'll see that trails lead into or around the various visitation areas. Most of these trails are easy, and only a few involve moderate climbing to reach a lookout. Although much of the island is covered in lava rock, heavy leather boots aren't necessary. Bring a sturdy pair of sneakers for your explorations.

Although the animals on the islands are tame and can often be approached within the range of a 50mm lens, you might want to carry a tripod and a long telephoto lens. Its limited depth of field and narrow angle of view produces a dramatic image without background clutter. Since you are restricted to established trails, you might also need the telephoto lens' magnification for subjects that nest or roost some distance away.

SOUTHERN RIGHT WHALE, Valdes Peninsula, Argentina. 50mm F3.5 lens, 1/125 sec. at ƒ/11, Kodachrome 64.

Whales are among the most awe-inspiring of animals and one of the most trusting. This unusual piebald female repeatedly swam up to our boat, submerging silently as she slipped underneath. Closeups were no problem, although we risked capsizing our boat as everyone leaned over the rail to take pictures!

TROPICAL WALKING STICK, Iguazu Falls National Park, Argentina. 200mm F4 lens, 1/8 sec. at ƒ/16, Kodachrome 64.

In tropical jungles, the variety of insect and spider life is staggering, although much of this is well camouflaged. I used a camera with mirror lockup and a cable release to prevent any blurs caused by camera shake. The subject, secure in its camouflage, remained motionless for the long exposure.

Argentina. Argentina, the eighth largest country in the world, offers an incredible diversity encompassing sub-Antarctic to subtropical jungle habitats. A well-established park system stretches from the jungles of Iguazu Falls on the Brazilian border to the Alaska-like climate of Tierra del Fuego National Park on the southern tip of the continent. Argentina's seasons are the reverse of those of the Northern Hemisphere's; spring in November offers a variety of nesting birds, congregating whales, and pleasant, but varied, temperatures and weather. Although the highway system is excellent, air travel is the most efficient way to cover the country.

A typical, well-rounded trip lasts 18 days. During that time, you might photograph southern right whales, elephant seals, tropical spiders and mantids, anacondas, and a large variety of birds, including Andean condors, flamingos, and Magellanic penguins. There are no dangerous animals in Argentina, so you can do all park explorations on foot. At a few locations, including the Valdes Peninsula, licensed guides accompany visitors, while in others, such as the penguin rookeries at Punta Tombo, ropes or fences cordon off the visitation areas. In most areas, however, you're free to roam at will, and there is plenty to explore.

CAPYBARA, Ibera Marshlands, Missiones Province, Argentina. 300mm F2.8 lens, 1/125 sec. at ƒ/4, Kodachrome 64.

At a few ranches in northern Argentina, the world's largest rodent—weighing over 130 pounds—can be filmed closeup by making a slow, casual approach. After a 2-hour stalk, a herd of 50 capybara accepted us, even using us as obstacles as they chased each other about in the shallow marsh. In the last seconds of light before sunset, I caught this tranquil silhouette, basing my exposure upon a reflected-light reading off the sky. Had I shot at my subject's level, the silhouette of the animal would have merged with the far shoreline.

Unfortunately, few tours visit this interesting part of the world, perhaps because parts of South America receive very negative press. Argentina has more in common with France or Germany than it does with most of South America. Despite occasional bouts of political unrest, it is a safe and hospitable land. It is so diverse that I recommend carrying a full complement of gear, including telephoto lenses for wildlife, wide-angle lenses and filters for the spectacular scenics, and macro lenses for insects and plants. A tripod is a necessity, because most photography takes place on foot.

Of course, many other ideal locations for photographing wildlife exist. They are exciting and offer unique opportunities. Nevertheless, in many ways there is no place like home, whether that is right in your backyard or within a day's drive. Although local wildlife is perhaps less dramatic, romantic, or dangerous than an African lion, local species afford far greater opportunities for quality shooting. Never forget that, especially when you are wistfully studying a globe during times of boredom or frustration. There is no limit to what you can photograph locally if you only open your eyes and mind.

THE GIRAFFE RUNNING AT SUNRISE

It is five minutes before sunrise, and you've positioned your van behind one of the acacia trees dotting Kenya's Masai Mara high country. In the final seconds before sunrise, you realize that the sun will pop up in the center of your frame, not off to the left as you had anticipated. You're about to ask your driver to move when, on your left, a giraffe steps into view outside of your picture area.

Challenges:
• What would moving have accomplished?
• How is a sunrise exposure determined?
• What lens could work to incorporate both the sun and the tree within your image?
• What role could the giraffe play?

When seeking dramatic sunrise silhouettes, you must look for backgrounds that are free of clutter. Two trees, a tree and brush, or any set of objects will merge as an unattractive blob of black when aligned in silhouette. In this situation, I had considered backing up so that the acacia tree and the sun would occupy the two lower points of power. But the appearance of the giraffe changed my mind. There was a chance that something wonderful might happen, and I didn't want to be out of position if it did.

For a typical silhouette, I base my exposure on a reflected-light reading of the brightest area of sky, keeping the sun out of the viewfinder. Its brightness could bias the reading, underexposing everything else as the meter makes the bright sun a middle tone. Also, looking at the sun through a long lens could damage my eyes.

To produce a large fireball, I needed a telephoto lens of 300mm or greater to magnify the sun's image. Because both the sun and the tree were magnified 6X with my 300mm lens, I had to back off from the tree in order to keep it within my frame. When the giraffe appeared, I changed to a faster shutter speed than I had initially set, to ensure that I would stop the animal if it walked past. As it was, the giraffe began to gallop across the plain; as it entered my field of view, I fired off a burst of six frames. During those few seconds, the giraffe passed completely through my frame. Of the six shots, this is my favorite. I didn't pan the giraffe because my working distance was great enough and my shutter speed was fast enough to allow my camera to remain stationary and still stop the giraffe's run.

300mm F2.8 lens, 1/1,000 sec. at ƒ/8. Kodachrome 64.

LIST OF SUPPLIERS

Contact these suppliers for the equipment and services for wildlife photography mentioned in the text:

A. G. Editions, Inc.
142 Bank St. #GA
New York, NY 10014

Publishes The Guilfoyle Report, *a quarterly newsletter for photographers covering markets, want lists, and new products, and* The Green Book, *a directory of natural history and general stock photography.*

Bogen Photo Corporation
565 East Crescent Avenue
P.O. Box 506
Ramsey, NJ 07446-0506

Strictly accessory items, including Bogen tripods and the Bogen Magic-Arm for camera stability.

Forster's Photo Accessories
HC1, Box 1378
Blakeslee, PA 18610

For Arca quick-release plates and custom accessories.

Johnny Stewart Game Calls
P.O. Box 7594
Waco, TX 76714-7594

Provides tapes and game callers for predator and bird calling.

L.L. Rue Enterprises
138 Millbrook Road
Blairstown, NJ 07825

Perhaps the largest and most diverse assortment of accessories for outdoor photographers. For photo vests, gun stocks, Gitzo tripods, the Groofwin pod, and the ultimate blind.

Joe McDonald Wildlife Photography
R.R. #2 Box 1095
McClure, PA 17841

For photography workshops, tours, and safaris throughout the United States and abroad.

Nature's Reflections
P.O. Box 9
Rescue, CA 95672

For Tele-flash brackets and Fresnel screens.

Nikon
19601 Hamilton Avenue
Torrance, CA 90502

The 8008S autofocus camera, SB-24 speedlight, databack, and more.

Phototrack Software
6392 South Yellowstone Way
Aurora, CO 80016

For IBM-compatible software slide-labeling programs.

Protech
5710-E Genl. Washington Drive
Alexandria, VA 22312

For Dalebeams.

Tekno
38 Green Street
New York, NY 10013

Exclusive importer for Arca-Swiss camera equipment, including monoball heads.

Tiffen
90 Oser Avenue
Hauppauge, NY 11788

Manufacturer and distributor of tripods, support systems, and filters, including polarizing neutral density, and color-graduated filters.

Tocad America, Inc.
Tower 1, Continental Plaza
401 Hackensack Avenue
Hackensack, NJ 07601

For Sunpak flash units.

Wild Eyes Game Ranch
894 Lake Drive
Columbia Falls, MT 59912

Wildlife photography models, including American big cats, canines, and other predators.

INDEX